Put any picture you want on any state book cover. Makes a great gift. Go to www.america24-7.com/customcover

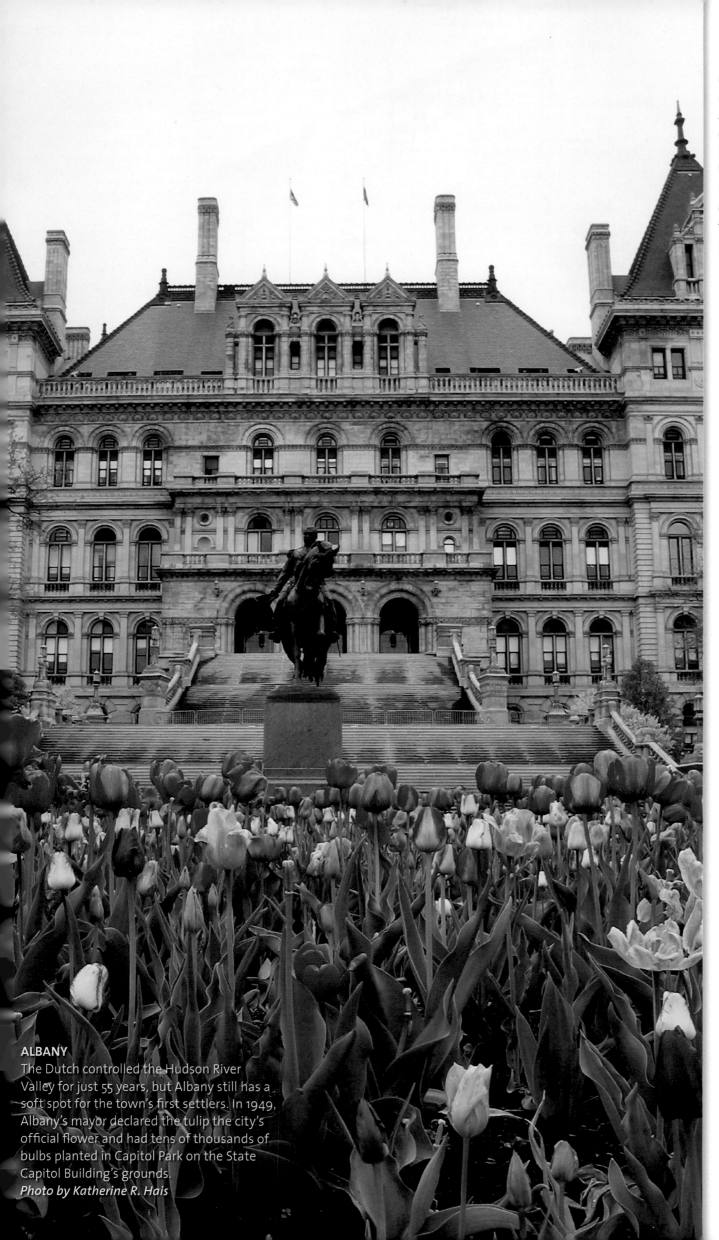

ALBANY
The Dutch controlled the Hudson River Valley for just 55 years, but Albany still has a soft spot for the town's first settlers. In 1949, Albany's mayor declared the tulip the city's official flower and had tens of thousands of bulbs planted in Capitol Park on the State Capitol Building's grounds.
Photo by Katherine R. Hais

New York 24/7 is the sequel to *The New York Times* bestseller *America 24/7* shot by tens of thousands of digital photographers across America over the course of a single week. We would like to thank the following sponsors, the wonderful people of New York, and the talented photojournalists who made this book possible.

Adobe

OLYMPUS

LEXAR
Media

snapfish

jetBlue
AIRWAYS

WEBWARE

Google

DIGITAL
POND

ebay

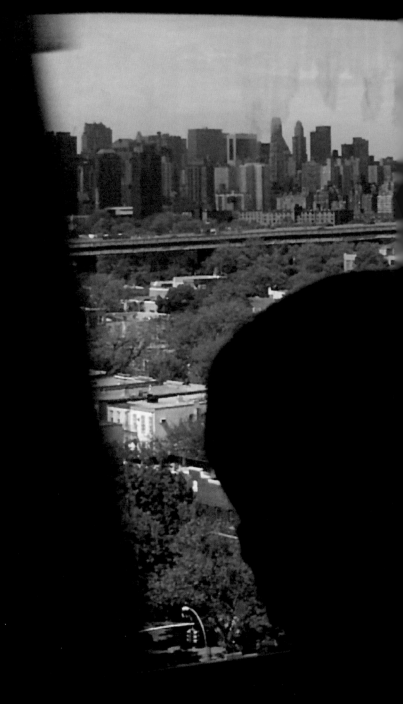

LONDON, NEW YORK, MUNICH, MELBOURNE, and DELHI

Created by Rick Smolan and David Elliot Cohen

24/7 Media, LLC
PO Box 1189
Sausalito, CA 94966-1189
www.america24-7.com

First Edition, 2004
04 05 06 07 08 10 9 8 7 6 5 4 3 2 1

Published in the United States by
DK Publishing, Inc.
375 Hudson Street
New York, NY 10014

DK Publishing, Inc. offers special discounts for bulk purchases for sales promo-
tions or premiums. Specific, large-quantity needs can be met with special edi-
tions, personalized covers, excerpts of existing guides, and corporate imprints.
For more information, contact:

Special Markets Department
DK Publishing, Inc.
375 Hudson Street
New York, NY 10014
Fax: 212-689-5254

Cataloging-in-Publication data is available
from the Library of Congress
ISBN 0-7566-0073-1

Printed in the UK by Butler & Tanner Limited

First printing, October 2004

QUEENS
A passenger aboard an Amtrak train bound
for Penn Station in New York City admires
the expansive view of the Triborough Bridge
and the midtown Manhattan skyline.
Photo by David H. Wells,
www.davidHwells.com

NEW YORK 24/7

24 Hours. 7 Days.
Extraordinary Images of
One Week in New York.

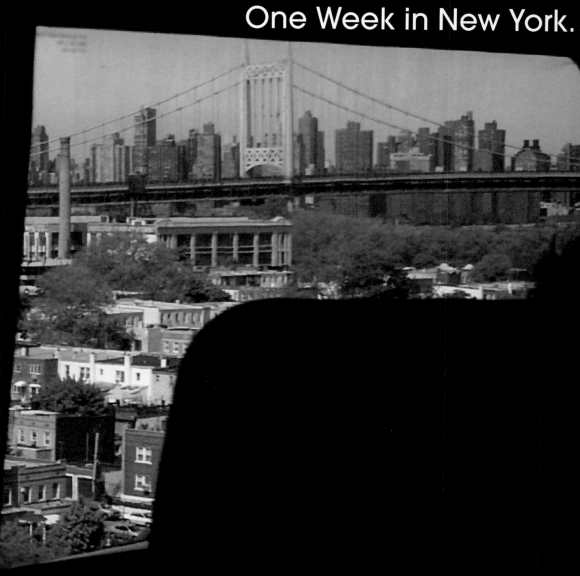

Created by Rick Smolan and David Elliot Cohen

DK Publishing

About the America 24/7 Project

A hundred years hence, historians may pose questions such as: What was America like at the beginning of the third millennium? How did life change after 9/11 and the ensuing war on terrorism? How was America affected by its corporate scandals and the high-tech boom and bust? Could Americans still express themselves freely?

To address these questions, we created *America 24/7*, the largest collaborative photography event in history. We invited Americans to tell their stories with digital pictures. We asked them to shoot a visual memoir of their lives, families, and communities.

During one week in May 2003, more than 25,000 professionals and amateurs shot more than a million pictures. These images, sent to us via the Internet, compose a panoramic yet highly intimate view of Americans in celebration and sadness; in action and contemplation; at work, home, and school. The best of these photographs, more than 6,000, are collected in 51 volumes that make up the *America 24/7* series: the landmark national volume *America 24/7*, published to critical acclaim in 2003, and the 50 state books published in 2004.

Our decision to make *America 24/7* an all-digital project was prompted by the fact that in 2003 digital camera sales overtook film camera sales. This technological evolution allowed us to extend the project to a huge pool of photographers. We were thrilled by the response to our challenge and moved by the insight offered into American life. Sometimes, the amateurs outshot the pros—even the Pulitzer Prize winners.

The exuberant democracy of images visible throughout these books is a revelation. The message that emerges is that now, more than ever, America is a supersized idea. A dreamspace, where individuals and families from around the world are free to govern themselves, worship, read, and speak as they wish. Within its wide margins, the polyglot American nation manages to encompass an inexplicably complex yet workable whole. The pictures in this book are dedicated to that idea.

—*Rick Smolan and David Elliot Cohen*

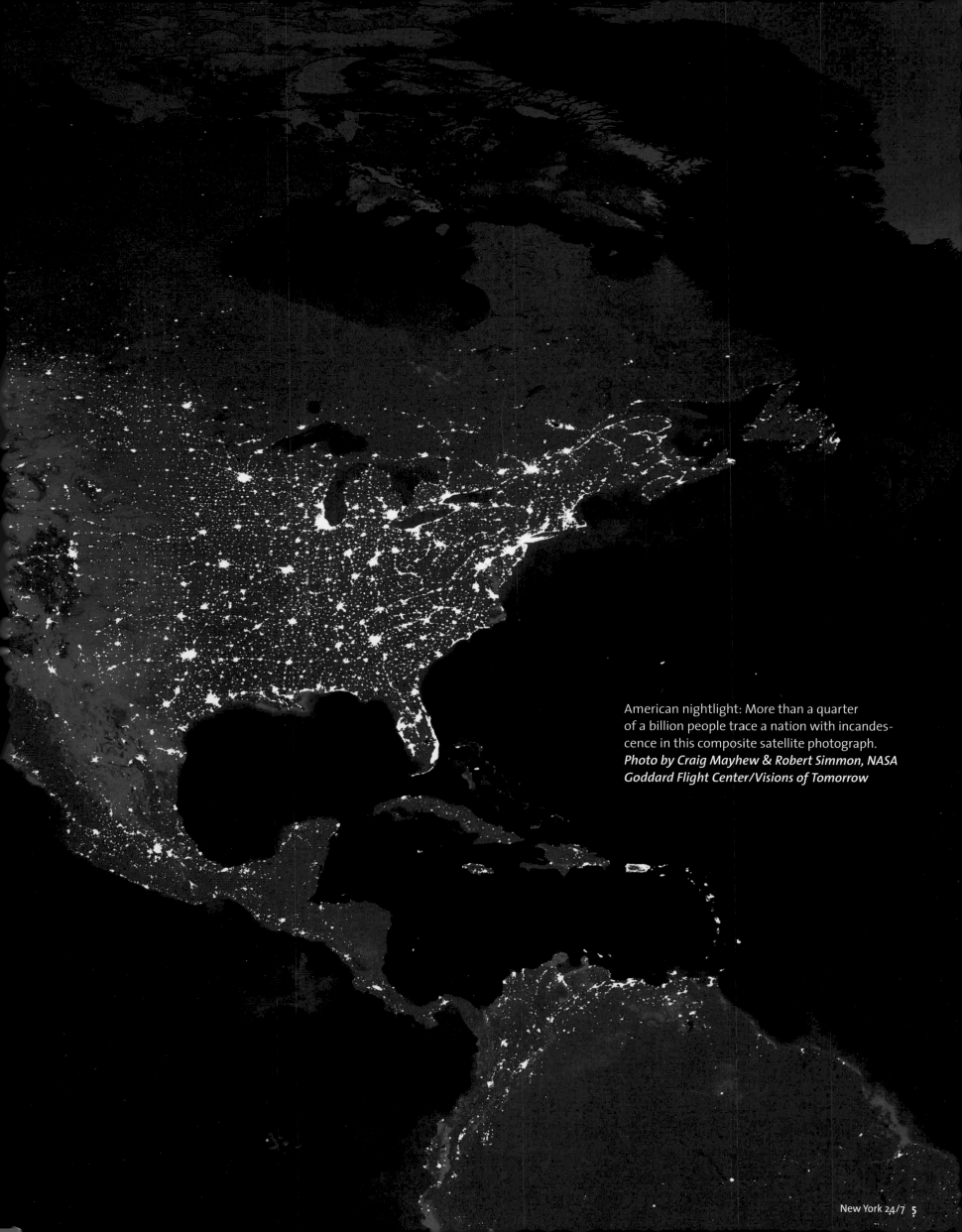

American nightlight: More than a quarter of a billion people trace a nation with incandescence in this composite satellite photograph.
Photo by Craig Mayhew & Robert Simmon, NASA Goddard Flight Center/Visions of Tomorrow

The Two New Yorks

By Fred LeBrun

New York City. A singular metropolis of magnificence, casting a long shadow over its same-name state. The glamorous, filthy machine is glued together by a palpable energy and a celebrated attitude. In the harbor, the blessed Lady of Liberty offers hope, sanctuary, and opportunity—even to those who would do us harm, and have.

An urban crush of wild contradictions and dueling economies: In a city with 40,000 homeless, a private kindergarten can cost $26,000 a year; sold-out Broadway shows are $100 a ticket, while 900,000 people within the five boroughs use food stamps; 50 percent of the city's black males are unemployed; more than 230,000 jobs, lost after 9/11, have not returned and a "gracious" three bedroom condo on Riverside Drive is listed at $4.2 million.

Upstate New York. A shyer and quieter counterpoint to Gotham. Midwestern-like rural towns and villages haven't changed much in a century. Agriculture still feeds the state, although it is Wall Street that fuels the New York economy. There are rolling miles of apple orchards, corn, and dairy farms. Along the shores of the Finger Lakes, a hundred wineries lure tourists, lagging in popularity only behind Niagara Falls, and, of course, the City. Within an easy drive of Manhattan, Rip Van Winkle's sleepy Catskill Mountains have become a refuge from the city's anxieties.

The tallest building in New York City is once again the Empire State Building, but the highest point in the state is at the summit of mile-high

LAKE PLACID
Nestled in the Adirondacks, the town of Lake Placid played host to both the 1932 and the 1980 Winter Olympics. The key attraction: 4,867-foot Whiteface Mountain, looming over the area's many glacially carved lakes.
Photo by Frank Koester

Mt. Marcy in Adirondack Park, a stunning and serene wilderness area the size of Vermont. Between the summit and the skyscraper is the 318-mile-long Hudson River Valley, a watery ribbon in a swooning landscape that spawned an American school of art and stirred writers and poets for centuries.

Yet even this seeming paradise has its snakes. The Hudson riverbed is poisoned with harmful industrial-age chemistry, making "America's Rhine" the longest Superfund site in the country. In Adirondack Park, acid rain from power plants in the Midwest is killing forests of spruce and maple. Alongside the nearly stagnant Erie Canal from Albany to Buffalo clanks a rusty chain of gasping upstate cities—Schenectady, Utica, Syracuse, Rochester, and, especially, Buffalo—hemorrhaging jobs, rapidly losing population, and scrambling for reinvention before there's nothing left.

Any reinvention will not be an Empire State of brick and mortar and manufacture. That age has passed. New York finds itself in an uneasy transition; not exactly sure where the empire goes next, but certain that there is no looking back.

For all of that and against what seems all reason, despite little growth and the lack of future focus while suffering the highest taxes in the country, despite watching other states spurt ahead economically, New Yorkers together remain cocksure of one thing: They are the chosen ones.

Bet against them at your peril.

FRED LEBRUN, *born in Manhattan to immigrant parents, is the metro columnist for the* Albany Times Union.

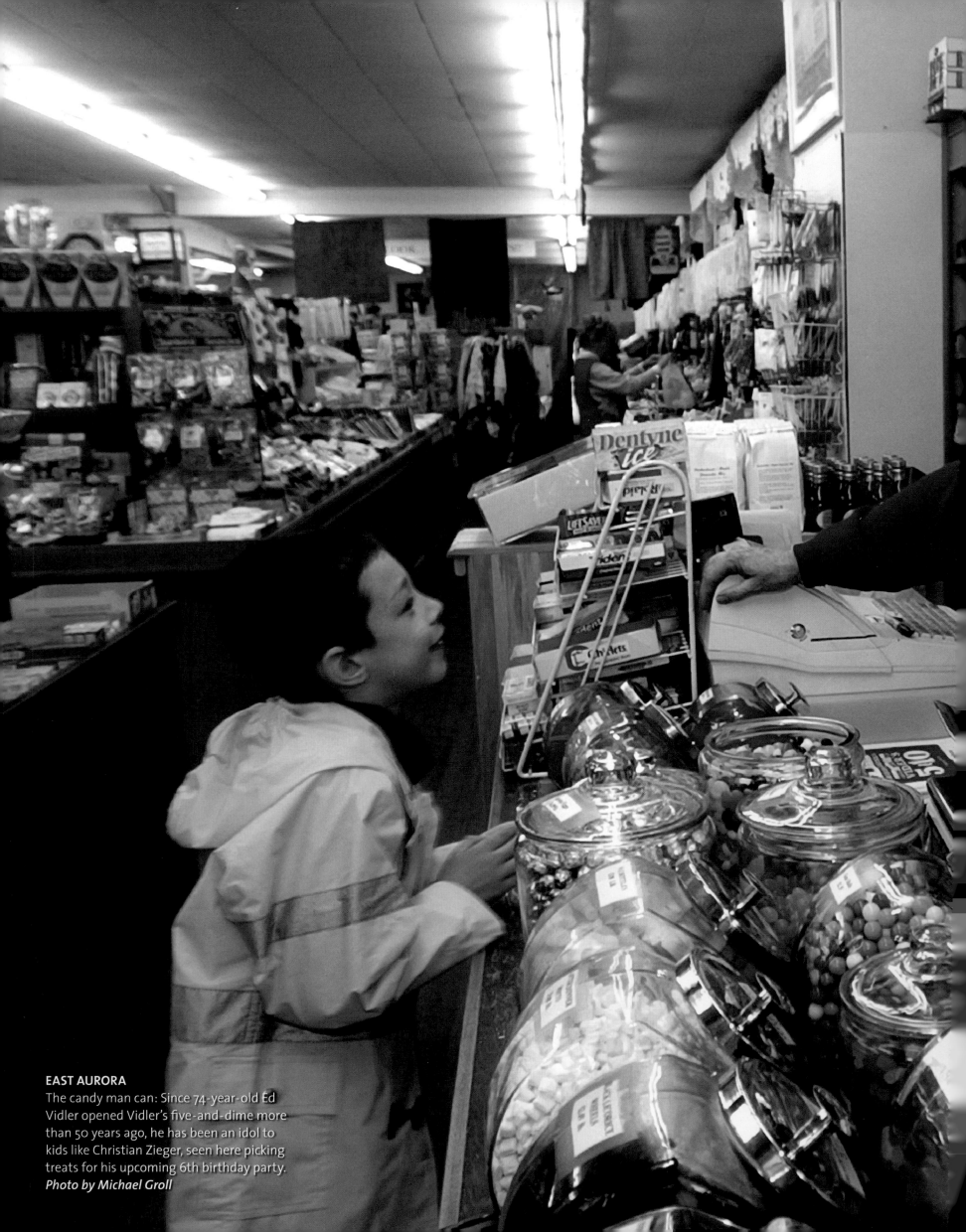

EAST AURORA

The candy man can: Since 74-year-old Ed Vidler opened Vidler's five-and-dime more than 50 years ago, he has been an idol to kids like Christian Zieger, seen here picking treats for his upcoming 6th birthday party.
Photo by Michael Groll

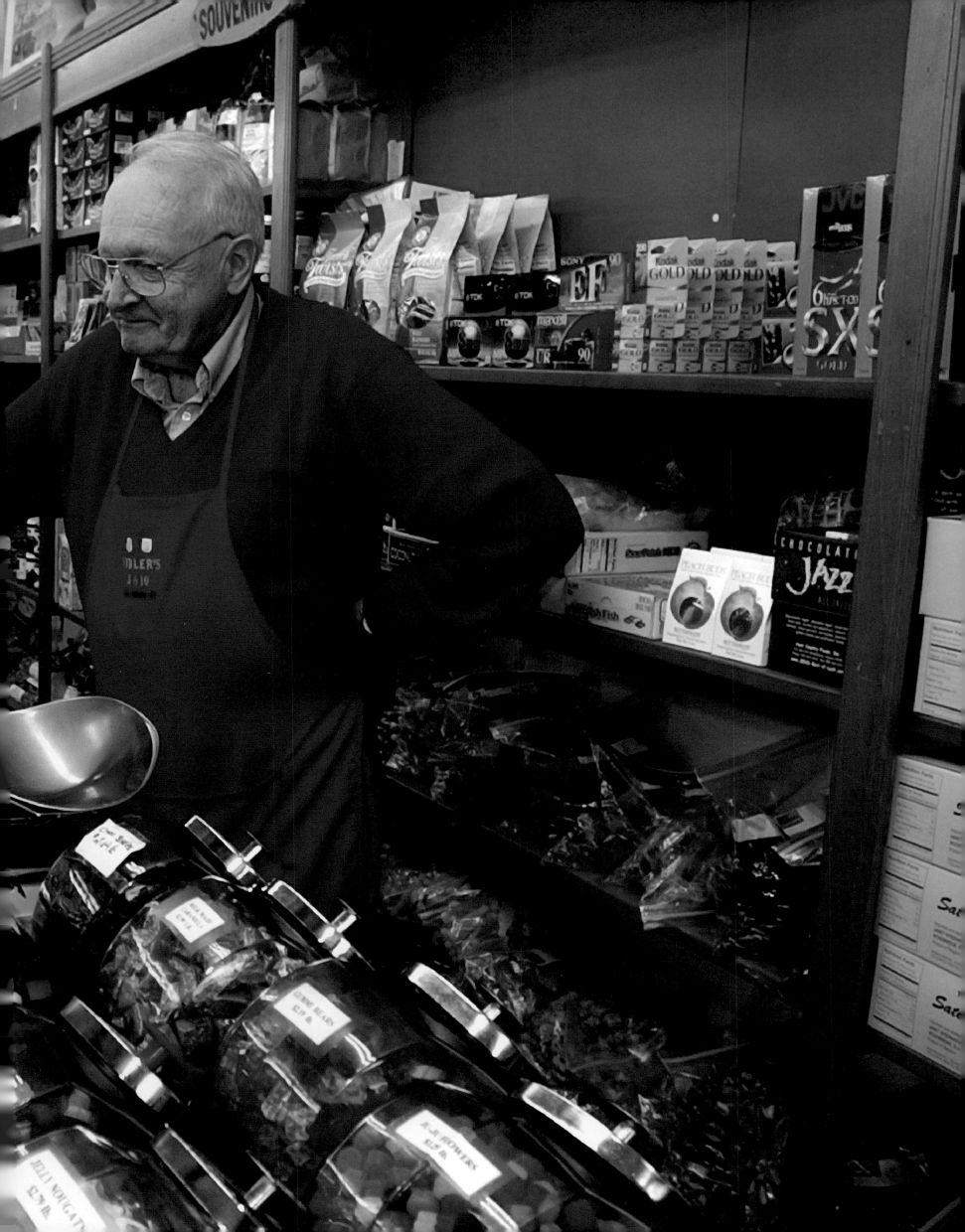

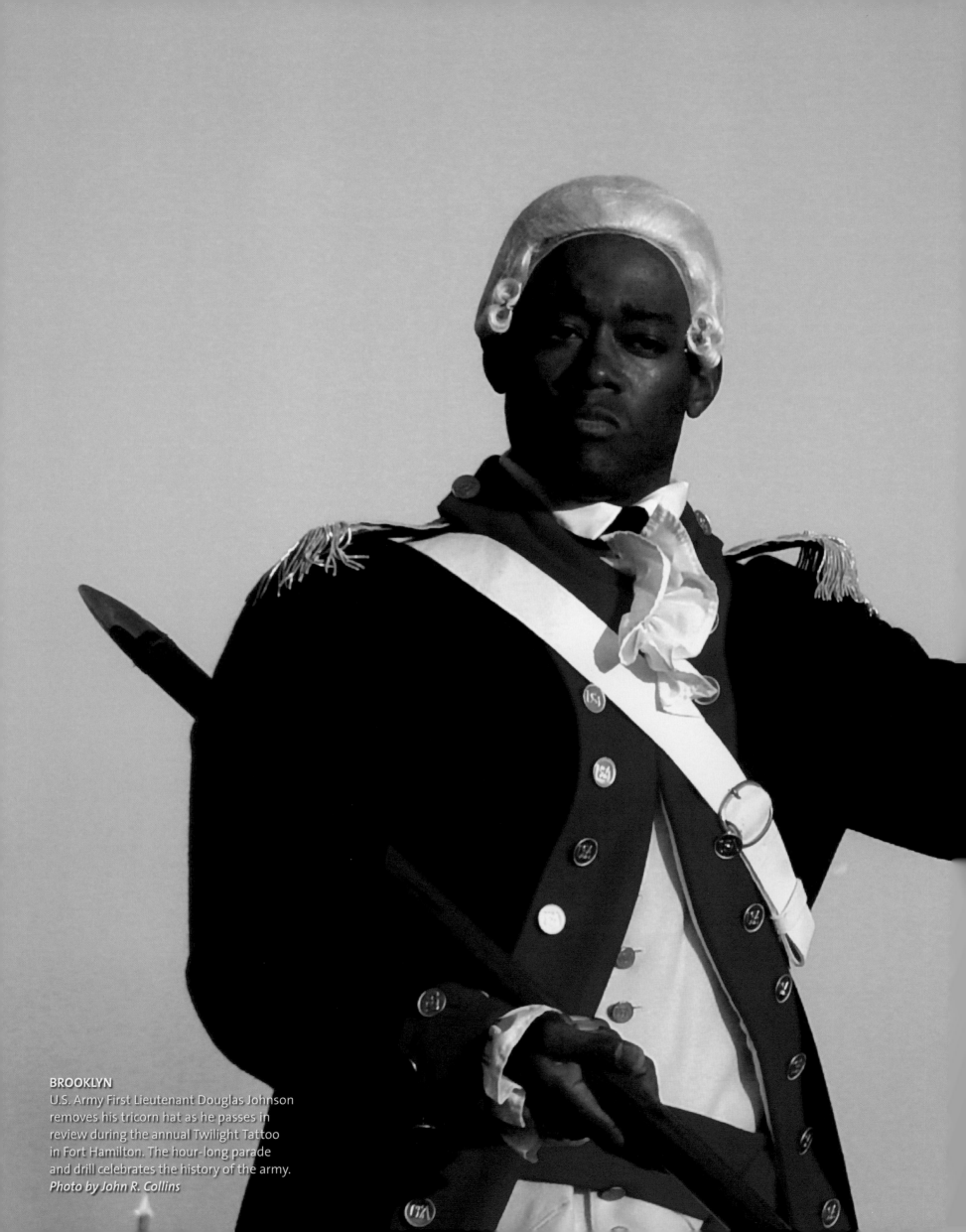

BROOKLYN
U.S. Army First Lieutenant Douglas Johnson removes his tricorn hat as he passes in review during the annual Twilight Tattoo in Fort Hamilton. The hour-long parade and drill celebrates the history of the army.
Photo by John R. Collins

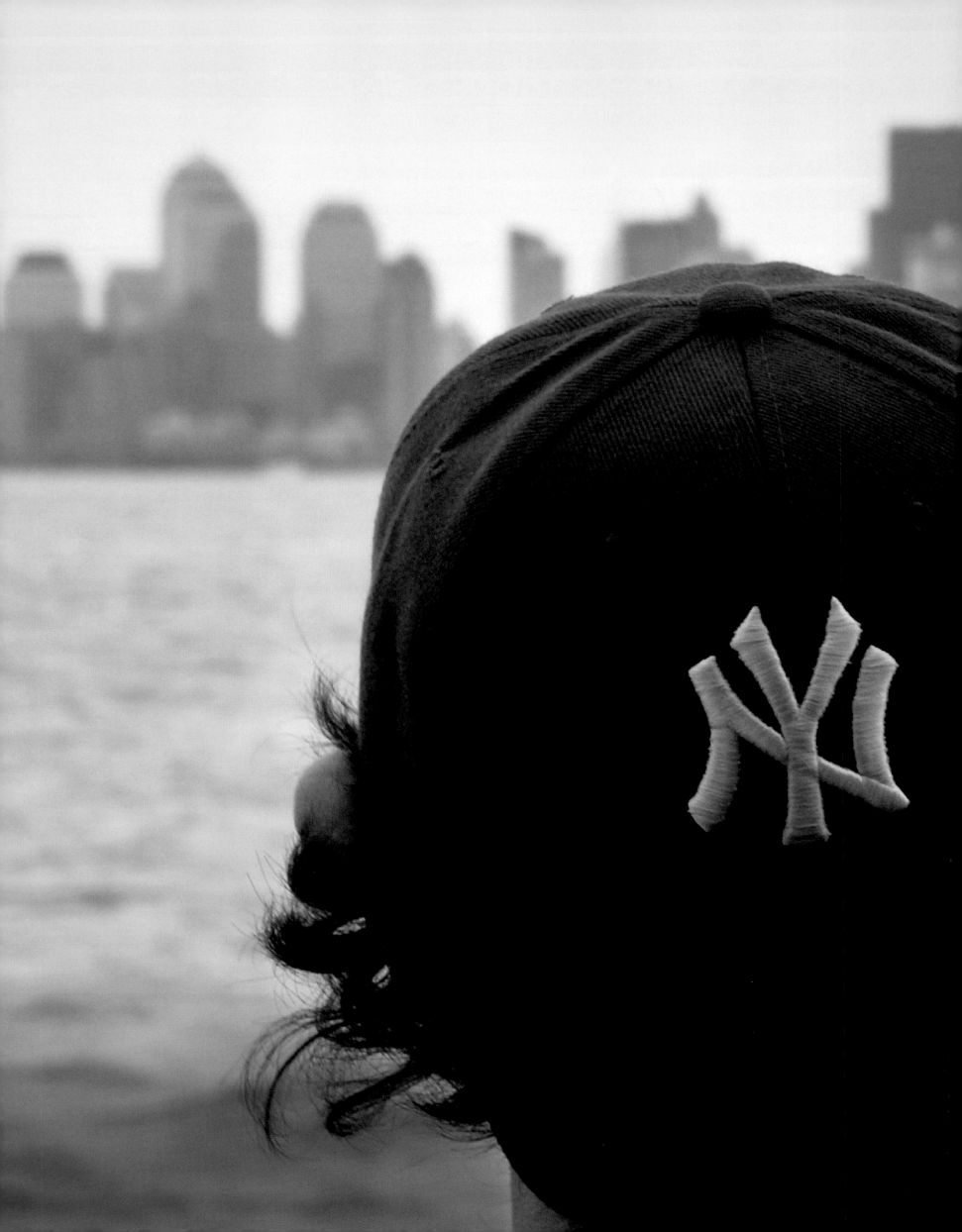

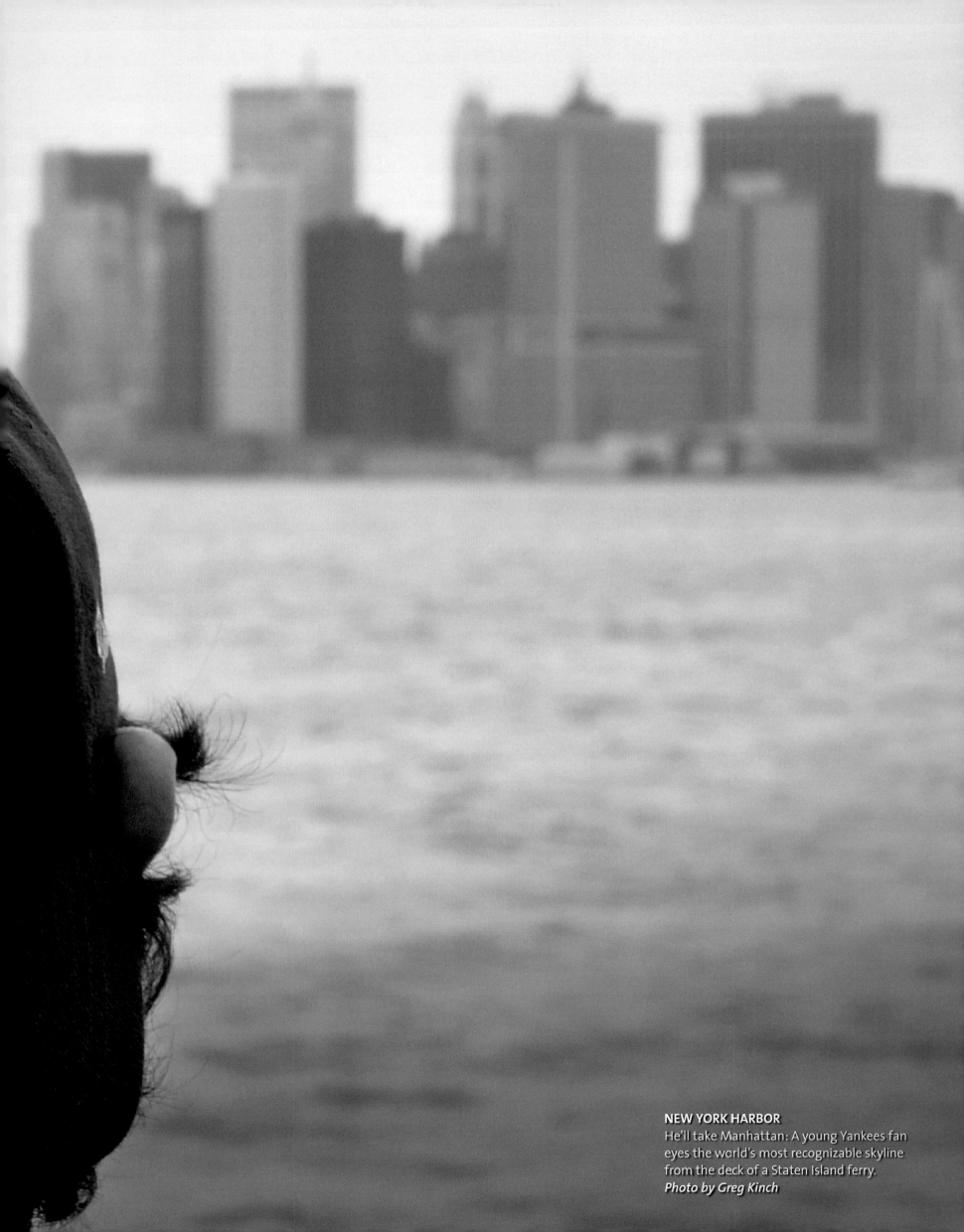

NEW YORK HARBOR
He'll take Manhattan: A young Yankees fan
eyes the world's most recognizable skyline
from the deck of a Staten Island ferry.
Photo by Greg Kinch

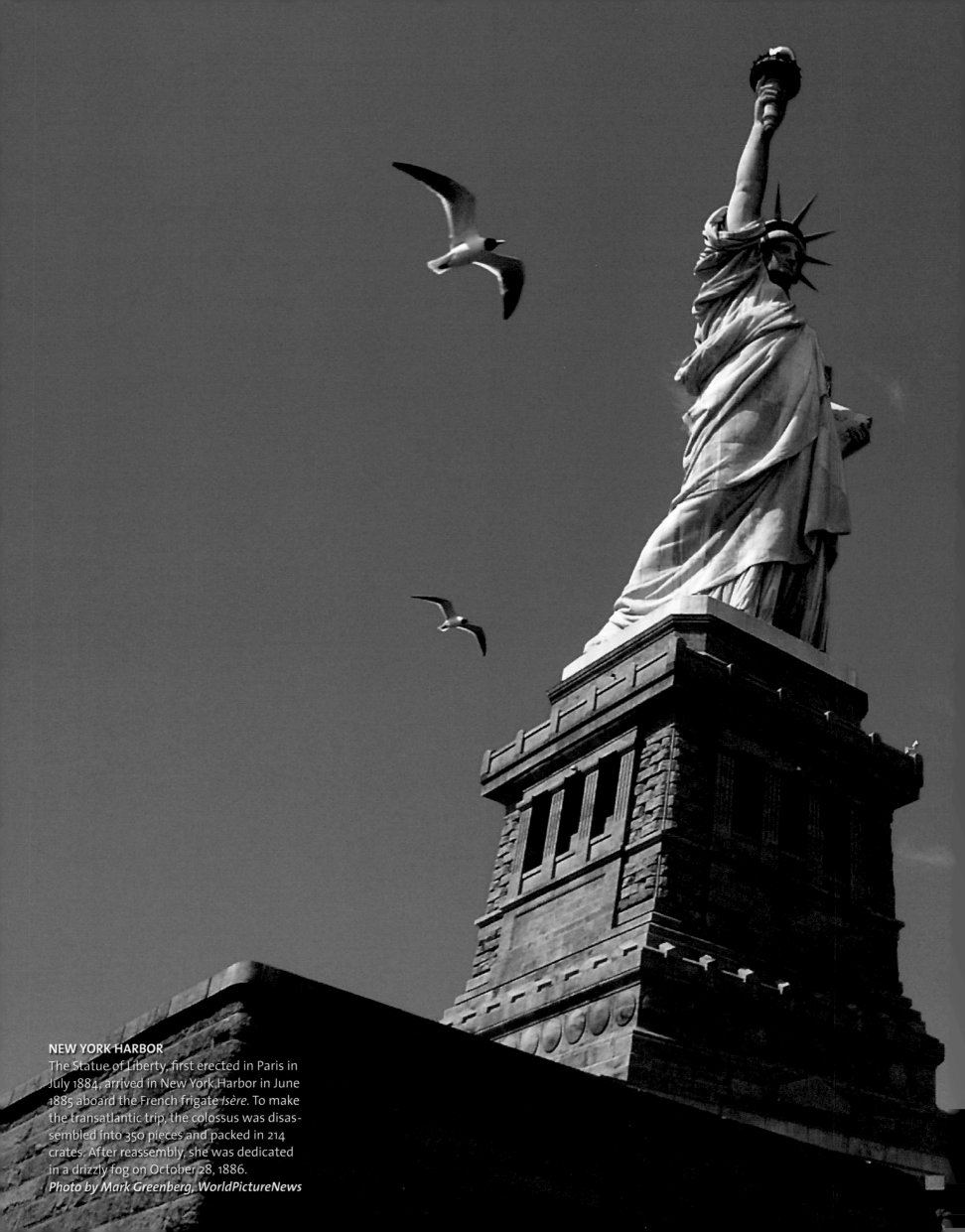

NEW YORK HARBOR
The Statue of Liberty, first erected in Paris in July 1884, arrived in New York Harbor in June 1885 aboard the French frigate *Isère*. To make the transatlantic trip, the colossus was disassembled into 350 pieces and packed in 214 crates. After reassembly, she was dedicated in a drizzly fog on October 28, 1886.
Photo by Mark Greenberg, WorldPictureNews

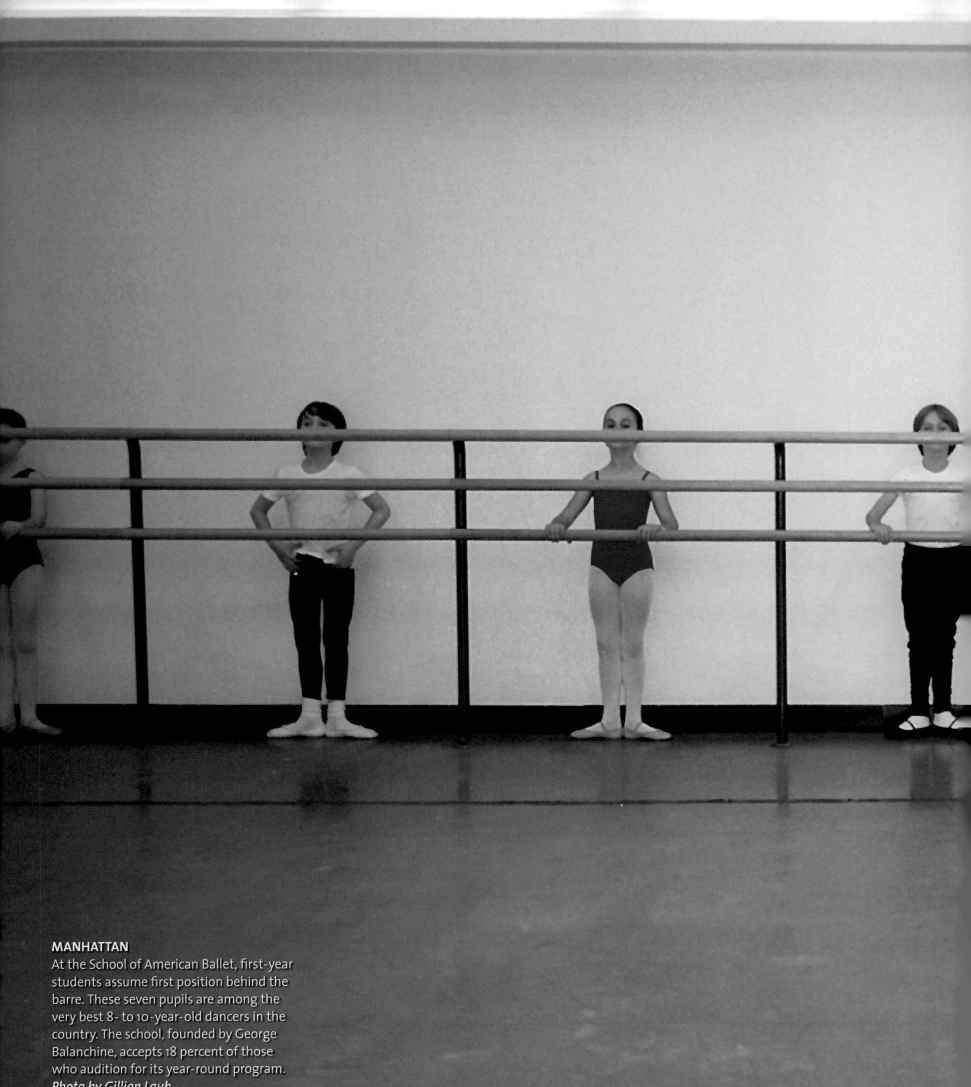

MANHATTAN
At the School of American Ballet, first-year students assume first position behind the barre. These seven pupils are among the very best 8- to 10-year-old dancers in the country. The school, founded by George Balanchine, accepts 18 percent of those who audition for its year-round program.
Photo by Gillian Laub

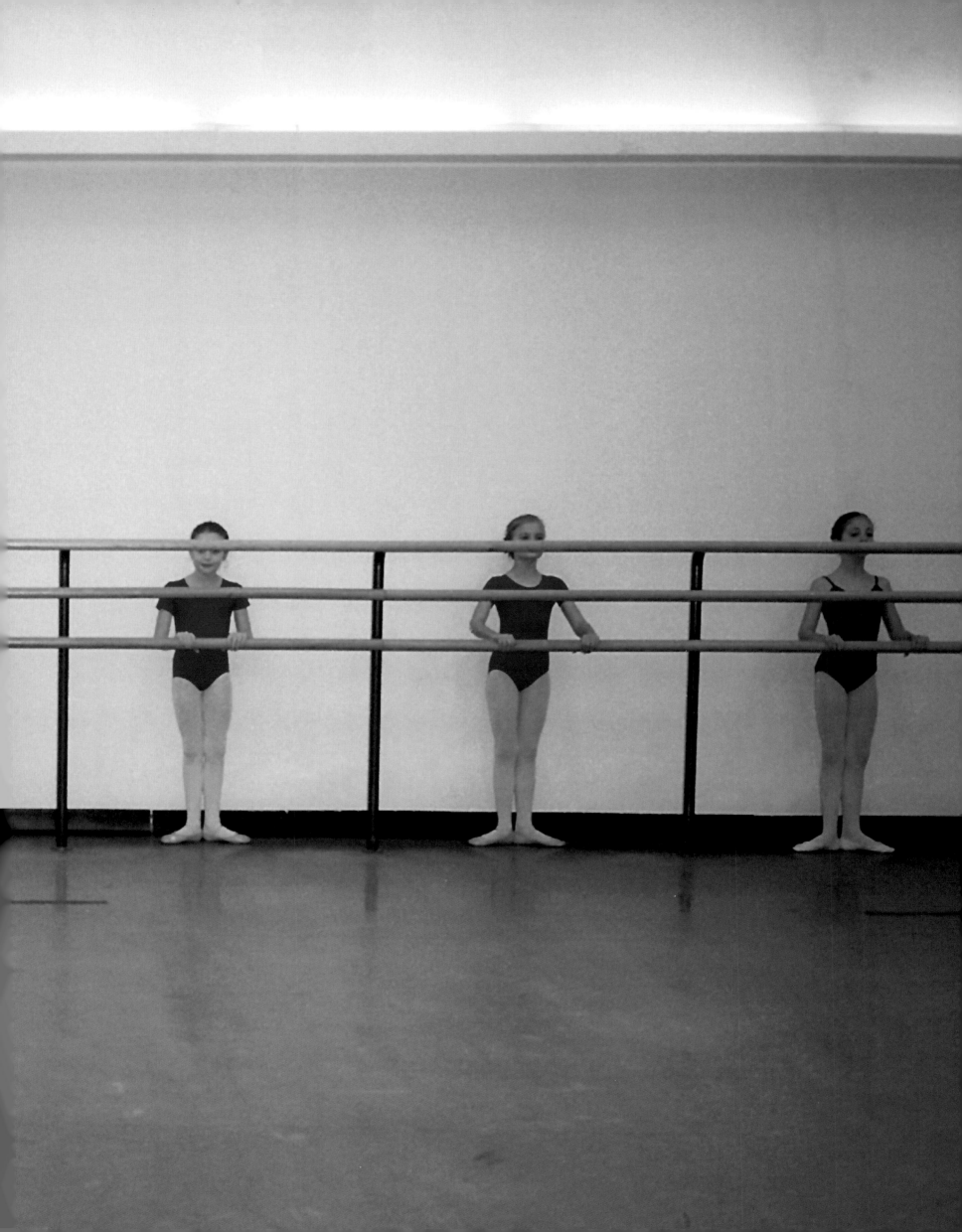

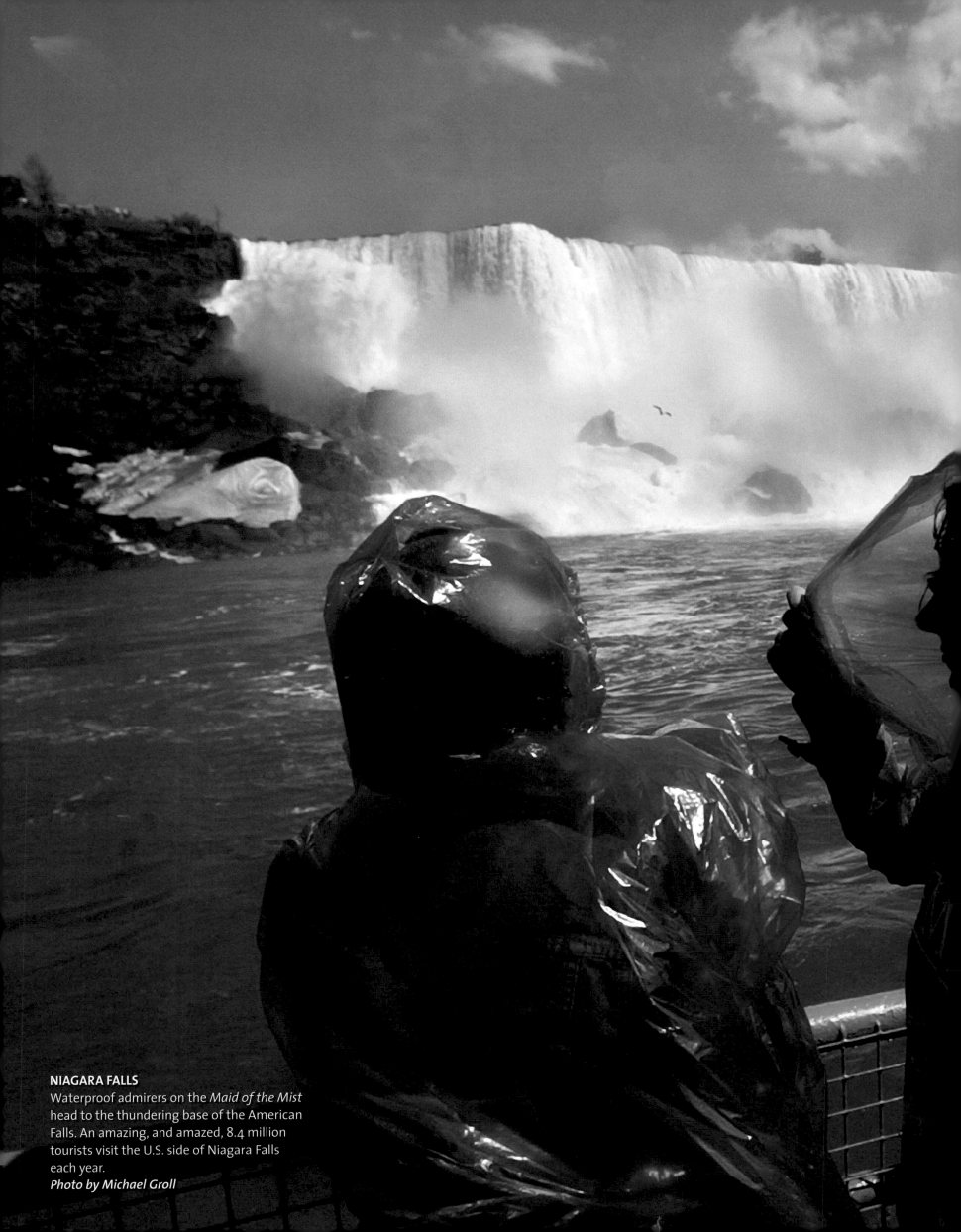

NIAGARA FALLS
Waterproof admirers on the *Maid of the Mist* head to the thundering base of the American Falls. An amazing, and amazed, 8.4 million tourists visit the U.S. side of Niagara Falls each year.
Photo by Michael Groll

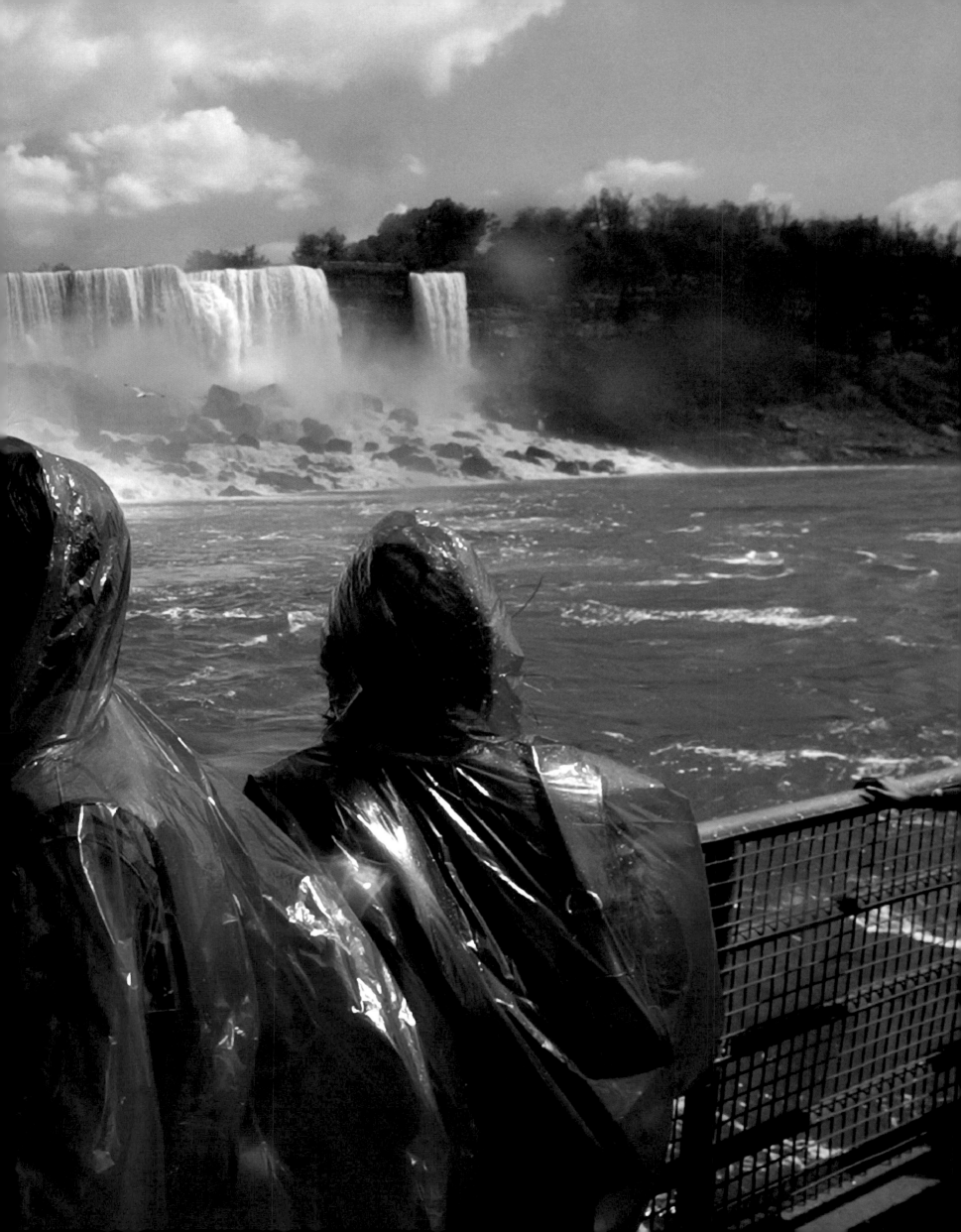

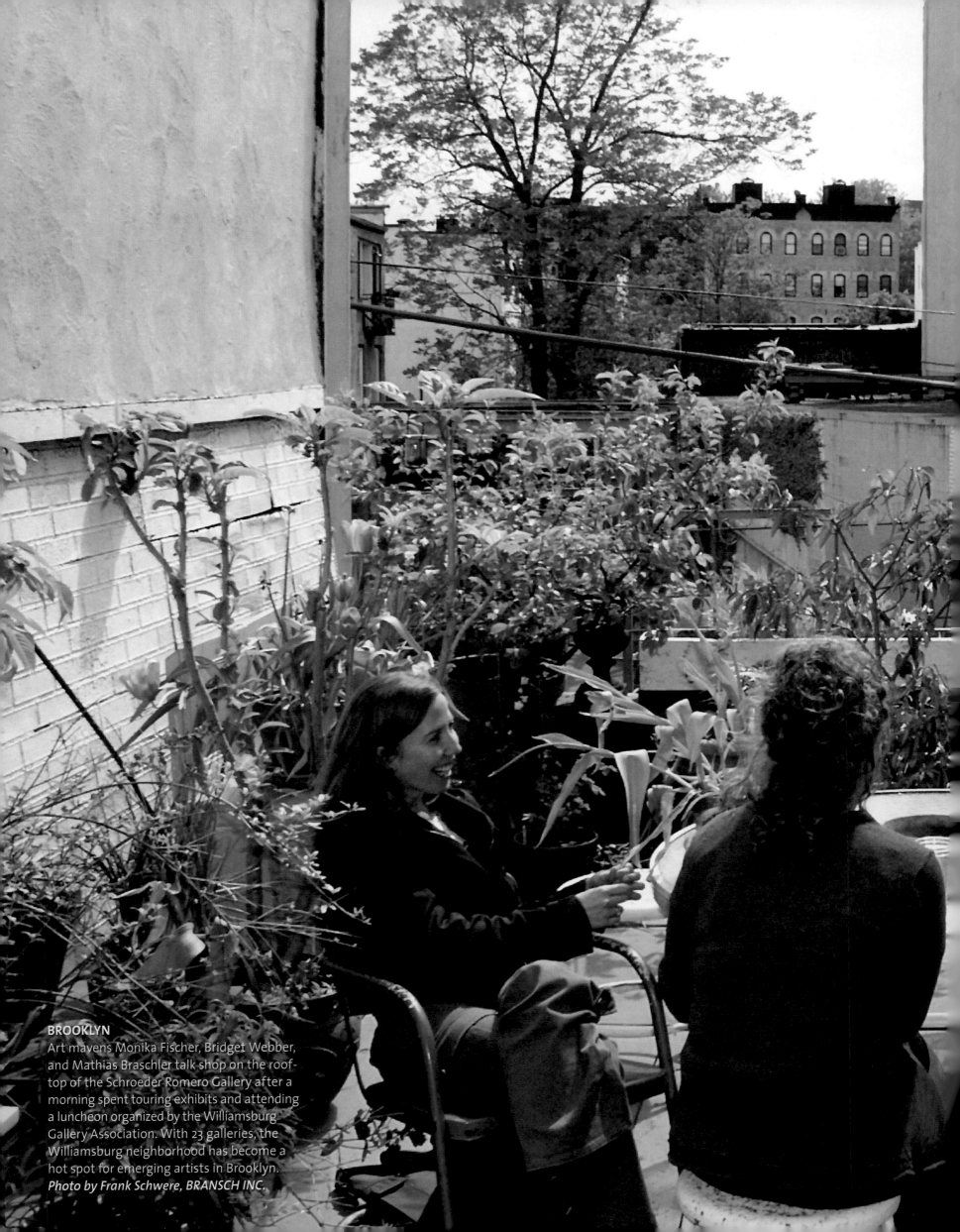

BROOKLYN
Art mavens Monika Fischer, Bridget Webber, and Mathias Braschler talk shop on the roof-top of the Schroeder Romero Gallery after a morning spent touring exhibits and attending a luncheon organized by the Williamsburg Gallery Association. With 23 galleries, the Williamsburg neighborhood has become a hot spot for emerging artists in Brooklyn.
Photo by Frank Schwere, BRANSCH INC.

Hearth & Home

BUFFALO

After 16 hours of labor, Josselyn Borowiec Staba brought forth Jackson (that's dad David's hand to the right). The baby weighed 9 pounds, 13 ounces at birth. "We're not petite people," remarked Josselyn. When she found out she was pregnant, she stopped smoking and drinking. Dad tossed his cigarettes, too.

Photo by Michael Groll

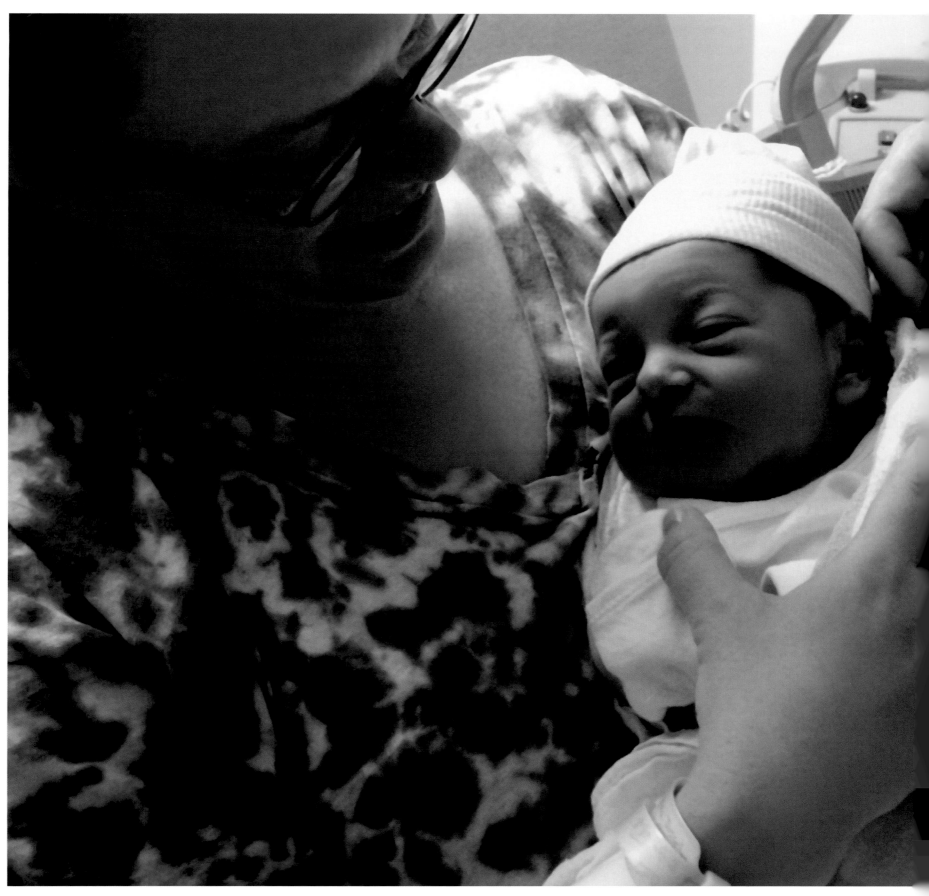

LAKEVILLE
New mother Kristen Mancini naps with her
1-month-old daughter, Morgan Alexis Bond,
in their home in upstate New York.
Photo by Avital Greener

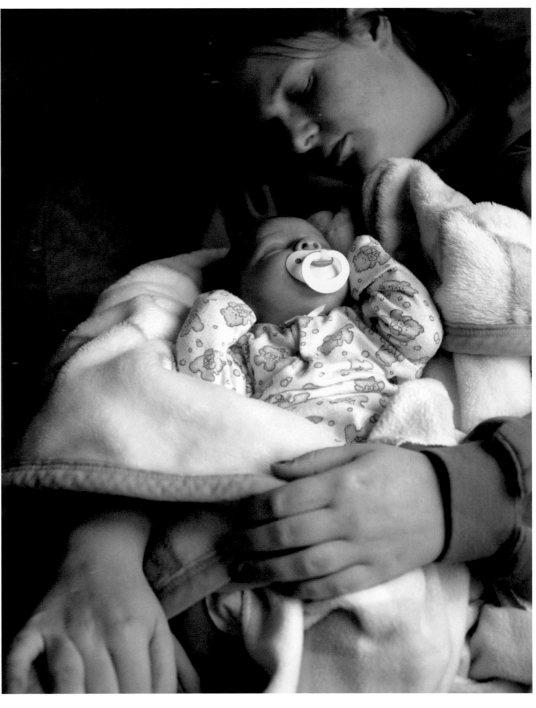

HAVERSTRAW

Daddy's girl: Photographer dad Ken Karlewicz used a wide-angle lens and his right hand to capture his morning ritual with daughter Emma. The 5-year-old, who lives with her mom, rarely leaves her father's side during her Wednesday visits.
Photo by Ken Karlewicz

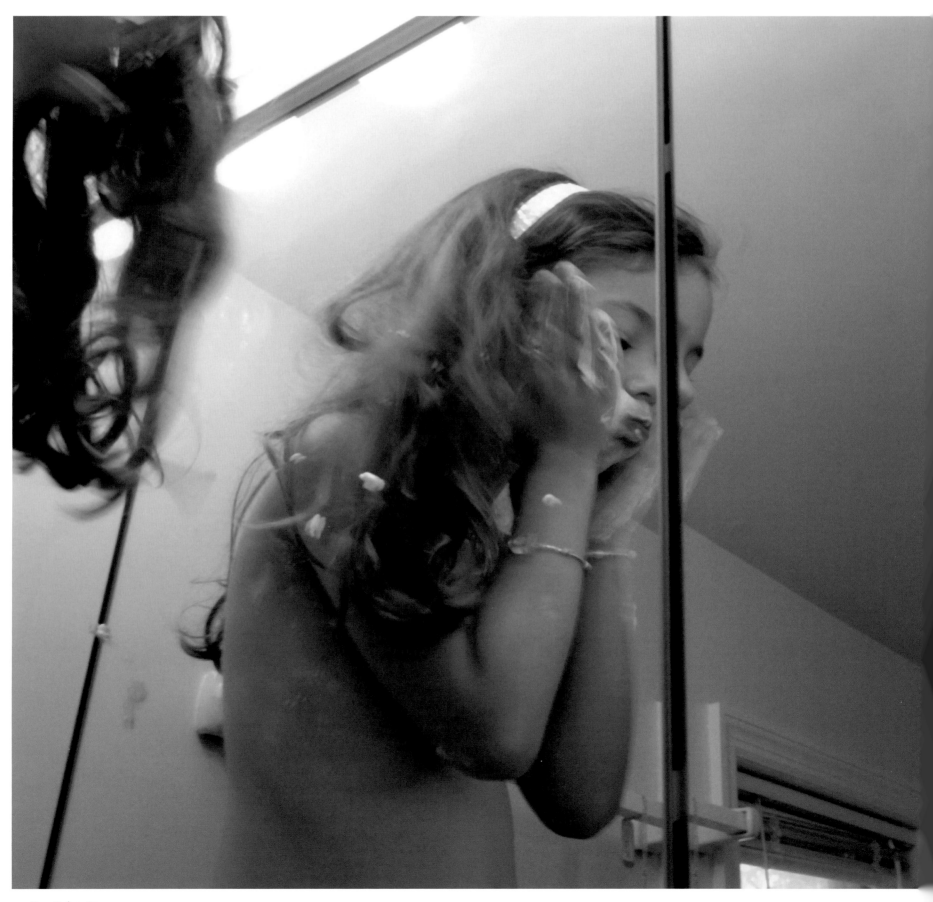

PORT JEFFERSON

As close as siblings can be, nature has a way of
separating them at a certain age if one is a girl
and one is a boy. This is one of the last times
that Michaela, 8, and Sean Griffin, 3, take a bath
together.

Photo by John Griffin

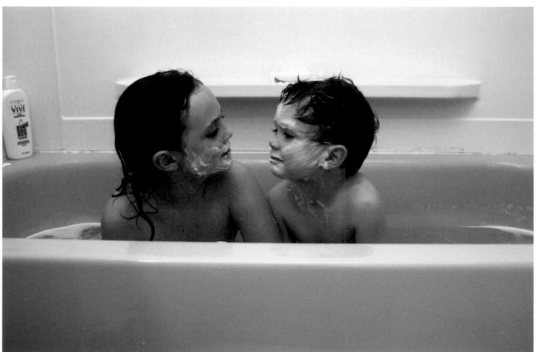

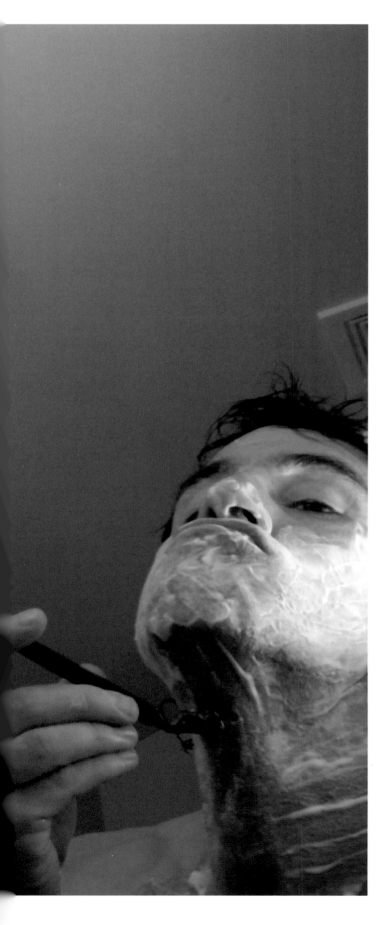

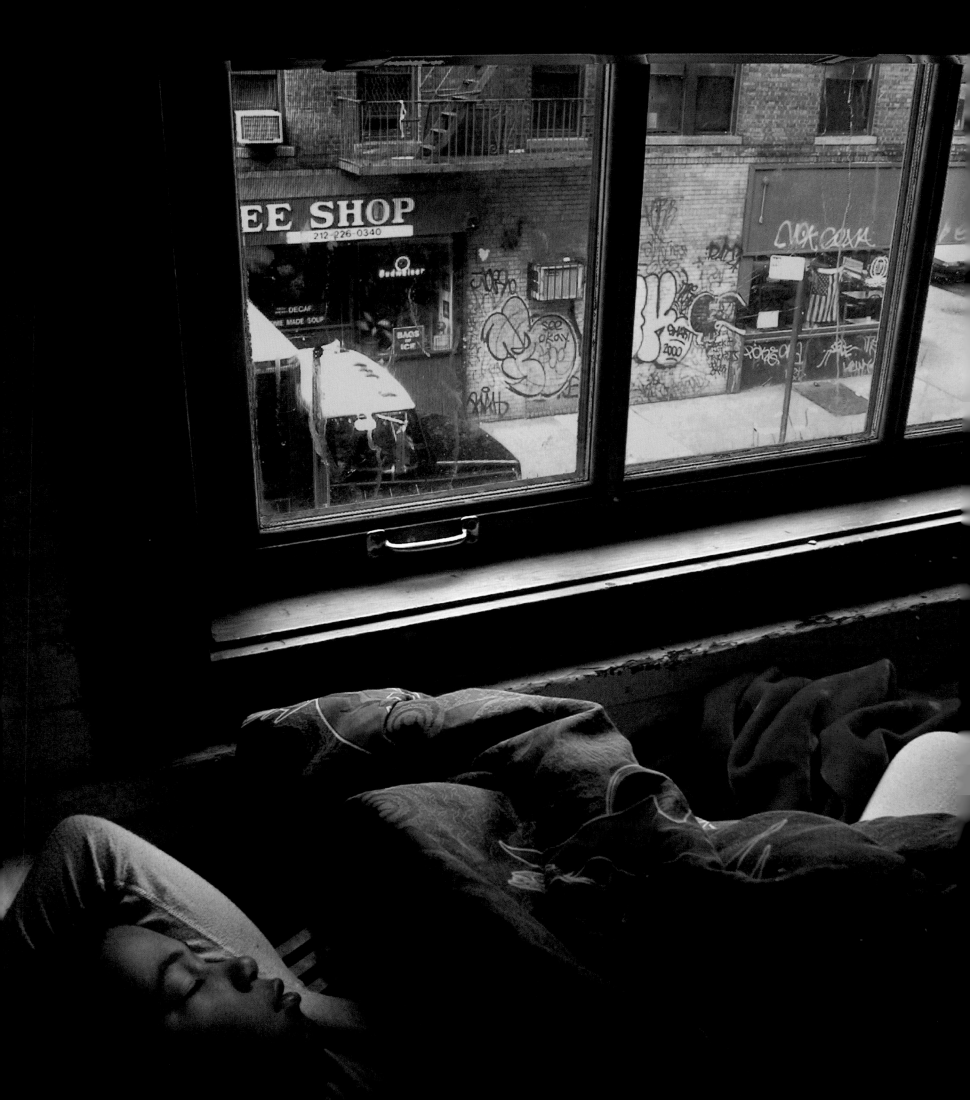

MANHATTAN

Every morning, when Allan Ludwig wakes up on Prince Street, his dad, Allan Sr., takes him across the street to Buffa's Coffee Shop for pancakes and orange juice. Then it's off to school on the city bus.

Photo by Gwen Akin

BROOKLYN

Like many 9-year-olds, Anna goes to school, plays sports, and idolizes Eminem. But unlike most of her peers, Anna has been HIV positive since birth. Fortunately, treatments have advanced significantly in the past eight years, allowing her to be healthy and lead a normal life.

Photo by Joseph Sywenkyj

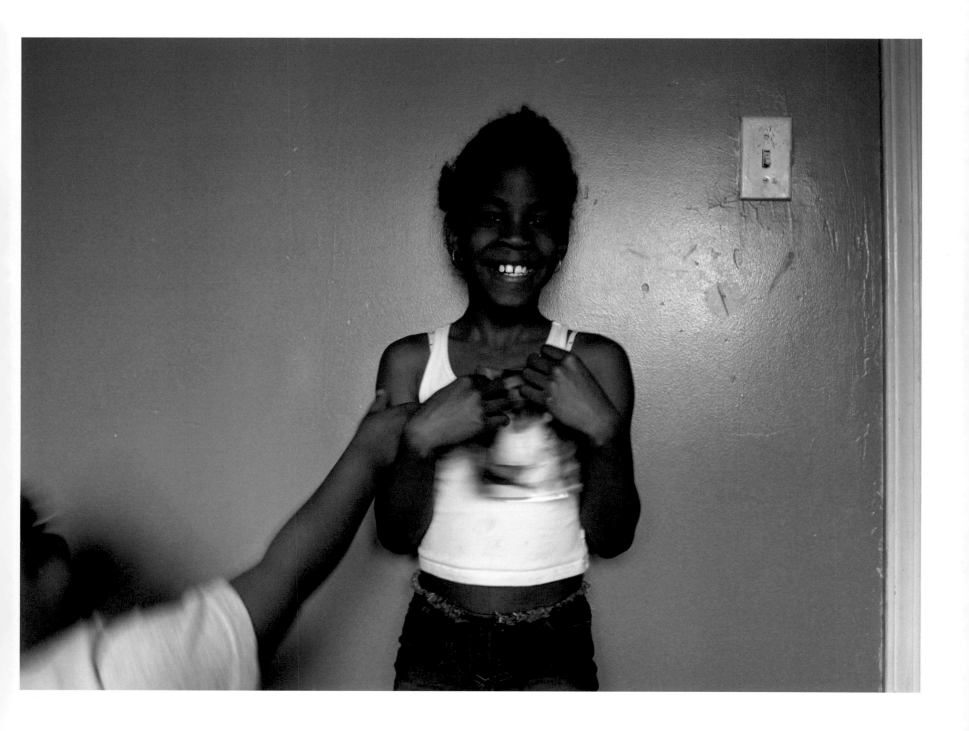

LEVITTOWN

Eight months ago, hospital administrator Barry Baretela was matched up with 12-year-old Kai Stoll by Big Brothers Big Sisters of Long Island. "When we met, it felt like we had known each other our whole lives," says Baretela. Kai, whose mom had him on her own, told Baretela, "If you want to tell people you're my father, it's okay."
Photo by Jay Brenner, Brenner Lennon Photo

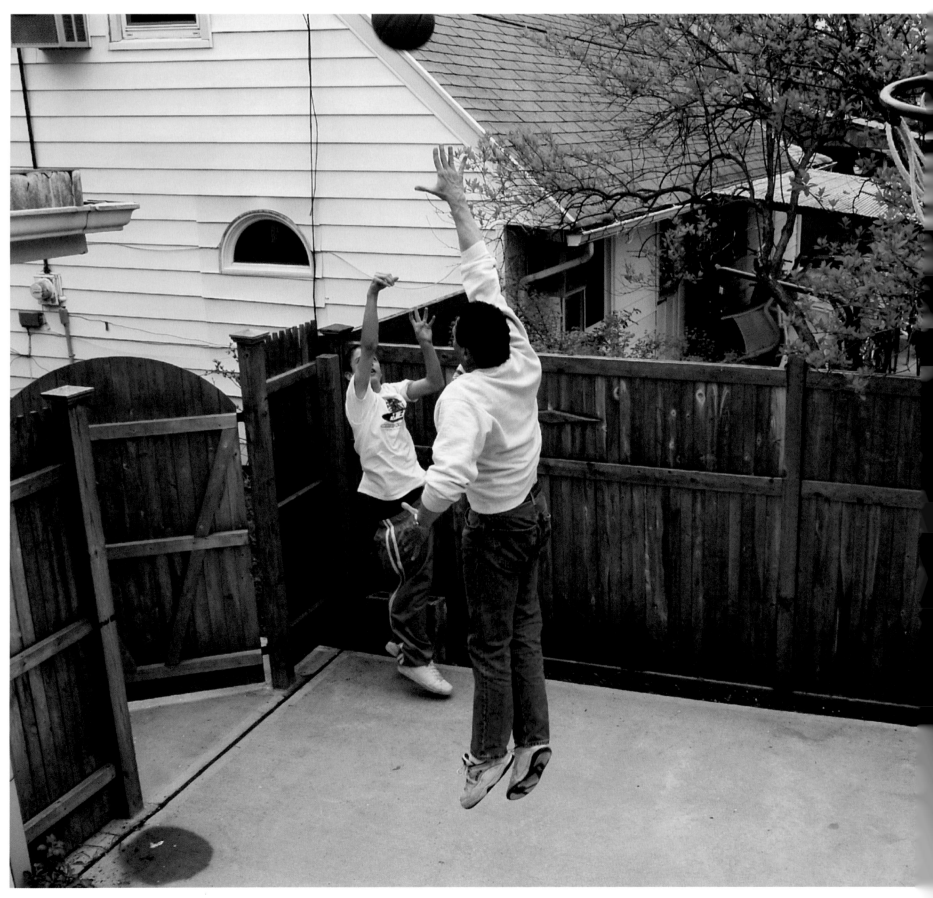

HASTINGS-ON-HUDSON
After helping to clean up after breakfast, fraternal twins Decland and Wesley Sava patiently await their next task so mom can get to work. Kim Sava juggles raising her boys and making "trendy, funky, wacky" handbags from recycled materials.
Photo by Peter Freed

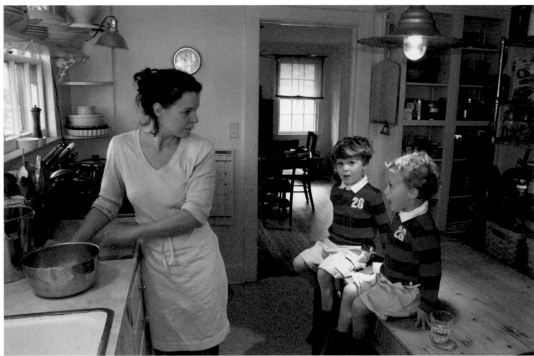

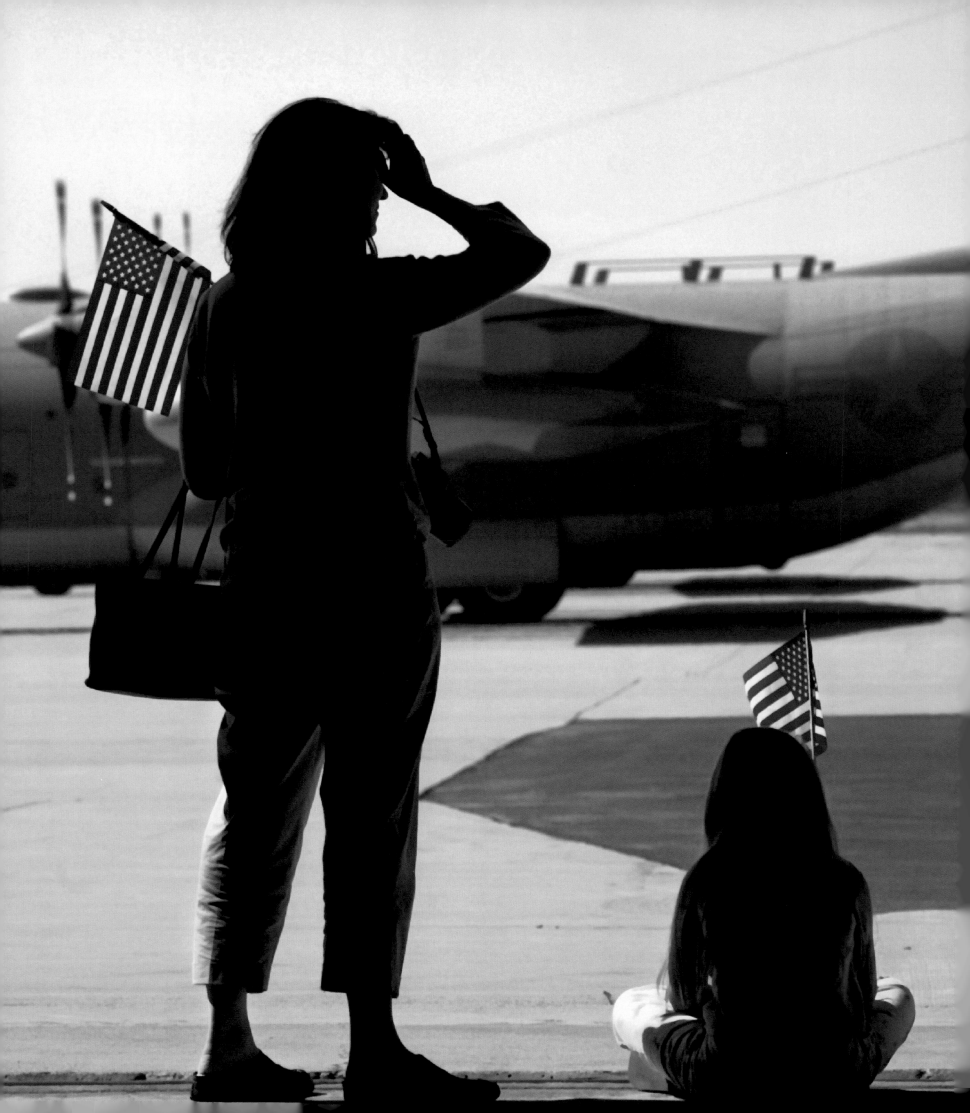

STEWART AIR NATIONAL GUARD BASE
Barbara Hall and daughter Catherine hold their breath as the C-130 aircraft carrying Lieutenant Colonel James Hall touches down at the base. Hall was returning from a three-month tour of duty in Iraq with the Marine Aircraft Group 49.
Photos by Mike McLaughlin

STEWART AIR NATIONAL GUARD BASE
"When we saw him, all the worry that we'd been trying to block out, we just let it go," says Barbara Hall. "We were overwhelmed with emotion."

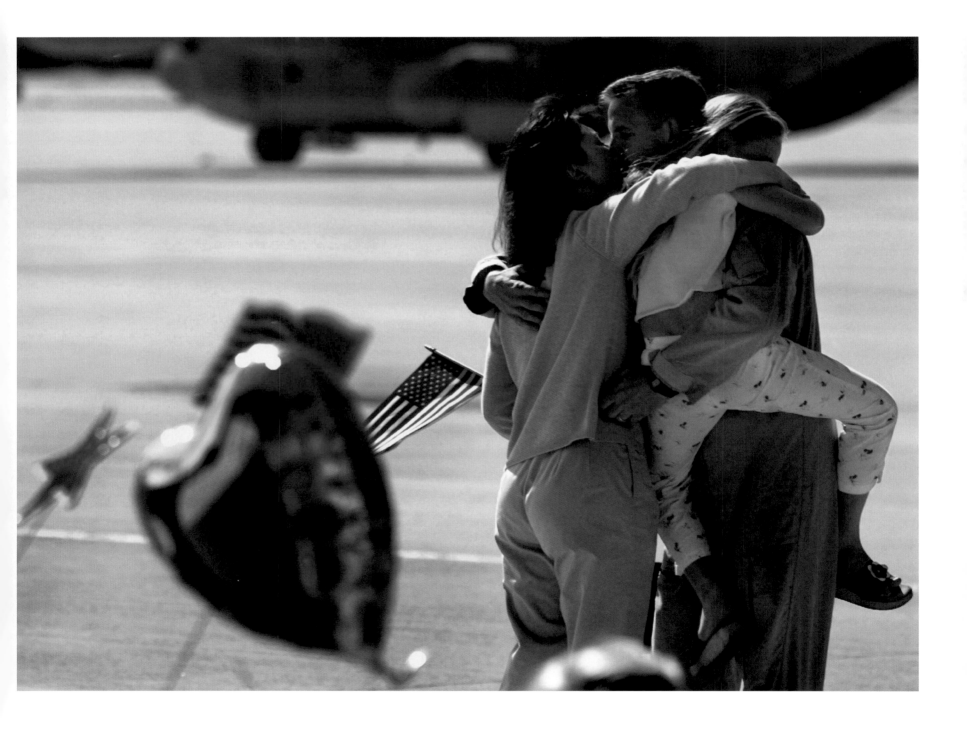

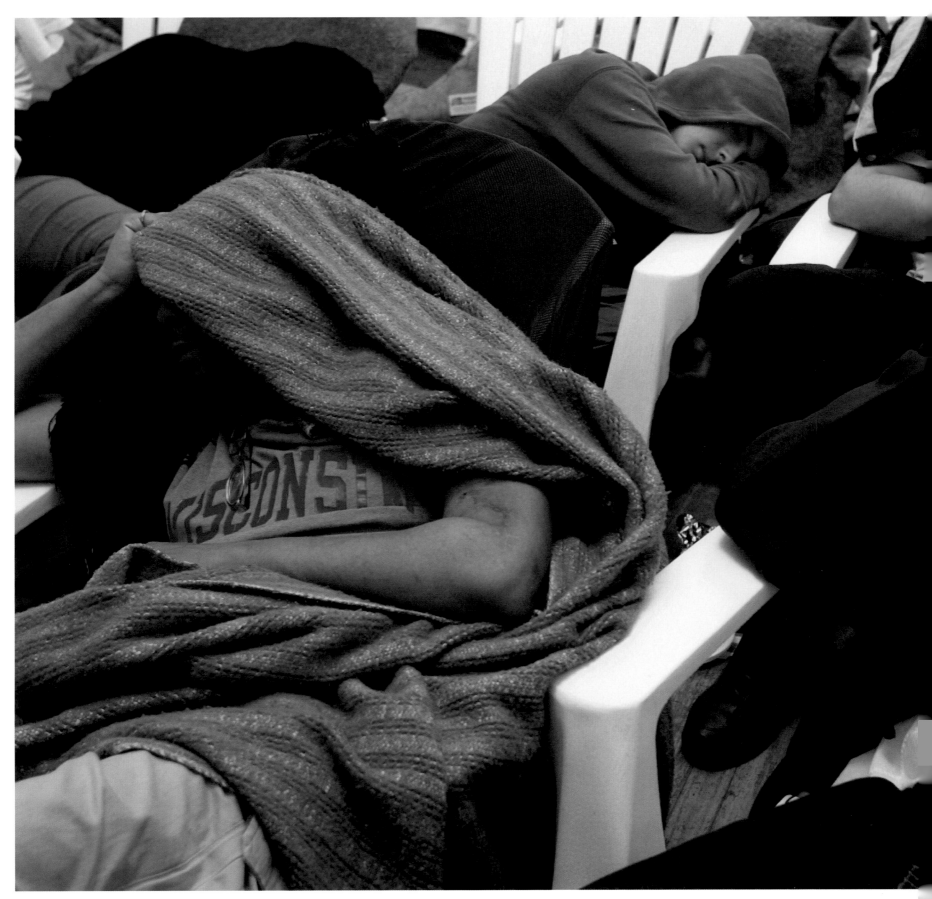

MANHATTAN

At Grand Central Neighborhood Social Services Corporation's homeless drop-in center, plastic chairs accommodate those who can't get a bed at a shelter. Finding a place for the night is tough these days: The city's homeless shelter population has ballooned by 82 percent since 1998. Some folks have been sleeping in these chairs for more than a year.

Photo by Lori Grinker, Contact Press Images

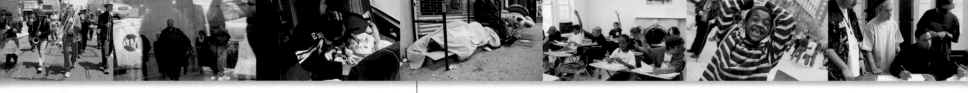

MANHATTAN
6:23 a.m. After the West Village's noisy club
crowd goes home and before the fast food joints
open for breakfast, the neighborhood's homeless
grab a few hours of shut-eye.
Photo by Sergio Rosa Cruz

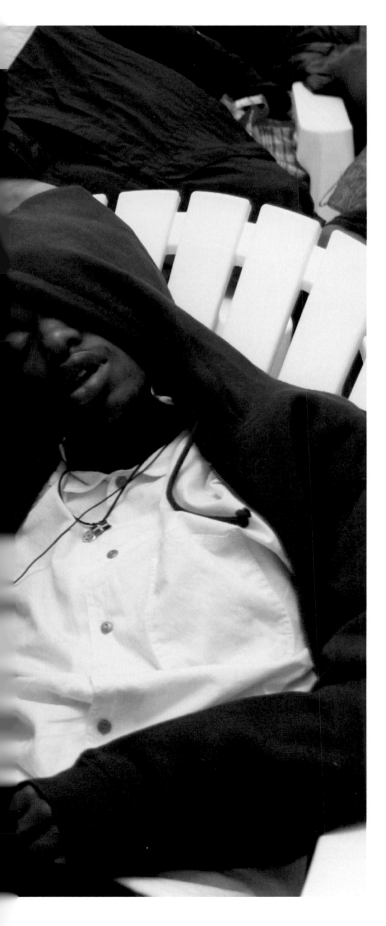

Steve Wright, Linda Jerbic, and Gigi take advantage of the Union Square Dog Run when the weather's nice. The fenced run allows Gigi the freedom to run and sniff to her heart's content.
Photo by Andrew DeMattos

PORT JEFFERSON

Sean Griffin and his older sister Michaela have different interests. He likes sports, she likes acting and dancing. But they come together often to play computer games like Babe (as in the pig).
Photo by John Griffin

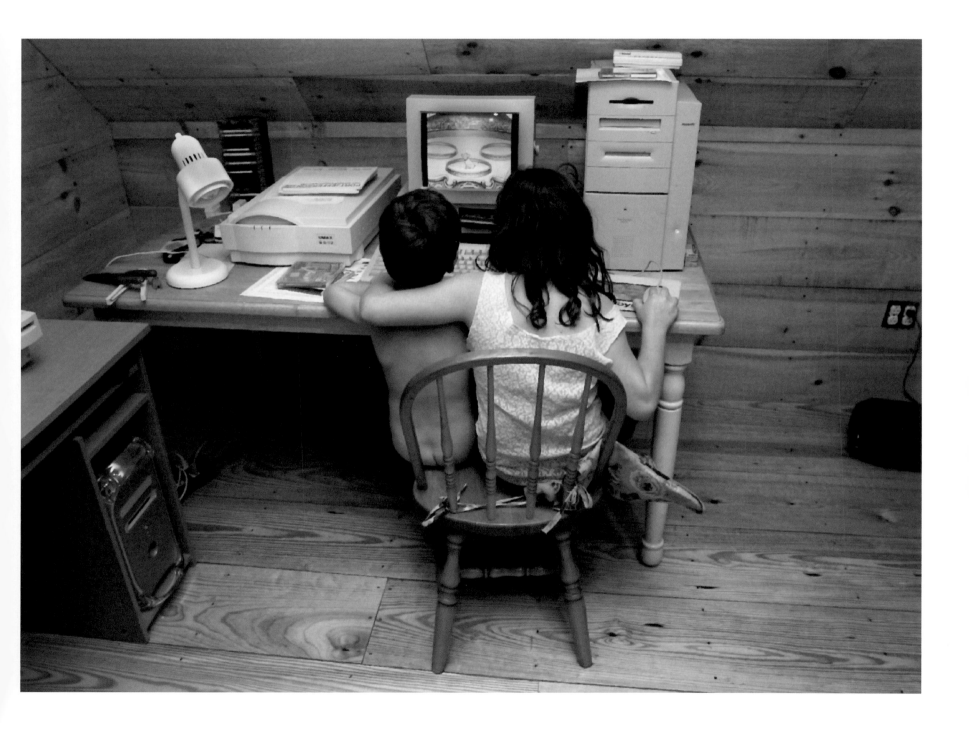

MIDDLETOWN

Nick and Frances Helt met at a dance held by the Association for the Help of Retarded Citizens and have been married for nine years. Nick, blind since birth, arranges silverware settings at a Red Lobster restaurant, and Frances does packaging and sorting at a local factory.

Photo by Chris Ramirez

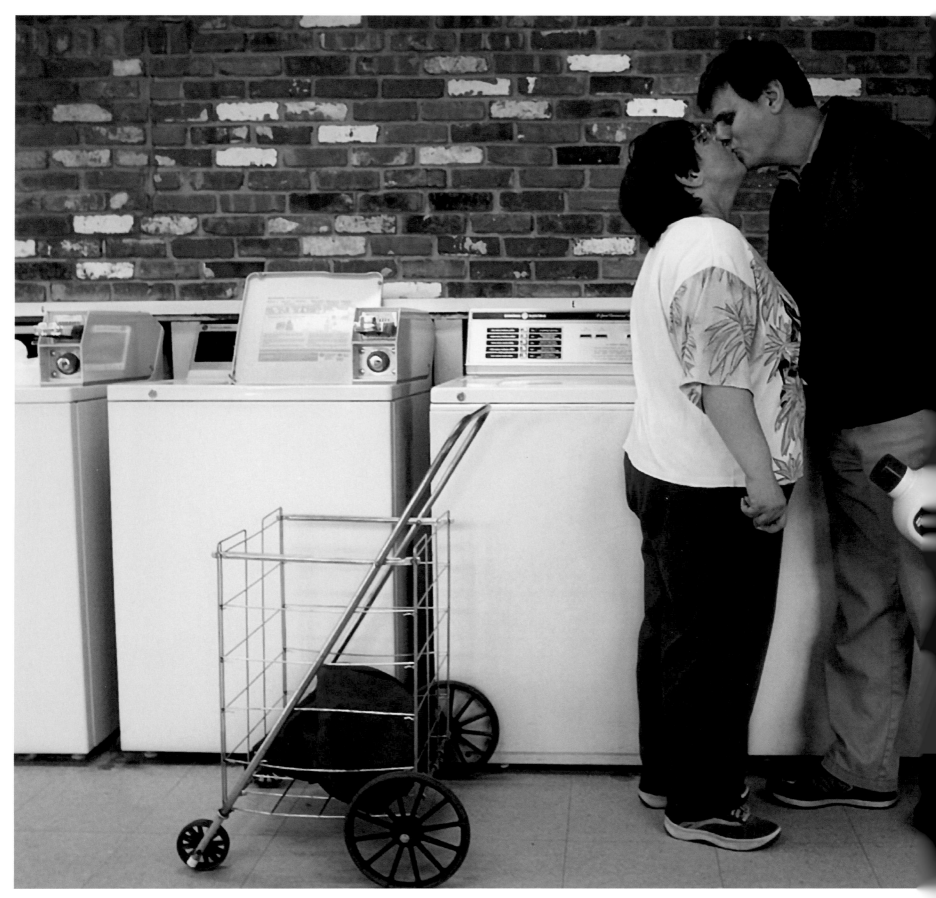

MANHATTAN
Documentary filmmakers Lorca Shepperd and Cabot Philbrick go to the laundromat in their Spanish Harlem neighborhood about once every two weeks. During wash and dry cycles, they take walks, do errands, or run home to work on their film, *Other People's Pictures*, about people who collect vintage snapshots.
Photo by Lisa Kahane

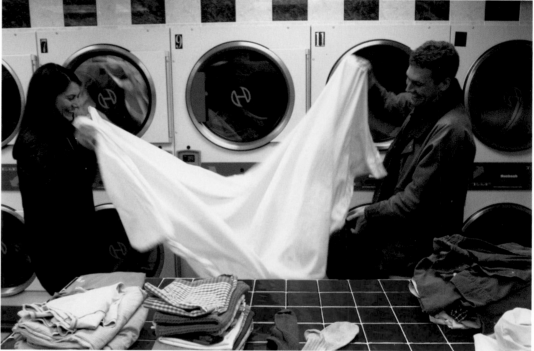

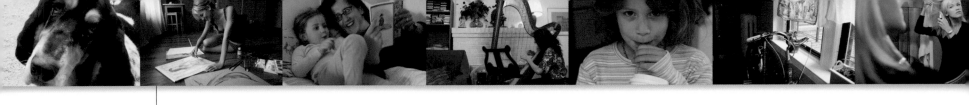

MANHATTAN

When she's not working the runway, fashion model Merily Jurna sketches people and scenes from her native Estonia in her Upper West Side studio. "When I paint, I remember my childhood in the countryside," she says. Nostalgia aside, the 21-year-old doesn't plan to head home anytime soon: "It's too cold in Estonia," she says.
Photo by Alicia Hansen

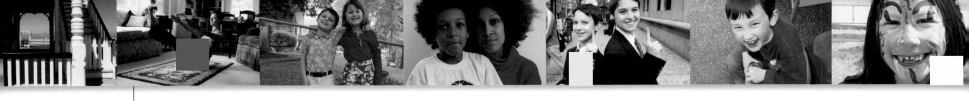

HASTINGS-ON-HUDSON

During a visit to her parents' home, Rebecca Rome begins her daily yoga routine with a pari-purna navasana, or full boat pose. An inveterate traveler, she studies photography in Maine and earns her living by modeling for fine-arts photographers.

Photo by Peter Freed

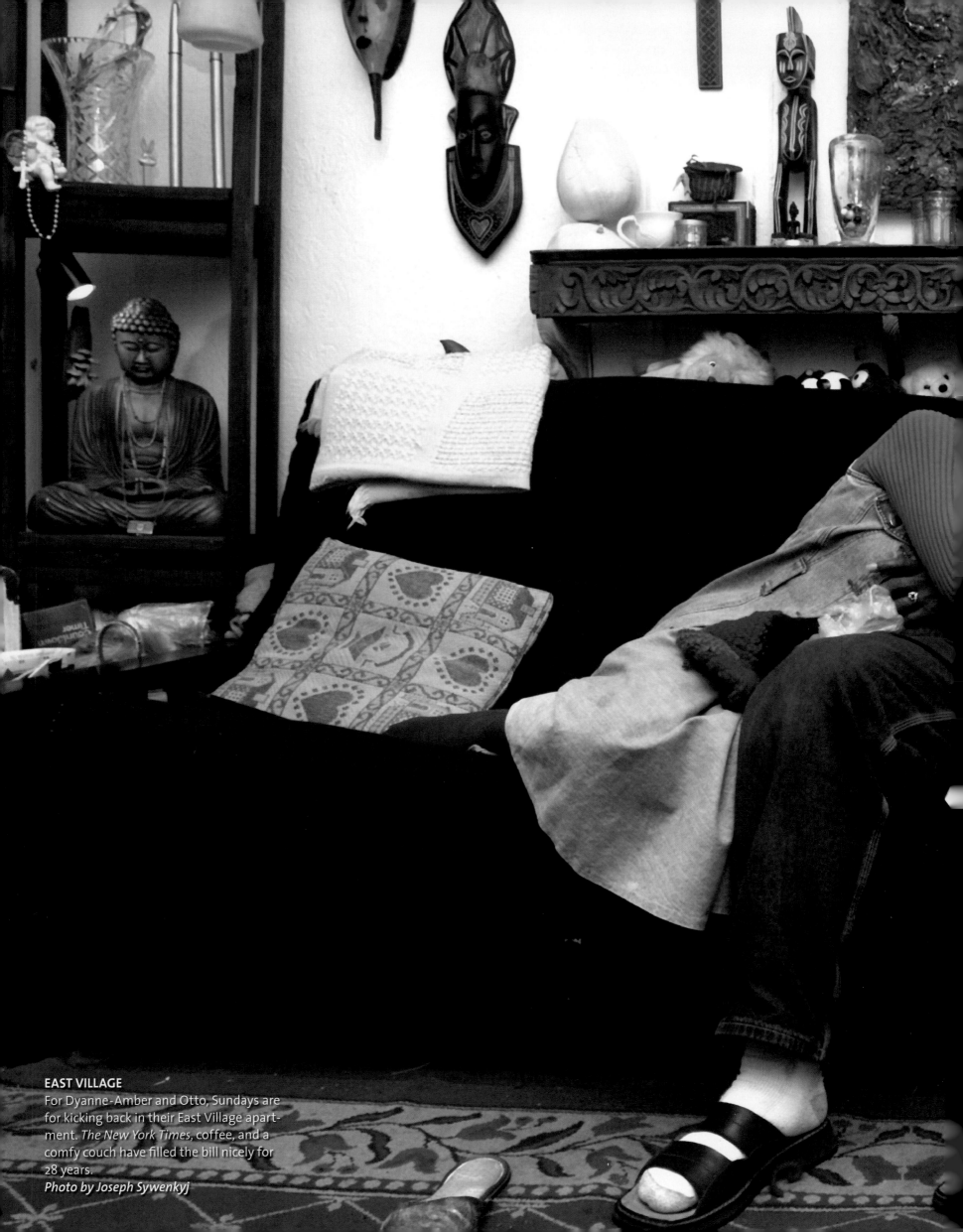

EAST VILLAGE
For Dyanne-Amber and Otto, Sundays are for kicking back in their East Village apartment. *The New York Times*, coffee, and a comfy couch have filled the bill nicely for 28 years.
Photo by Joseph Sywenkyj

MANHATTAN
Alessandra Siqueira of Brazil holds still for the brush at the Palace Hotel's spa before her wedding at the Church of Our Savior, followed by a reception at Le Cirque 2000. Siqueira met her future husband, Michael Bush, at a nightclub during a 2000 visit to the city. After a six-month courtship, her *amante Americano* popped the question to which Siqueira enthusiastically replied, "*Sim.*"
Photo by Andre Maier

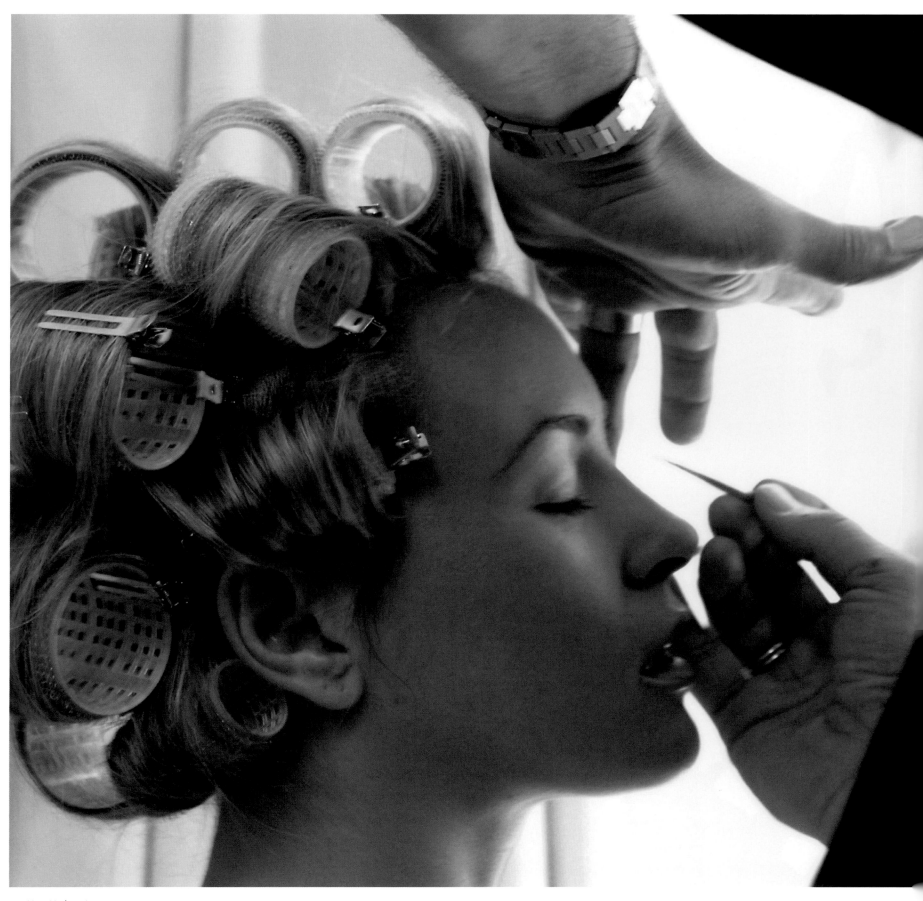

MANHATTAN

Central Park serves countless purposes for countless New Yorkers. For newlyweds Jenny Zhang and John Chen, a spot near Bethesda Fountain serves as a backdrop for their wedding pictures.
Photo by Lynn Goldsmith

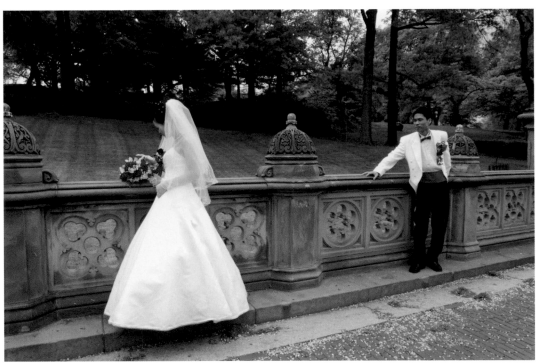

BROOKLYN

Seconds before walking down the aisle at St. Anselm Church in Bay Ridge, Elly Curreri adjusts her veil in the anteroom. Her late arrival made the bride more than a bit flustered, but then the sanctuary doors opened, and she saw Andy Blankenbuehler waiting at the altar.

Photos by Andrew Lichtenstein

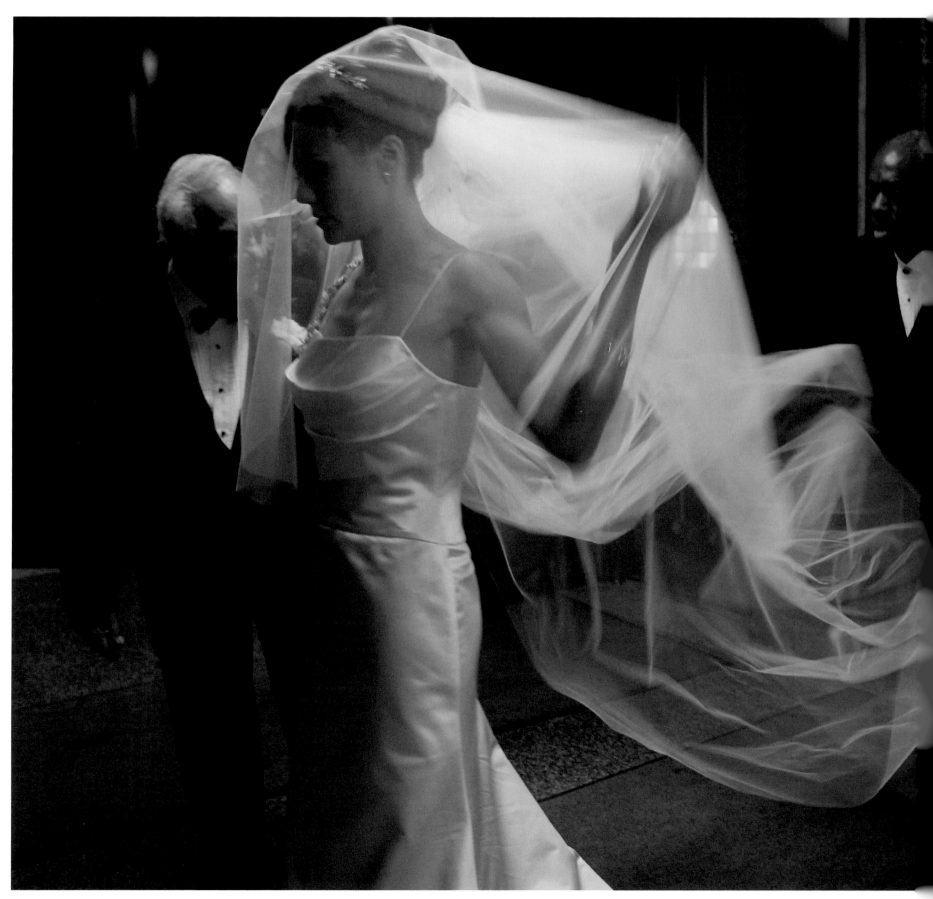

BROOKLYN

At the Blankenbuehler and Curreri wedding, old family friend Morty Steur (right) shares a laugh with Anthony Gagliardi, the bride's brother-in-law, and Salvatore Curreri, her uncle.

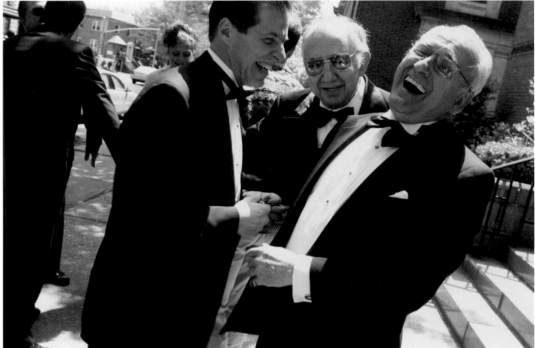

HEWLETT HARBOR
"All three of them took out every bit of hostility on their poor mommy," says Andrea Herman, overwhelmed in a pillow fight with daughters Whitney, Alex, and Morgan. All the Herman women bare very white teeth; the man of the household is a dentist.
Photos by Lynn Goldsmith

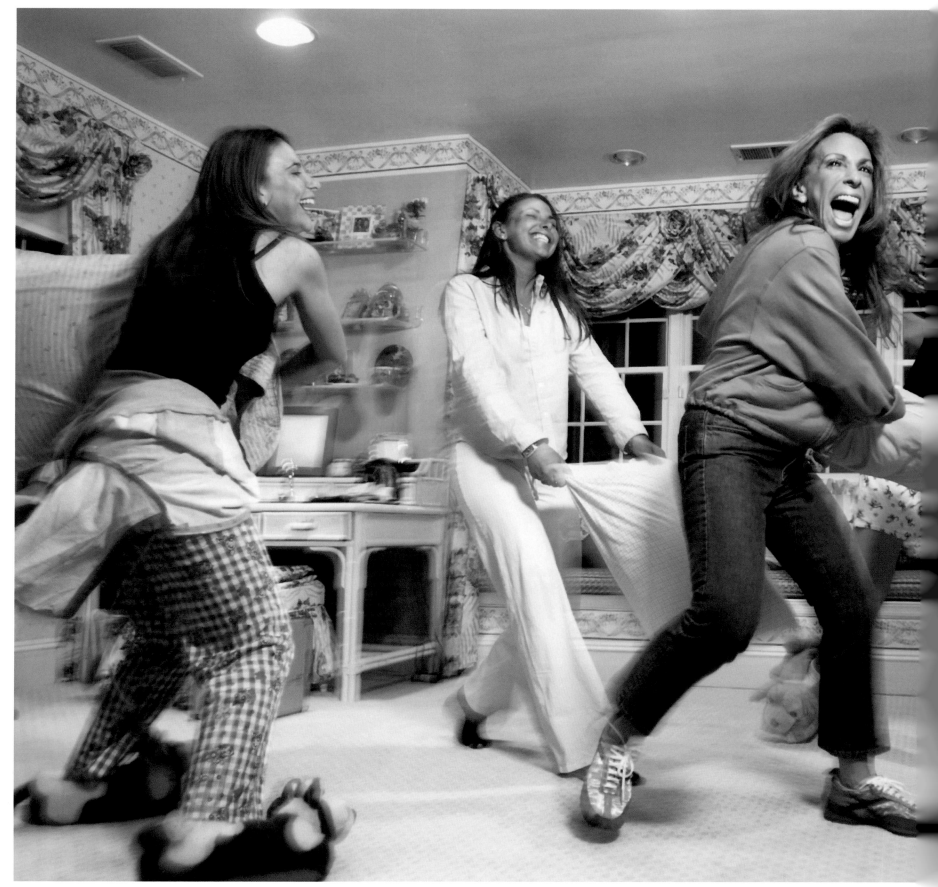

HEWLETT HARBOR

According to Herman family lore, Alex sets the standard as the family clotheshorse. The business student just returned from a semester studying art in Florence. She bought clothes there, as well as in Rome, Prague, Venice, London, Barcelona, Paris, and Amsterdam.

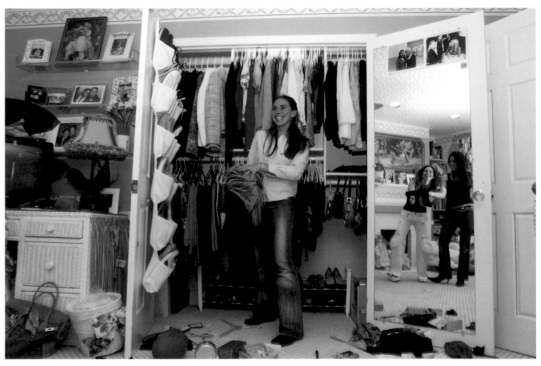

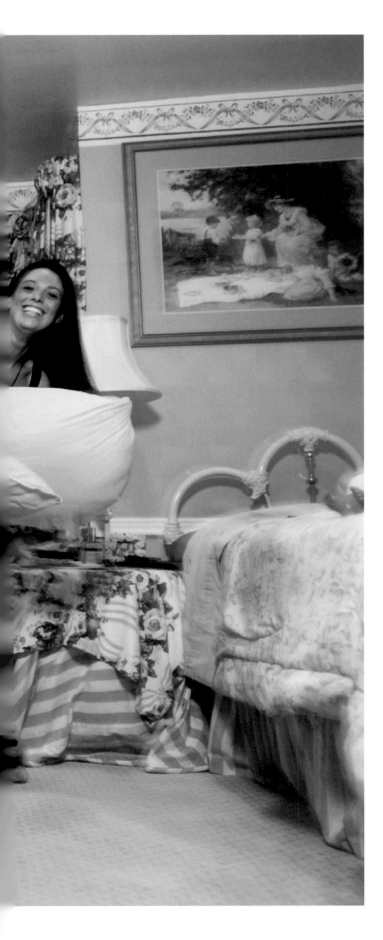

MANHATTAN
At the Cabrini Hospice on E. 19th Street, Lydia
Ponce receives a Reiki treatment from practitioner
Agi Hendell while husband Edwin Rosas holds
her hand.
Photo by Barbara Alper

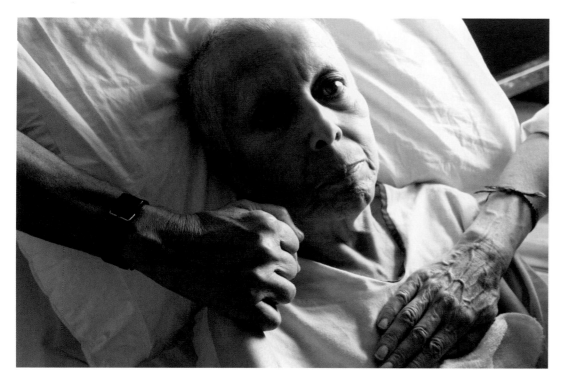

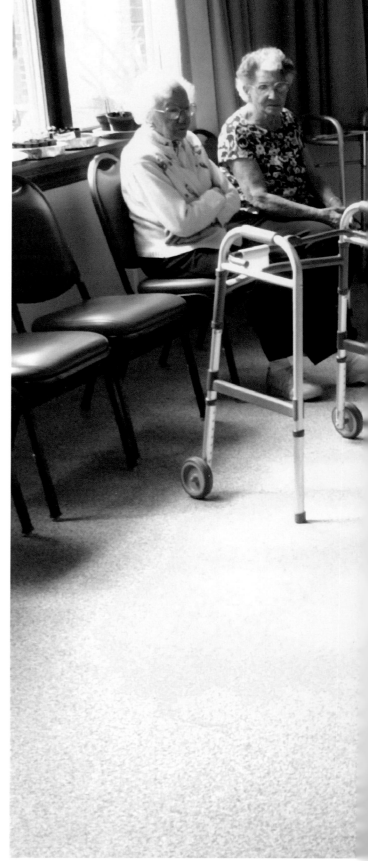

AUBURN

Francis Philbrook, Nancy Trinca, Pearl Forward, and Glenn Prudom, members of The Beauties bowling team, take turns warming up for their weekly Tuesday match against The Buttercups. The residents of The Home, a 60-bed assisted-living complex, compete for the best team and best player trophies, which are presented at an awards banquet in late May.

Photo by Kevin Rivoli

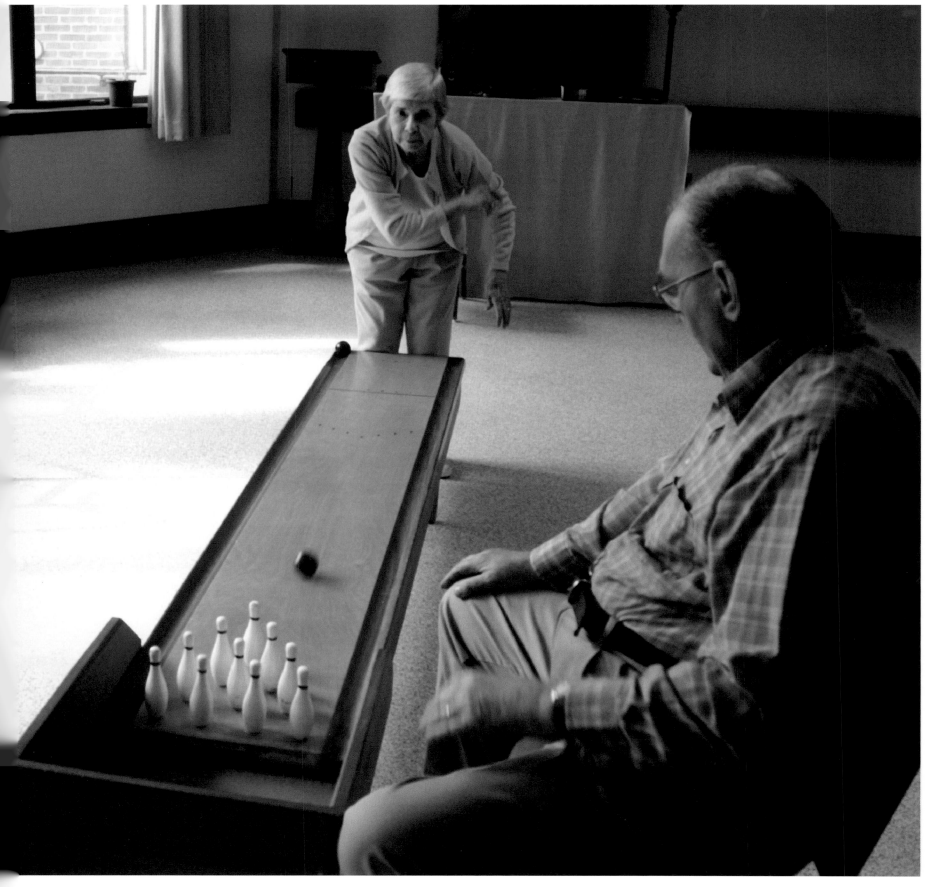

IRVINGTON

After surviving an abusive marriage to the late jazz musician Stan Getz, Monica Getz founded the Coalition for Family Justice in 1988. The non-profit provides information, counseling, and referrals to families dealing with divorce and domestic violence. Board meetings are held at Getz's mansion.

Photos by Peter Freed

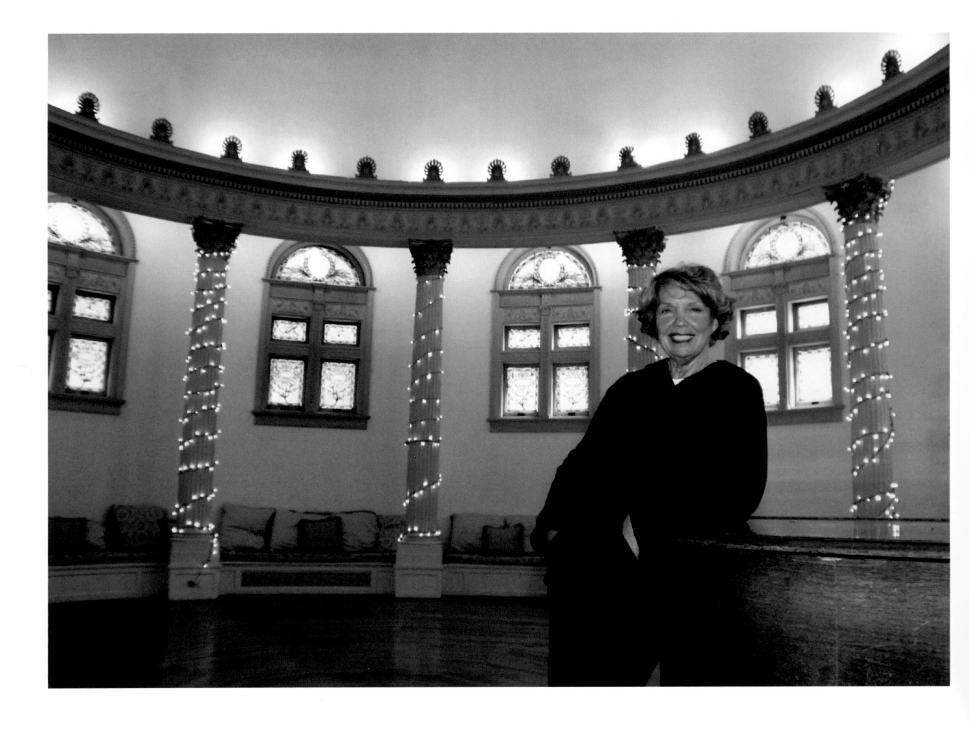

NEW HAMBURG

Philanthropist Fran Reiss stands in the foyer of her home. A major landowner in the Hudson River Valley, Reiss has worked with the Scenic Hudson preservation group for four decades. She has also donated her time and finances to many environmental, educational, and health organizations throughout the state.

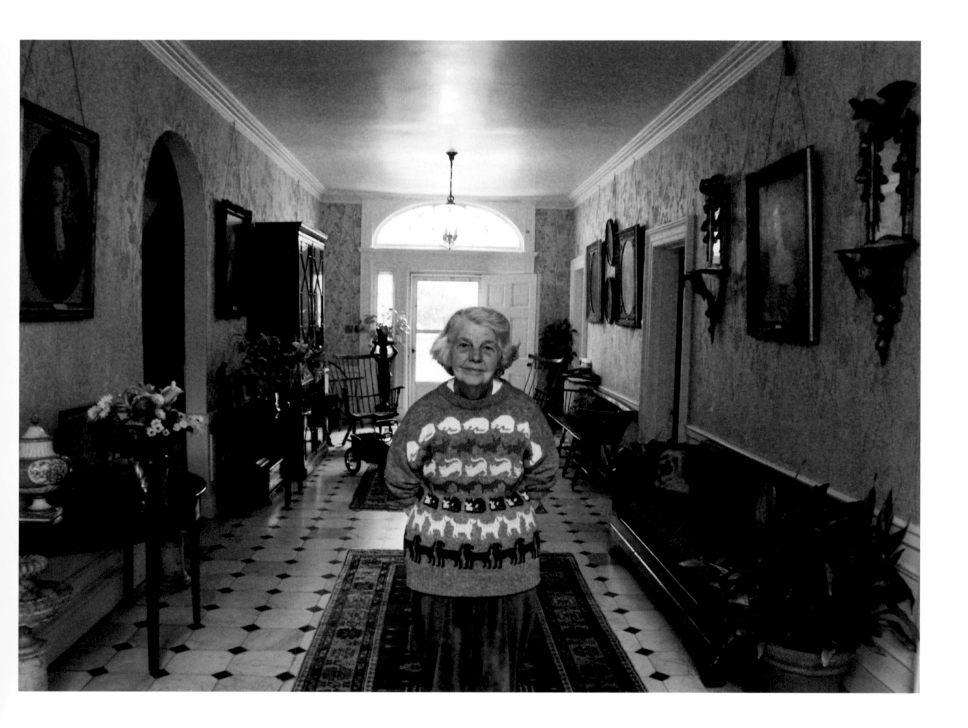

BROOKLYN

Adopted by their mother Robin as infants, Ashley, Julian, and Anna were born with HIV. It was a constant struggle to keep them alive, but the children responded to antiretroviral treatments introduced seven years ago and are now thriving. The state pays for medications, which cost $30,000 a year. Also on the couch is Robin's grandson Mohammed.

Photo by Joseph Sywenkyj

BROOKLYN

Aida Robello (left) has lived on Sackett Street in the same house for 52 years. "I moved here from Puerto Rico when I was young, met my husband next door, and had 11 children. I love this street. Everybody says 'Hello,' 'Goodbye,' and 'How are you?' It's home."

Photo by Andrew Lichtenstein

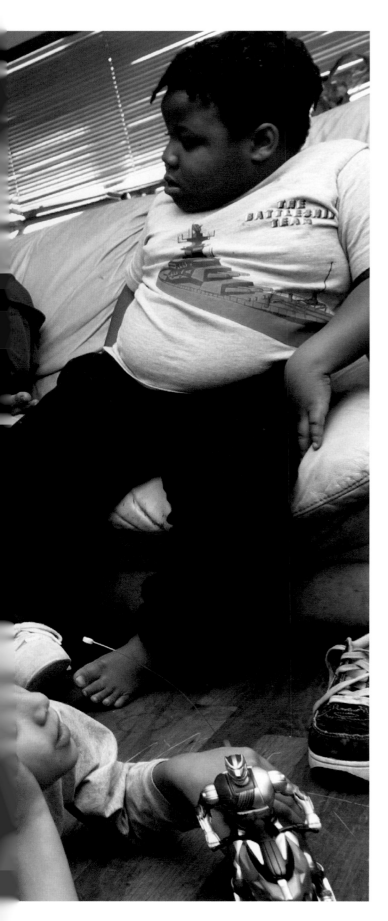

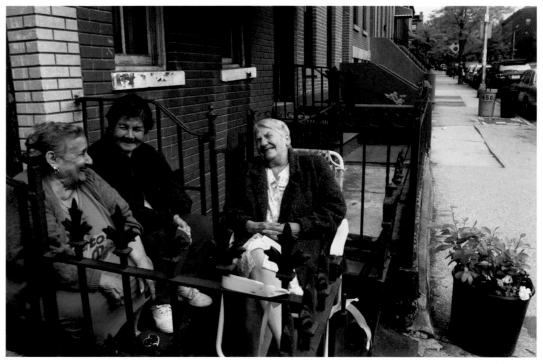

The year 2003 marked a turning point in the history of photography: It was the first year that digital cameras outsold film cameras. To celebrate this unprecedented sea change, the *America 24/7* project invited amateur photographers—along with students and professionals—to shoot and, via the Internet, submit digital images. Think of it as audience participation. Their visions of community are interspersed with the professional frames throughout this book. On the following four pages, however, we present a gallery produced exclusively by amateur photographers.

BROOKLYN Erected on Coney Island in 1912, Charles Carmel's handcrafted carousel was moved to Prospect Park in 1952 and closed for renovations from 1983 to 1990. In 2003, a whirl remains a relative bargain at just 50 cents. *Photo by Howard Mandel*

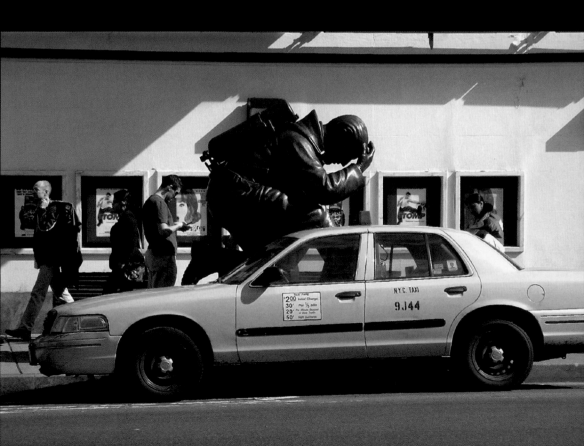

MANHATTAN Cast in Italy by Matthews International Corporation, this 2,700-pound commissioned bronze fireman arrived at Kennedy Airport, en route to Missouri, on September 9, 2001. Within days, it was donated to New York City's Milford Plaza Hotel. *Photo by Brian Fish*

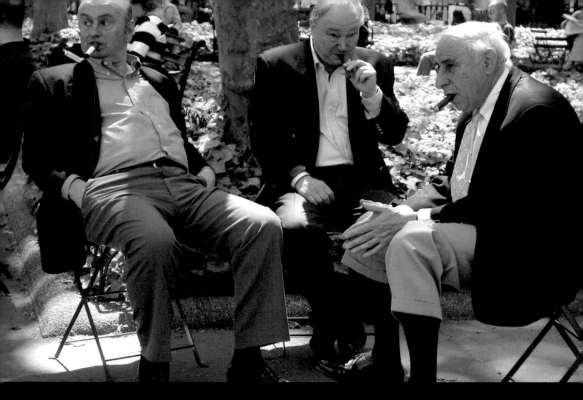

MANHATTAN Mayor Michael Bloomberg has made smoking in public places more difficult these days, but it's not a problem for these three cigar-chomping chums in Bryant Park. *Photo by Vincent Rodriguez*

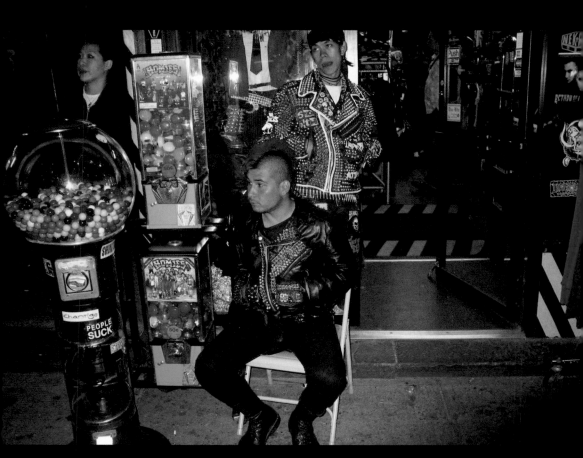

MANHATTAN In most places in the country, Spider's mohawk and leather attire would garner a few disapproving stares—but on St. Mark's Place in the East Village, he's passé. *Photo by Stan Tracy & Jolie Krupnik*

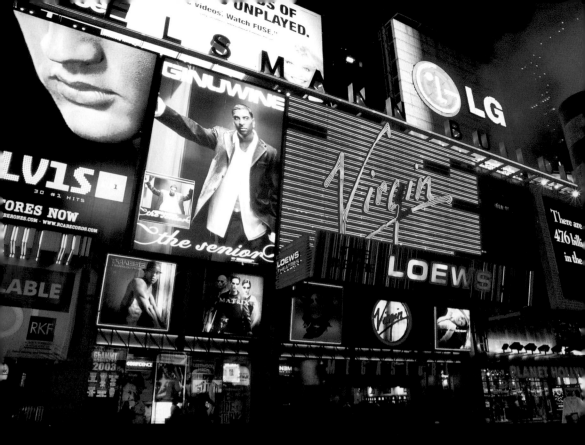

MANHATTAN Named for its early occupant, *The New York Times*, Times Square still delivers bright lights. Some complain, though: The place is just not as seedy—or intriguing—as it once was. ***Photo by Wyett Baker***

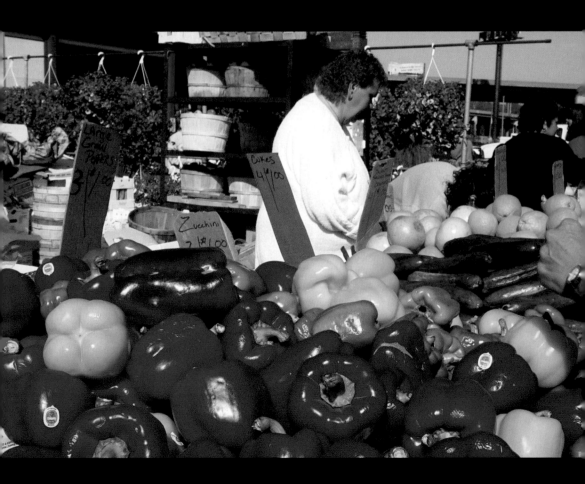

SYRACUSE *Capsicum annuum grossum*, or sweet bell peppers, brighten up the stalls at the Syracuse Farmer's Market held every Tuesday...October. ***Photo by Marc Cohen***

MANHATTAN The hangar-sized Sackler Wing of the Metropolitan Museum of Art houses the 2,000-year-old Temple of Dendur and boasts a view of Central Park. *Photo by Enrique Gonzalez*

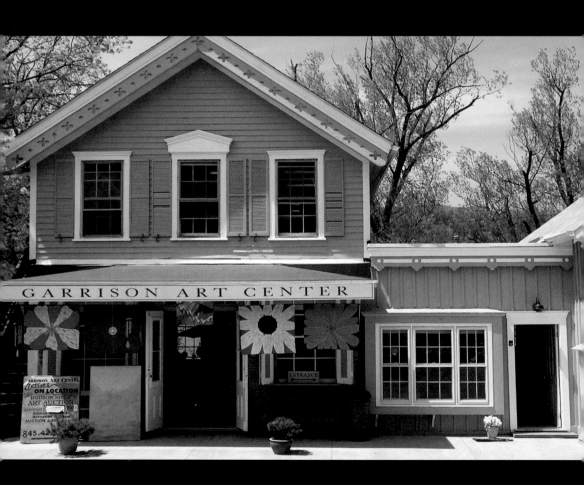

GARRISON Housed in a building that used to serve as post office and general store, the nonprofit Garrison Art Center now offers artists a place to exhibit, teach, or take classes. *Photo by Larry Glade*

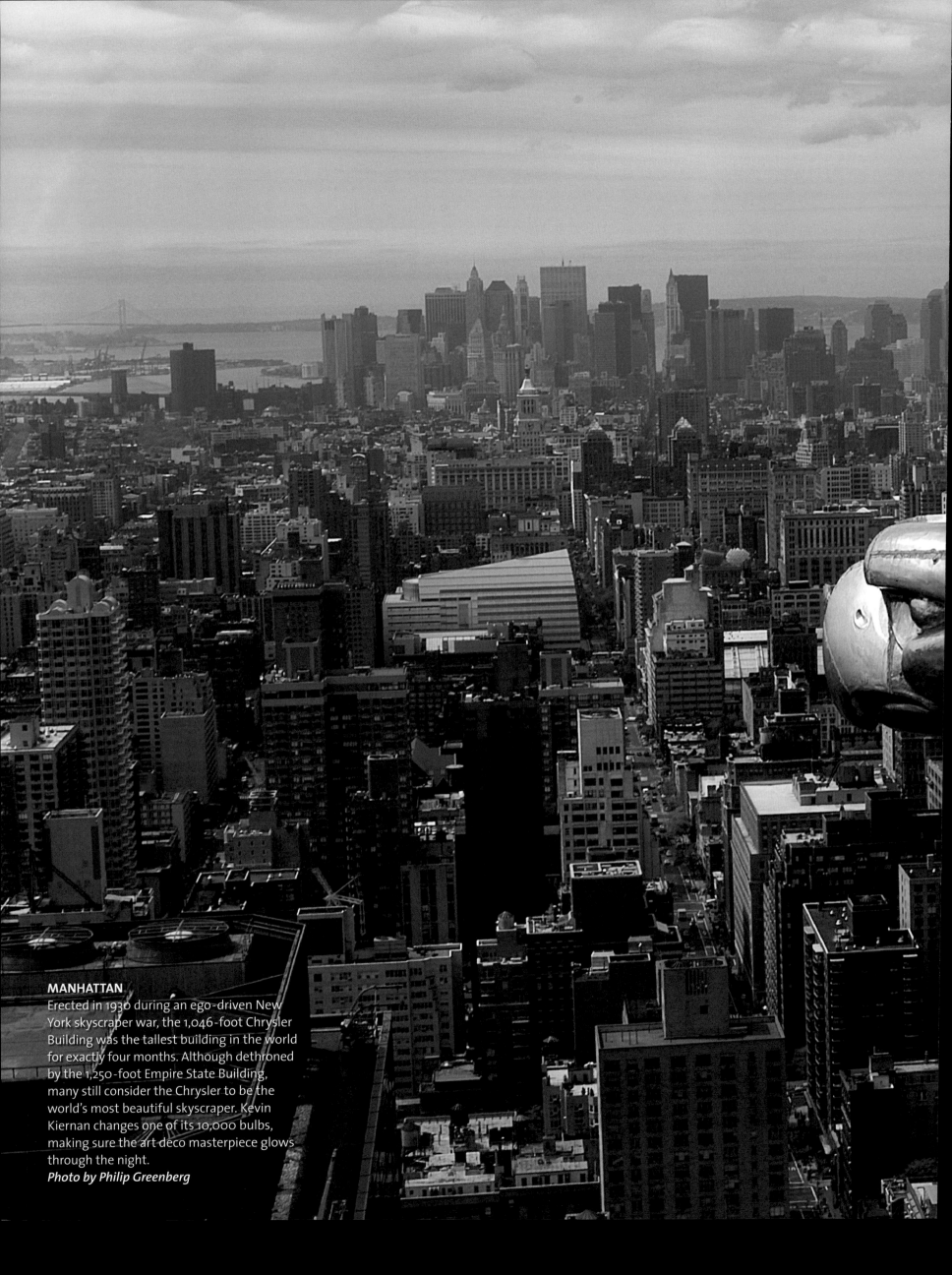

MANHATTAN
Erected in 1930 during an ego-driven New York skyscraper war, the 1,046-foot Chrysler Building was the tallest building in the world for exactly four months. Although dethroned by the 1,250-foot Empire State Building, many still consider the Chrysler to be the world's most beautiful skyscraper. Kevin Kiernan changes one of its 10,000 bulbs, making sure the art deco masterpiece glows through the night.
Photo by Philip Greenberg

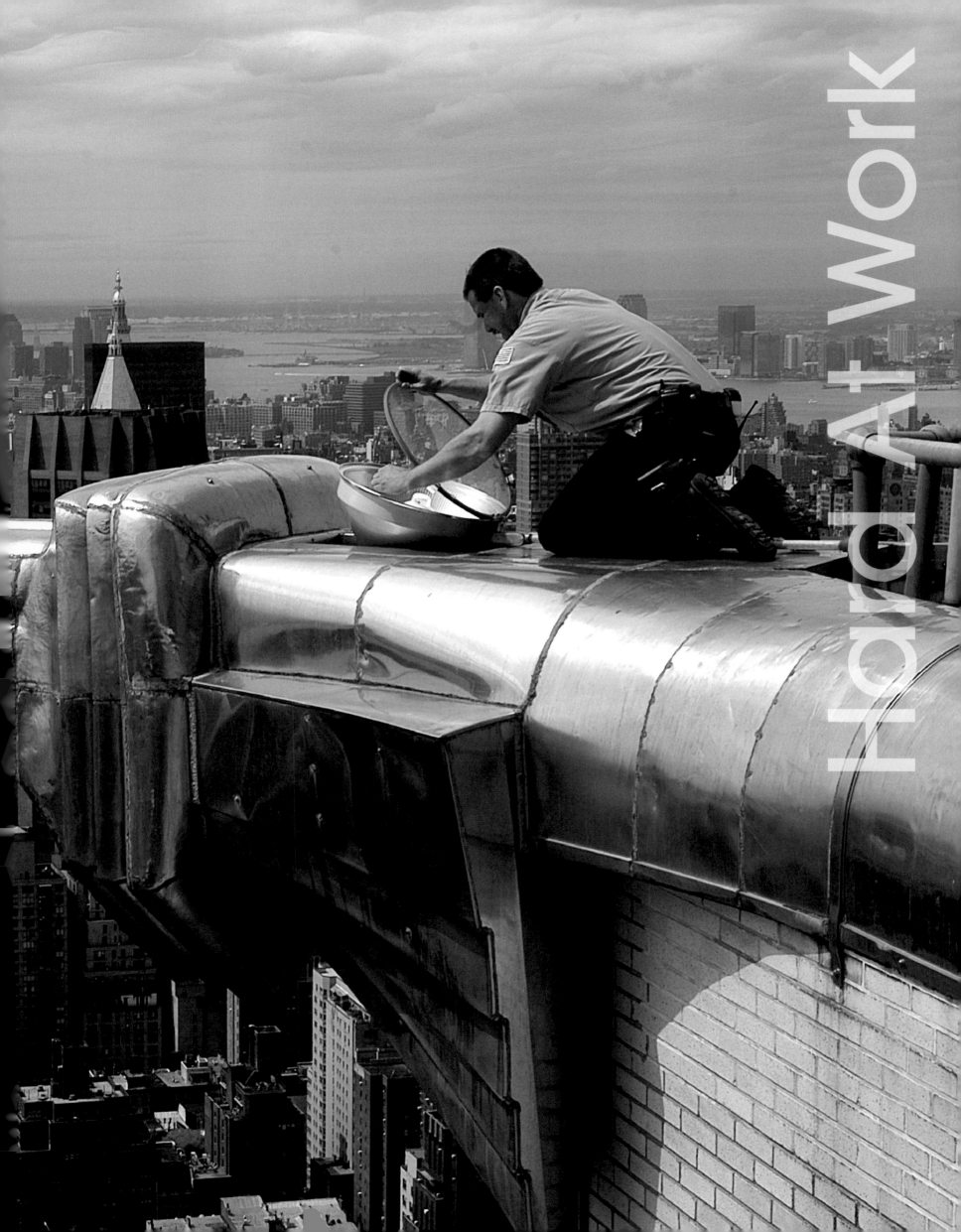

MANHATTAN

12:30 p.m., May 12, 2003, the New York Stock Exchange: The Dow is rising and traders scramble to make sales before grabbing the proverbial New York bite. By day's end, the Dow Jones will be up by 123 points—a high for the week.
Photos by James Salzano

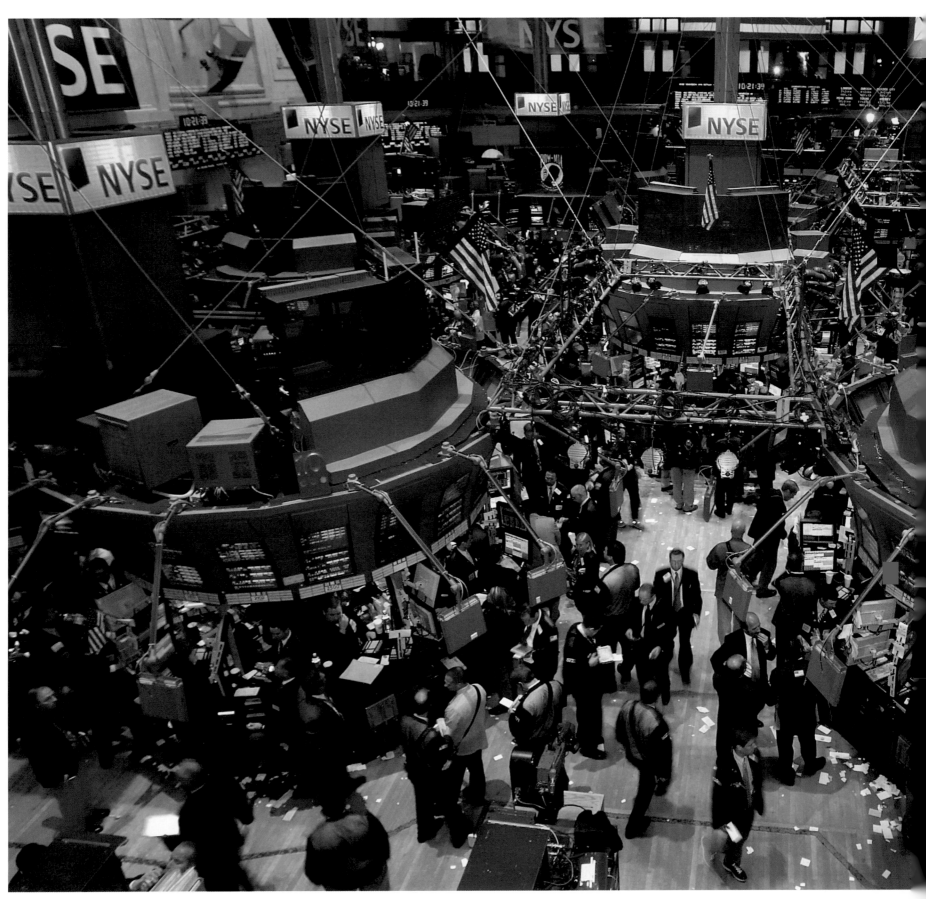

MANHATTAN
Since the terrorist attacks of September 11, 2001, security at the New York Stock Exchange has increased markedly. At 3 a.m., George Milian and Stephen Wimpel guard the front door to the American marketplace.

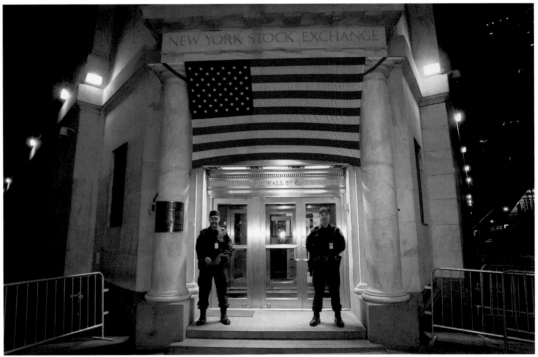

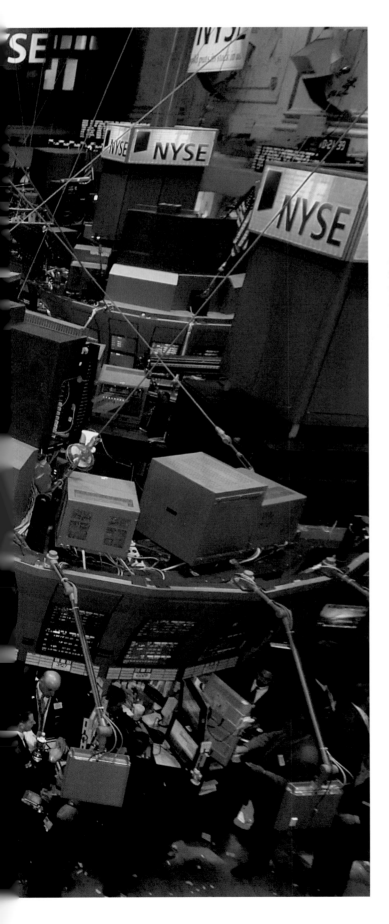

MANHATTAN

The man is known for private weekends out of town, but at his day job, Mayor Michael Bloomberg sits in the thick of the action. The founder of the financial colossus Bloomberg LP brought the configuration of trading-floor cubicles to city hall.
Photo by Mark Peterson

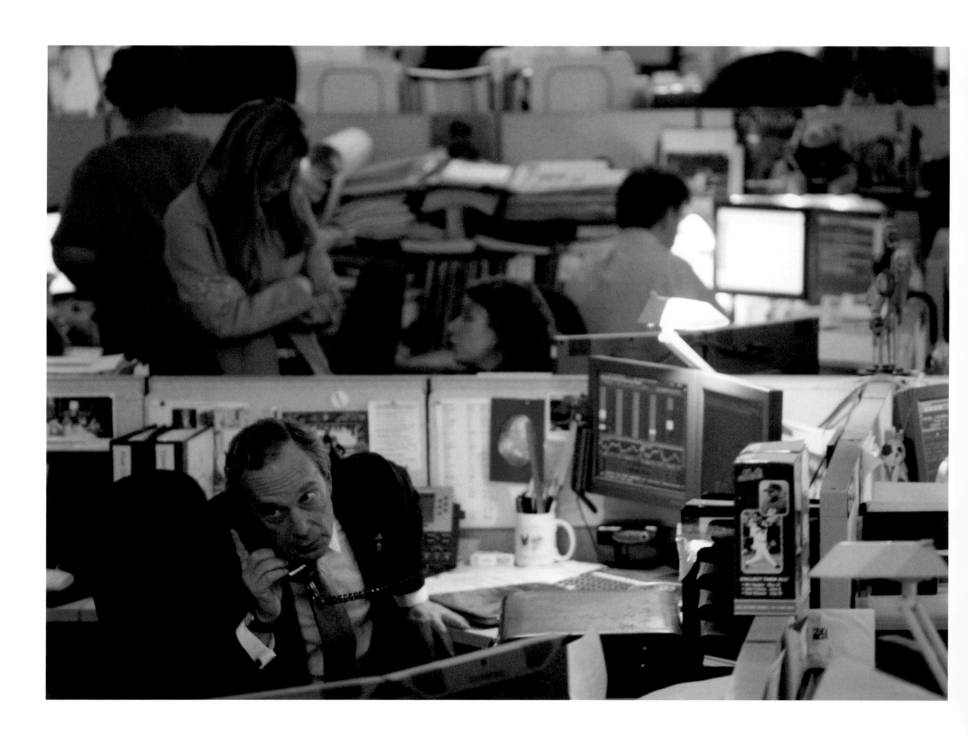

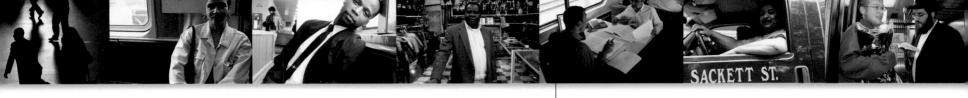

RHINECLIFF

Linemen: On Amtrak's Albany to New York City run, train cars become offices on wheels, as cafe car tables become desks. On the 7:55 a.m. ride, an engineer and lawyer get a jump on the work day.
Photo by Patrick Harbron

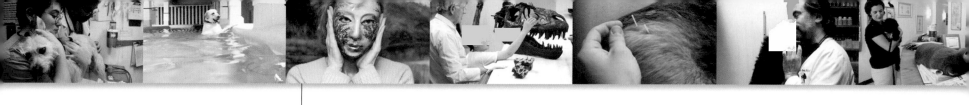

BOICEVILLE
Who is that masked woman? Landscape artist Ellen Nieves painted this verdant visage to wear at a masked ball benefitting the nearby 83-year-old Woodstock Artists Association. She stands in front of her diptych, *Spring Sunrise, Red Trees*.
Photo by Lynn Goldsmith

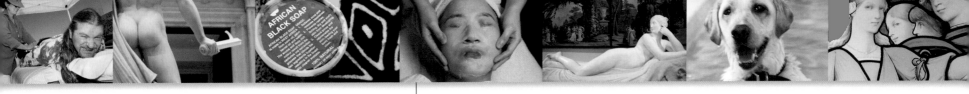

MANHATTAN

Traffic, noise, grimy soot, crowds—it's enough to make a Manhattanite retreat to the Toto Beauty Salon in Chinatown for a facial and massage.
Photo by Kristen Ashburn, Contact Press Images

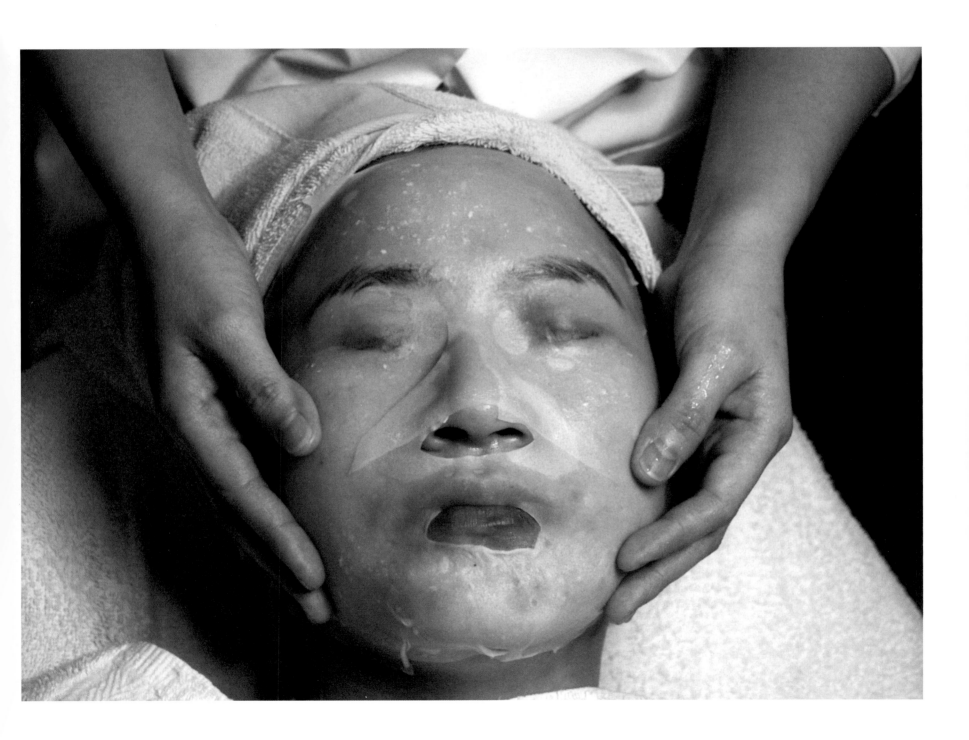

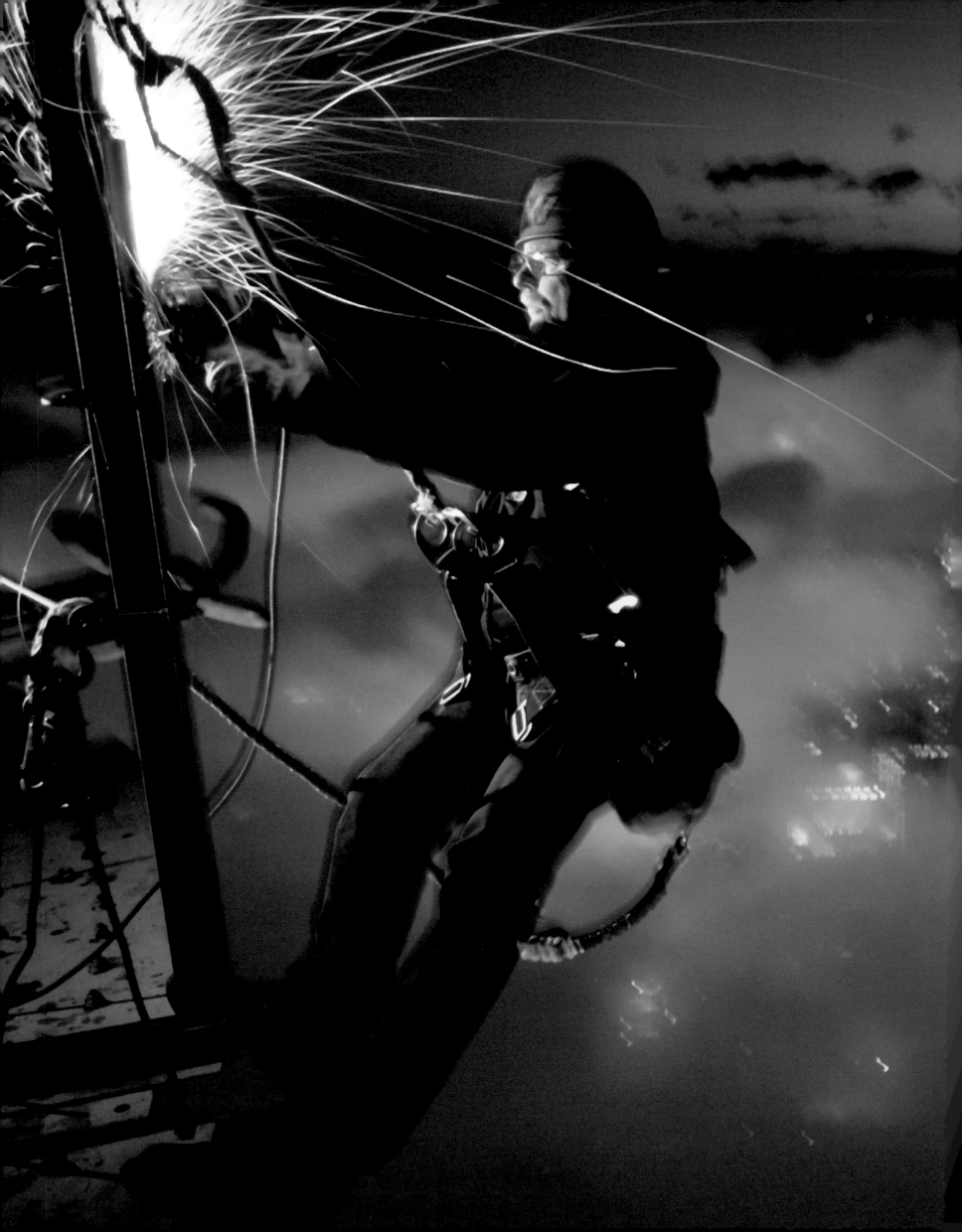

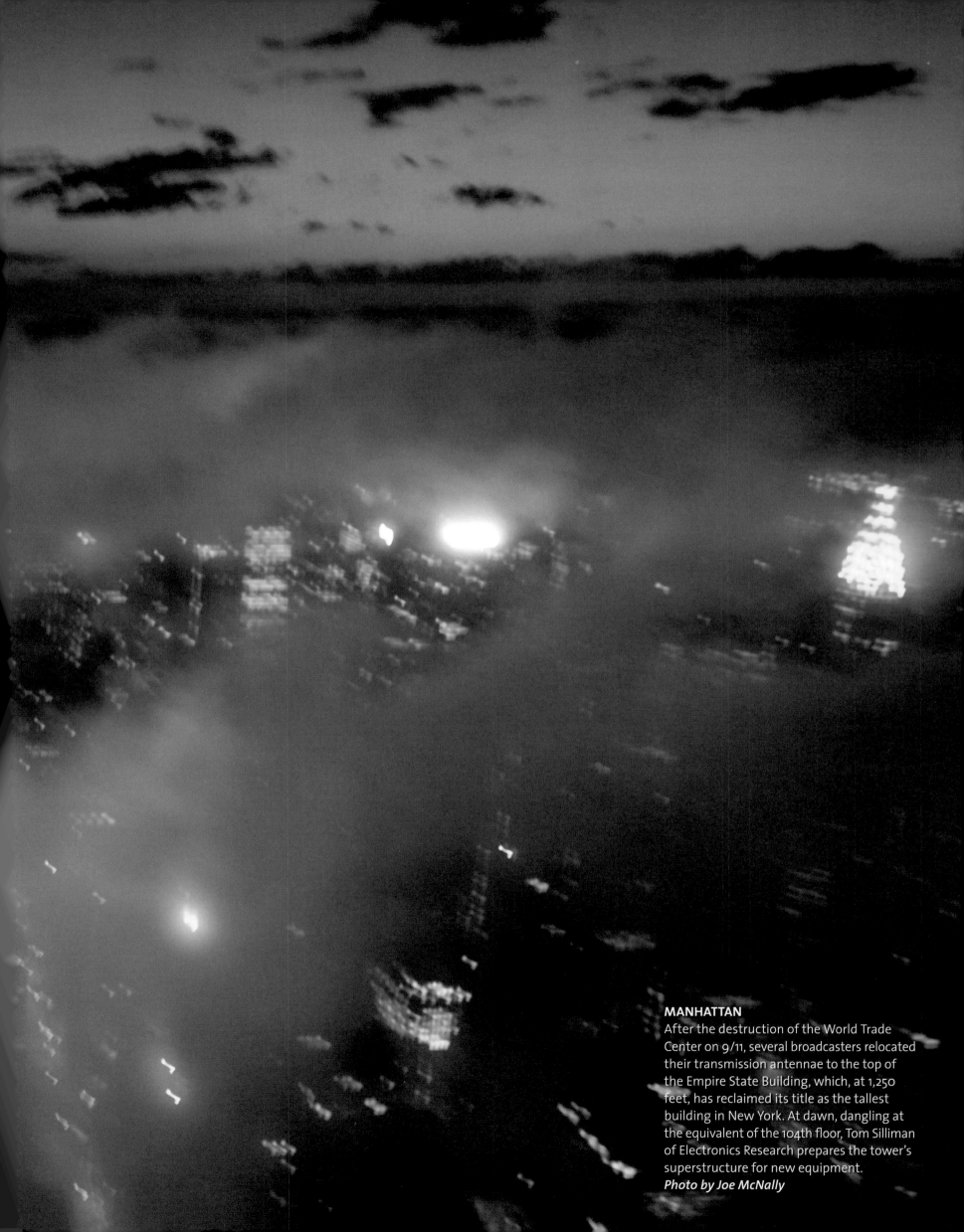

MANHATTAN
After the destruction of the World Trade Center on 9/11, several broadcasters relocated their transmission antennae to the top of the Empire State Building, which, at 1,250 feet, has reclaimed its title as the tallest building in New York. At dawn, dangling at the equivalent of the 104th floor, Tom Silliman of Electronics Research prepares the tower's superstructure for new equipment.
Photo by Joe McNally

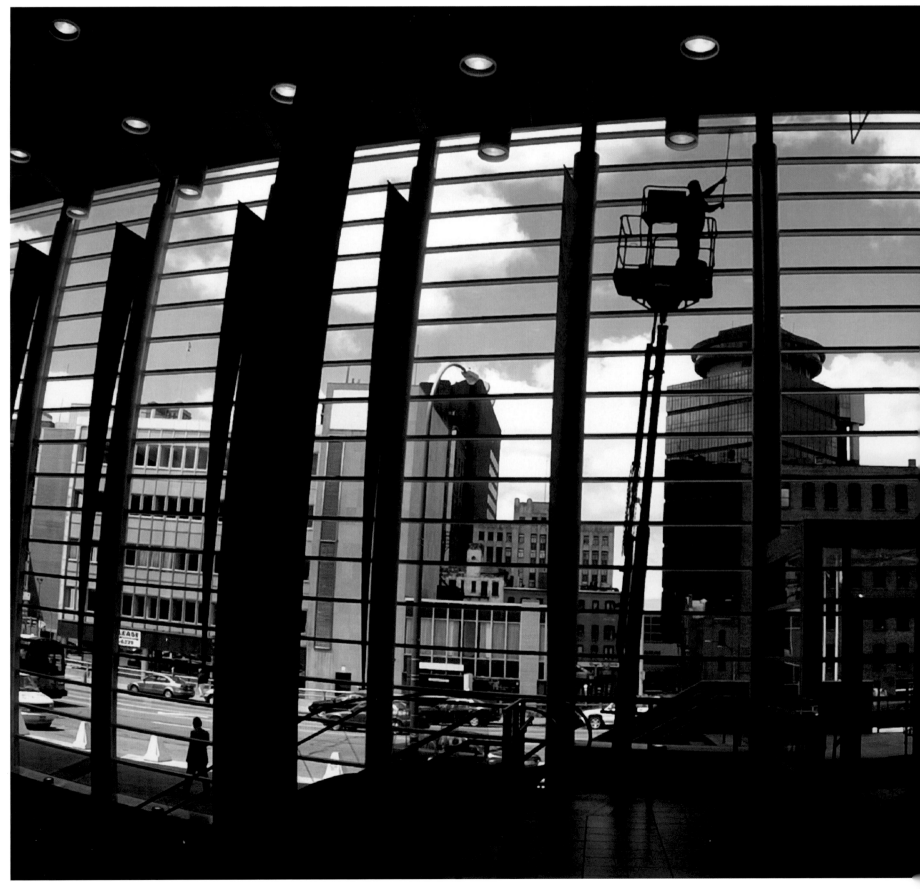

ROCHESTER

A fall that broke his back didn't faze Ted Stein, who has been cleaning Rochester's skyscrapers since 1985. The third-generation window washer had titanium hinges put in his spine and returned to work shortly after his surgery. Today's assignment: scrubbing the 50-foot panels of the Blue Cross Arena's atrium.

Photo by Carlos Ortiz, Democrat and Chronicle

MANHATTAN

It's one in the morning, and Beverly Wilson hoses down the 86th Street subway station at Broadway. Wilson has been working the graveyard shift for the Metropolitan Transit Authority's Mobile Wash Unit since 1999.
Photo by Philip Greenberg

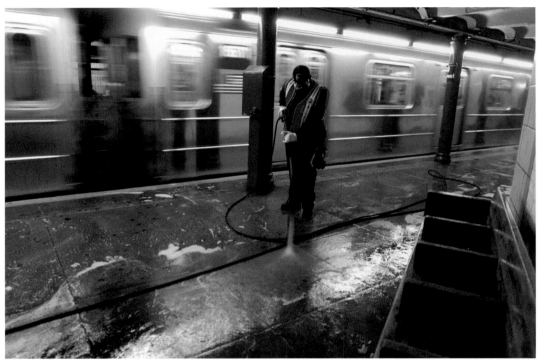

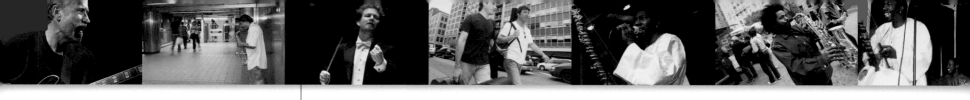

STONY BROOK

David Wiley conducts the Long Island Philharmonic's season finale at the Staller Center for the Arts at SUNY Stony Brook. The program includes pieces by Mozart and Strauss. Each season, performances are split between the Staller Center and the Tilles Center for the Performing Arts.
Photo by John Griffin

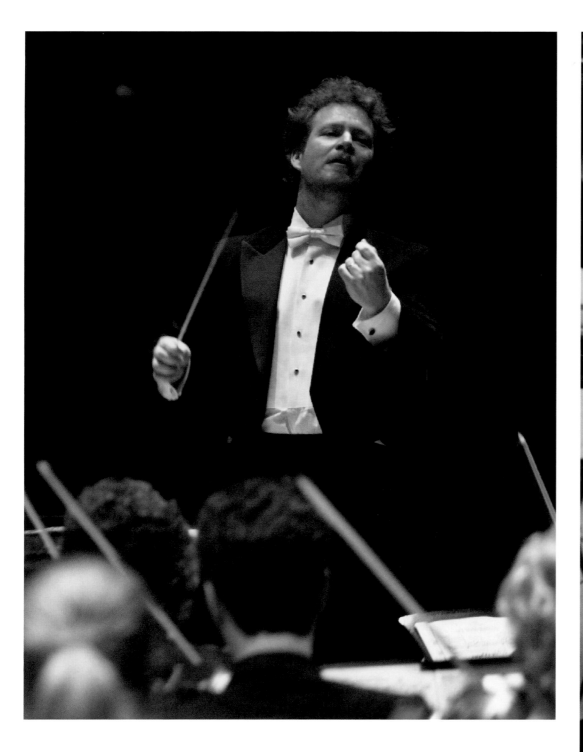

MANHATTAN

José Quintana, a 35-year resident of the Lower
East Side, is the owner of this barbershop/guitar
closet on Avenue C. Between tonsorial tasks,
Quintana picks out some tunes.
Photo by Joe Kohen

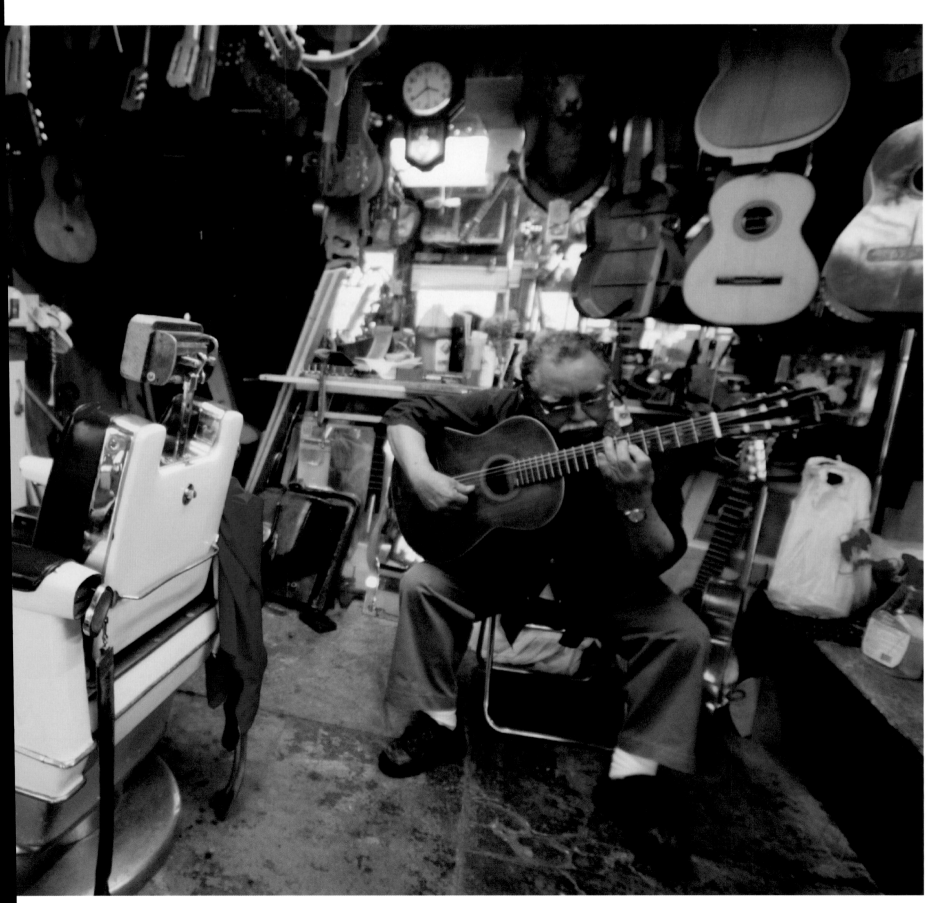

ROCHESTER

Incoming wounded: Linda Greenfield, owner of the Chili Doll Hospital and Victorian Doll Museum, restrings a broken arm in the ER (aka her repair workshop). Greenfield began collecting dolls as a young girl and now has 3,000 vintage models in her collection, including one of every Shirley Temple doll issued since 1934.

Photo by Carlos Ortiz, Democrat and Chronicle

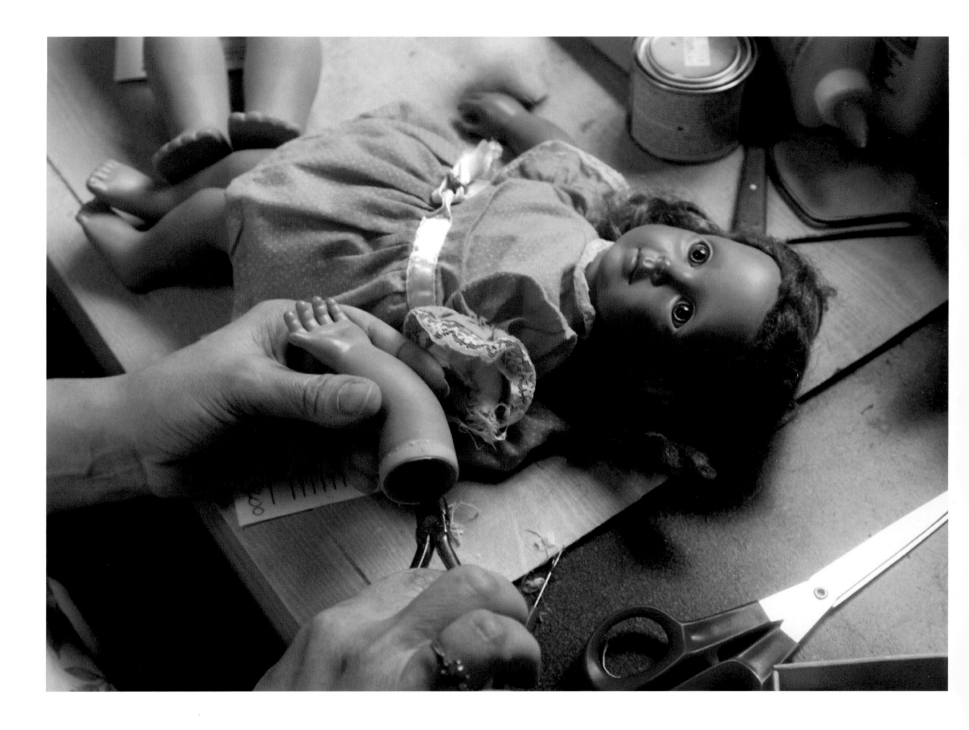

COLD SPRING

When he was 11 years old, hunter and fisherman Kurt Fox signed up for a correspondence course to learn how to mount his trophies. In 1979, Fox opened Fox Studio Taxidermy, where he's turned his hobby into a full-time job, mounting animals as tiny as tarantulas and as big as elephants.

Photo by Peter Freed

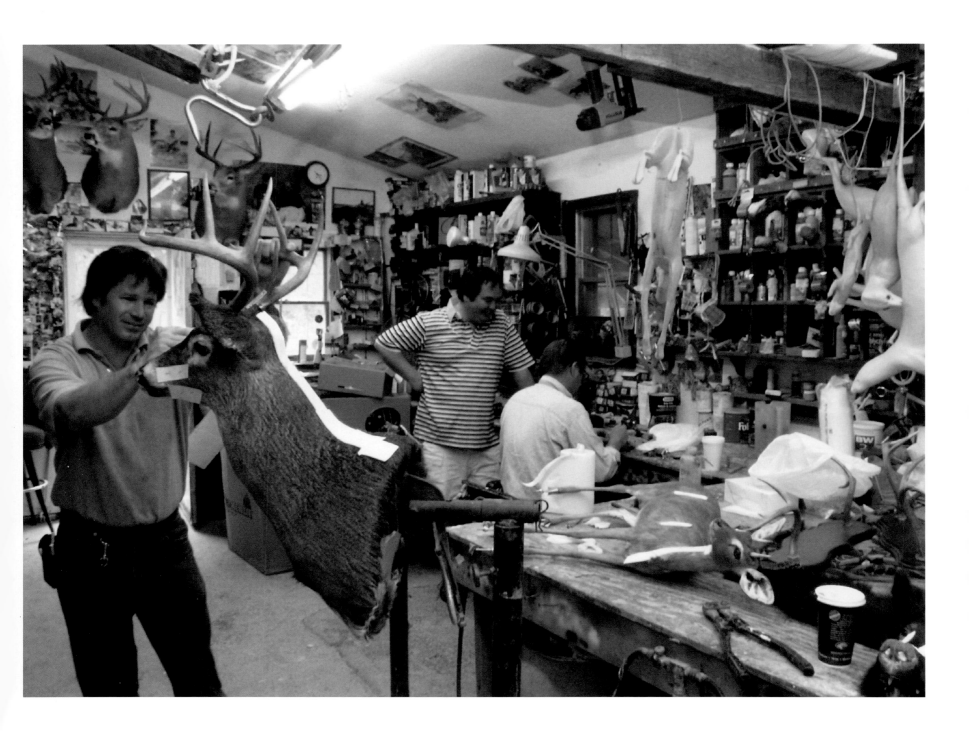

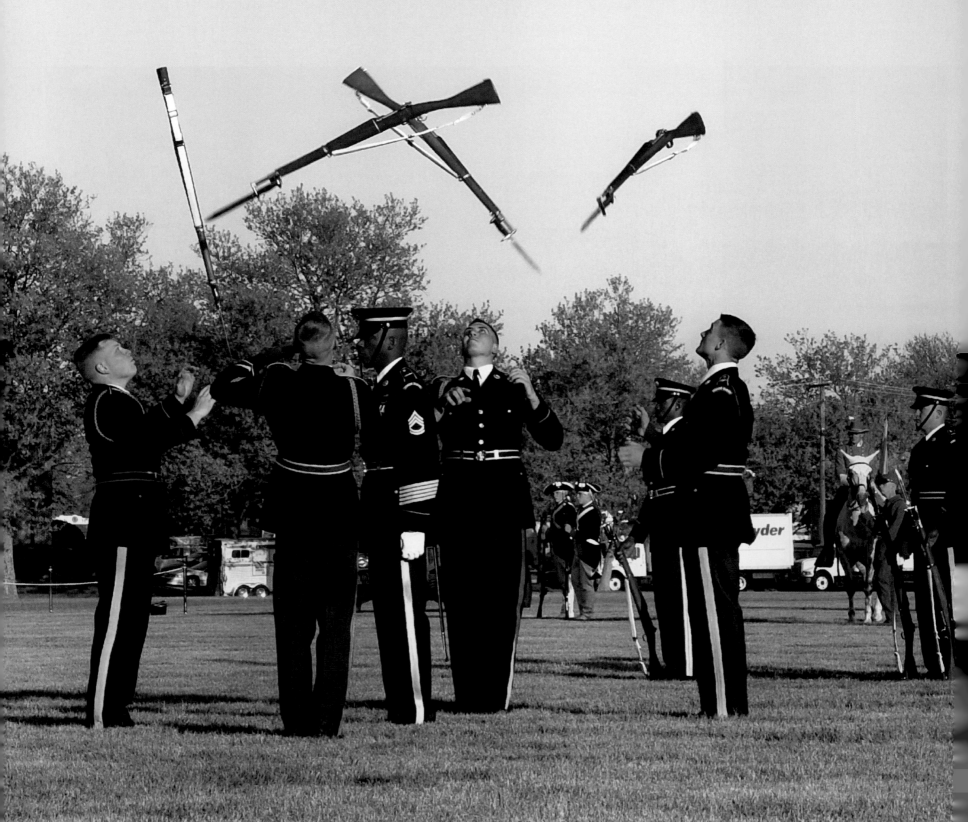

BROOKLYN
Members of the U.S. Army Drill Team toss
their Springfield rifles during a synchronized
performance at the annual Twilight Tattoo
in Fort Hamilton.
Photo by John R. Collins

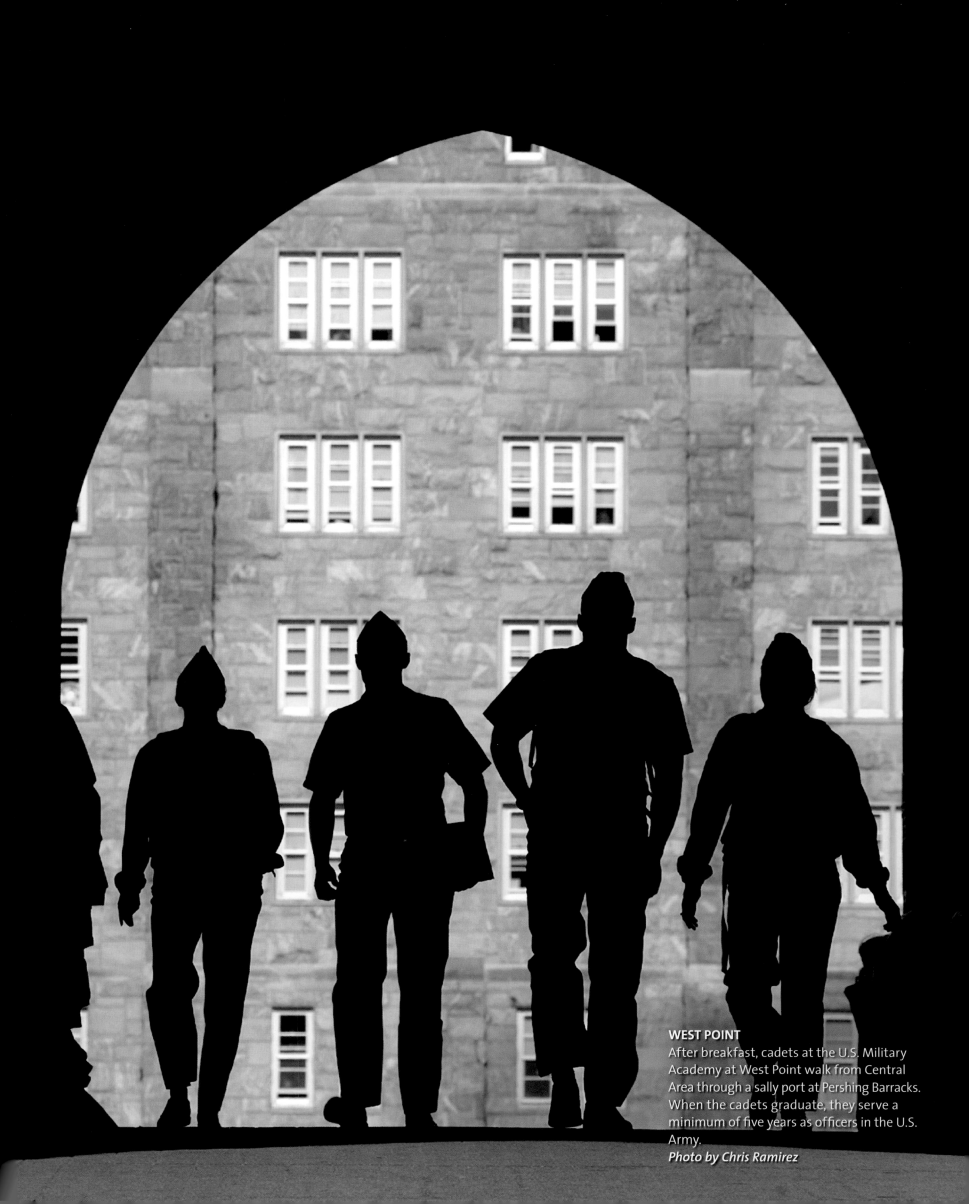

WEST POINT
After breakfast, cadets at the U.S. Military Academy at West Point walk from Central Area through a sally port at Pershing Barracks. When the cadets graduate, they serve a minimum of five years as officers in the U.S. Army.
Photo by Chris Ramirez

MANHATTAN
At Lexington Avenue and 122nd Street, firefighters from "Heaven in Harlem," as they call their fire-house, douse a fire in a vacant building. Chris Fenyo, Chris Bohn, Sheldon Cummings, Mike Baranowski, and Lt. Vic Spadaro are with Engine 35, Ladder 4.
Photo by Joe McNally

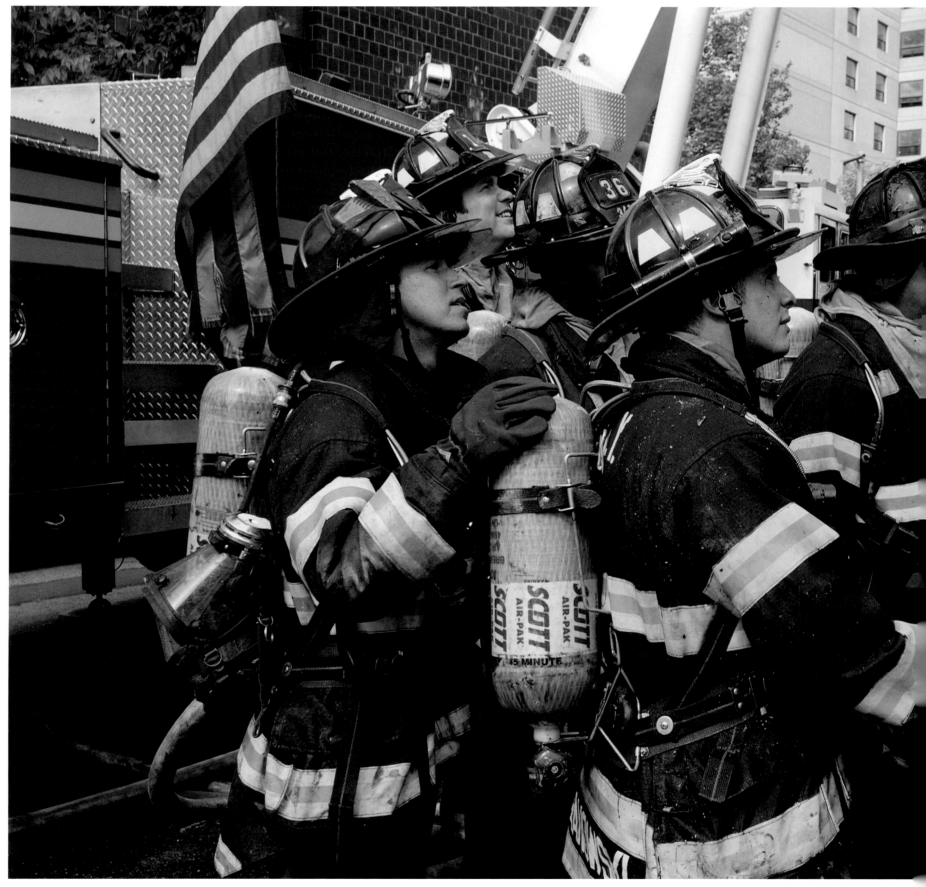

ROCHESTER

Firefighter Tom Rogan empties a water pipe on a tower ladder at the Company Quint/Midi 8 firehouse. The 40-foot truck's hoses and water tanks rarely get a full workout: Eighty percent of the station's calls are for gas leaks, emergency medical cases, elevator rescues, and false alarms.

Photo by Carlos Ortiz, Democrat and Chronicle

MANHATTAN

Got spinach? At Engine 9, Ladder 6 on Canal Street, Mike Cook flexes for Rob McGuinness. The Chinatown-based crew call themselves the Dragonfighters, but they're also called Miracle Ladder 6 after what happened on 9/11: All were stuck in a stairwell of the World Trade Center's north tower—and all survived.

Photo by Joe McNally

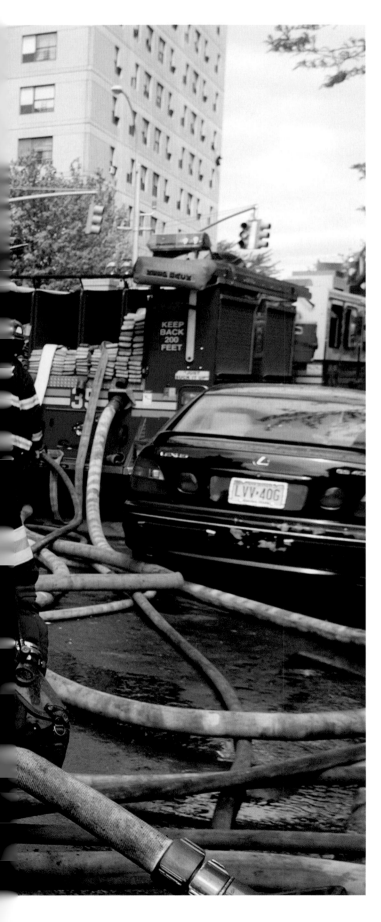

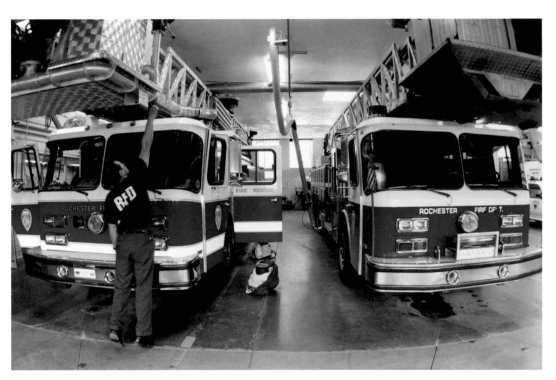

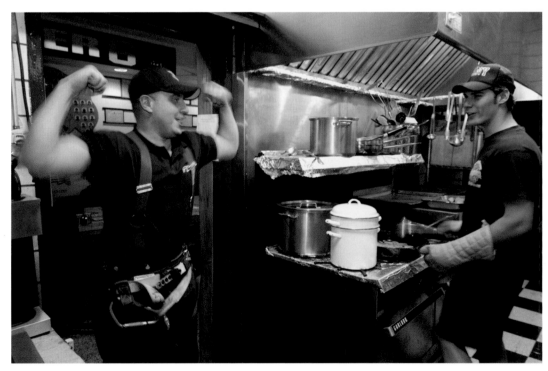

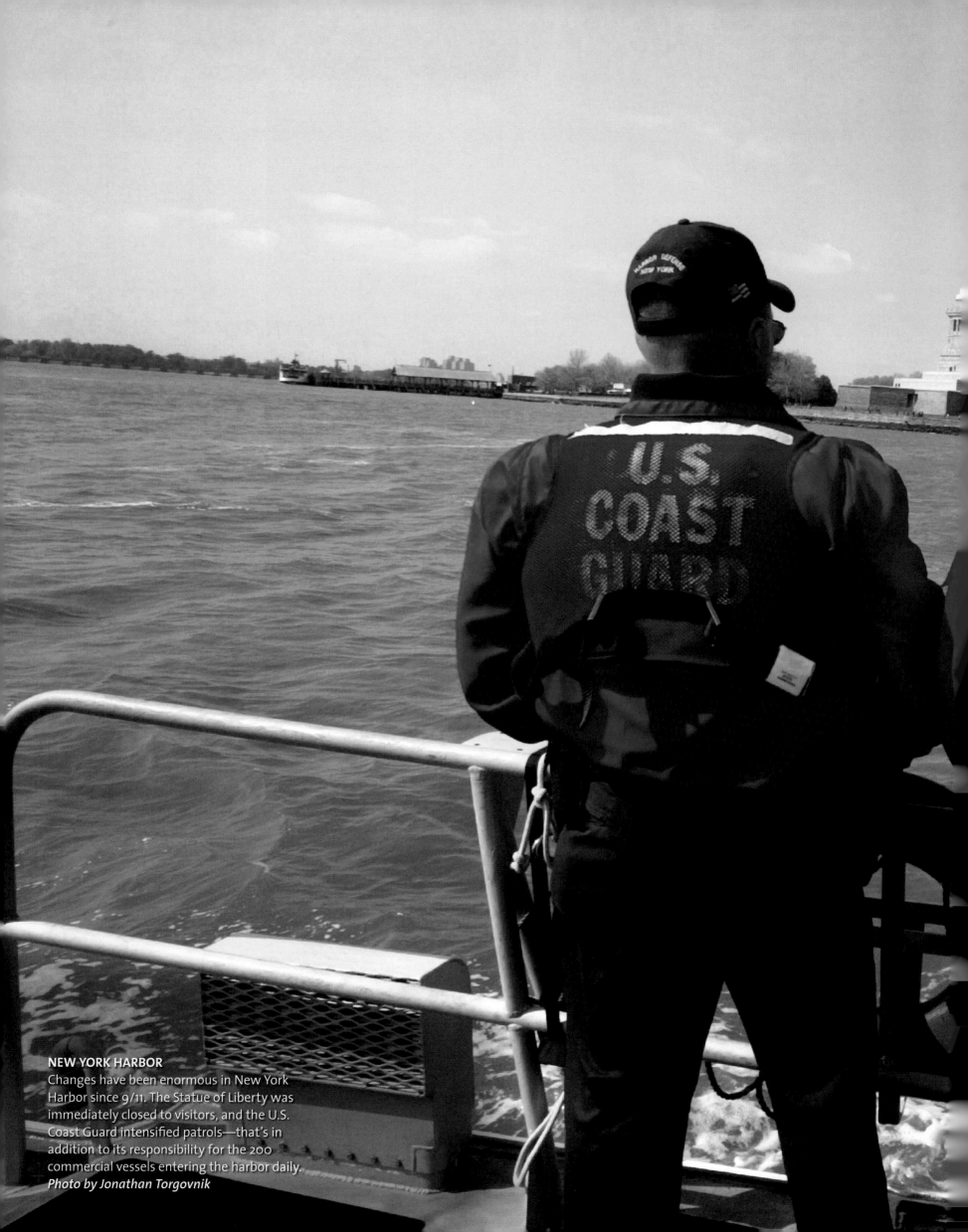

NEW YORK HARBOR
Changes have been enormous in New York Harbor since 9/11. The Statue of Liberty was immediately closed to visitors, and the U.S. Coast Guard intensified patrols—that's in addition to its responsibility for the 200 commercial vessels entering the harbor daily.
Photo by Jonathan Torgovnik

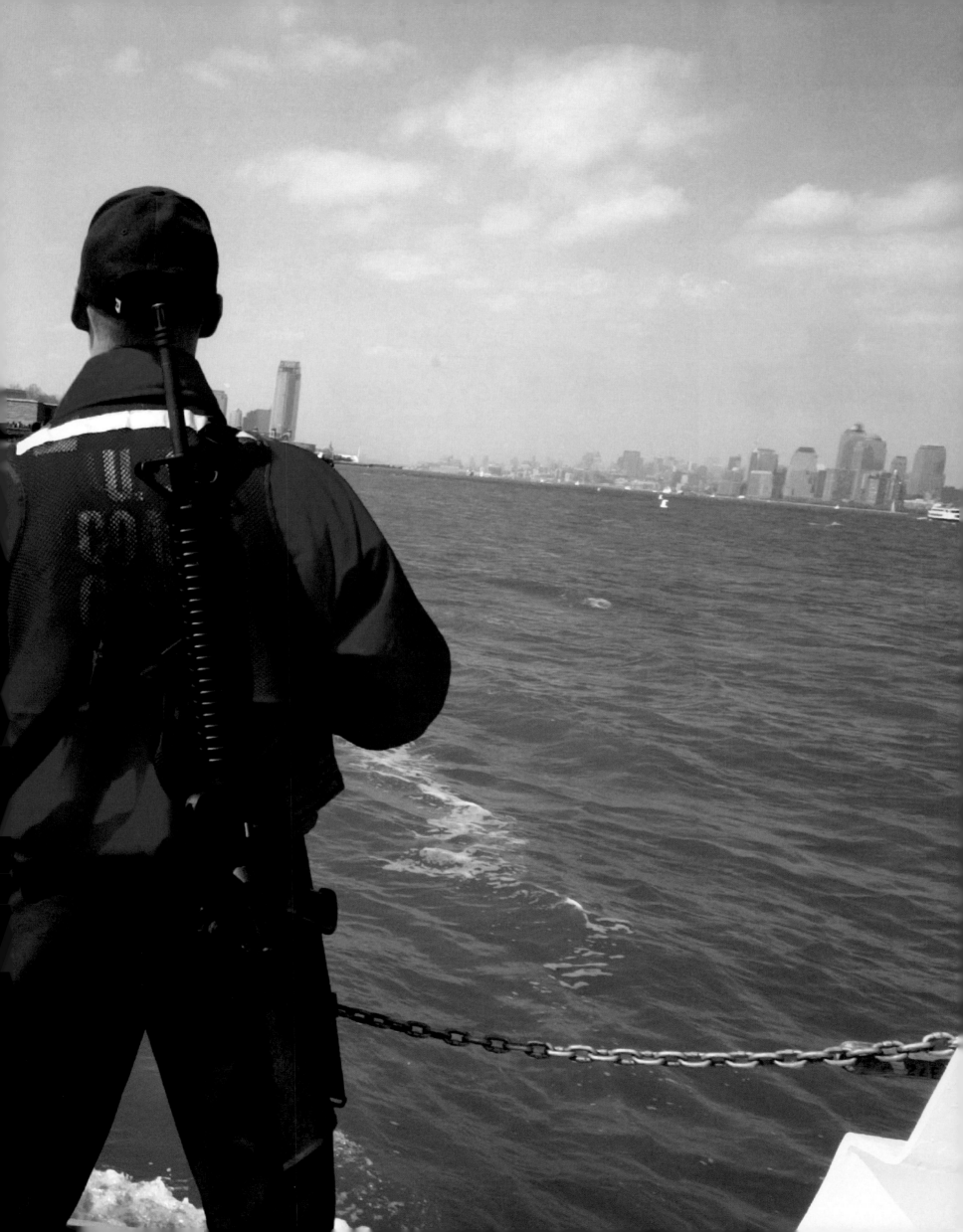

MANHATTAN
Merily Jurna works the camera during a *For Him Magazine* photo shoot. She was discovered by a London-based agency after she won the Top Model beauty contest in Estonia at the age of 15. Her career has allowed her to travel throughout Europe and America. "Most Estonians can't even get visas," says Jurna, "but I've been able to see the world."
Photos by Alicia Hansen

BROOKLYN
Rollin' on the River: Shye Jones, Lynda Daisley, and model Merily Jurna skate over the East River to Manhattan on the 1.13-mile Brooklyn Bridge. After wheeling around the city for an hour, the physique-conscious trio burned 316 calories— enough to warrant a Caesar salad dinner at the Bridge Cafe on Water Street.

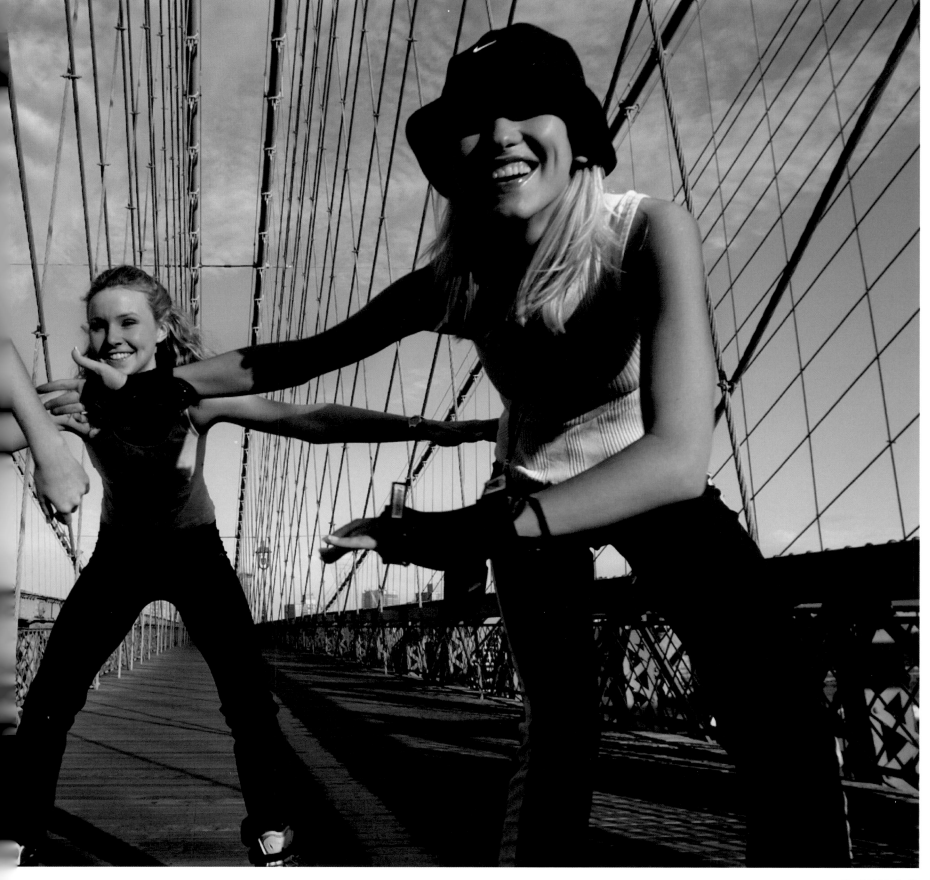

MANHATTAN

Grand Central Station, now restored in all its
Beaux Arts grandeur, remains one of the most
glorious coming-and-going and meeting places
in the country. New Yorkers treasure it even more
after almost losing it to a planned demolition in
the late 1960s—shortly after its crosstown coun-
terpart, Penn Station, was razed. Among the
picketers who saved Grand Central was
Jacqueline Kennedy Onassis.
Photo by Zack Leven

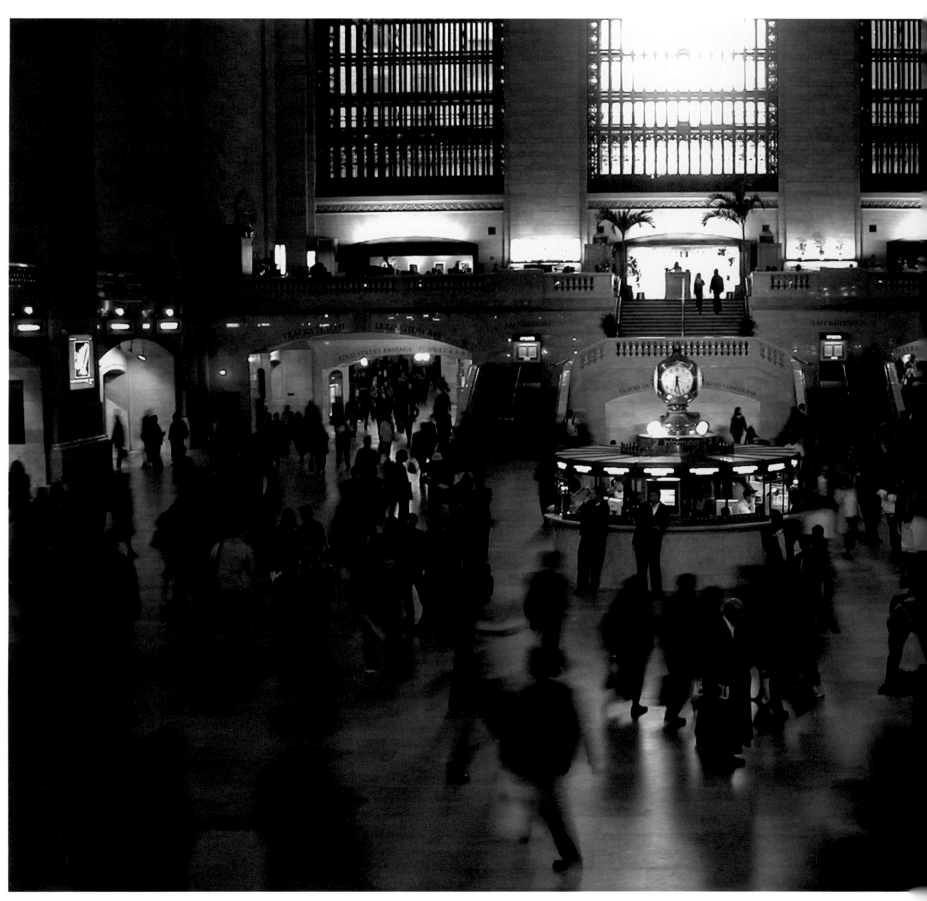

MANHATTAN

In a converted dairy on West 57th Street, Dan Rather anchors the daily broadcast of the *CBS Evening News*—as he has since March 9, 1981, when he took over from Walter Cronkite.

Photo by Josh Gelman

MANHATTAN

Media madness: Choices abound for a customer at a newsstand on 42nd Street between Fifth and Sixth avenues.

Photo by Gus Powell

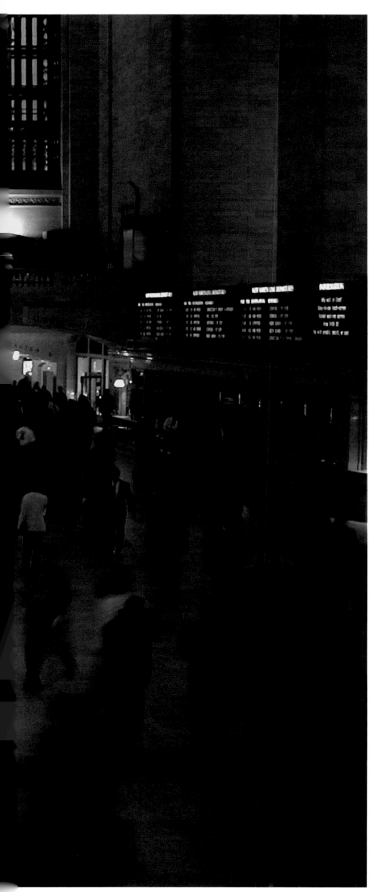

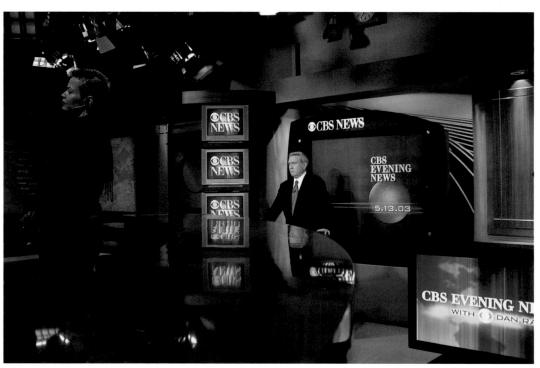

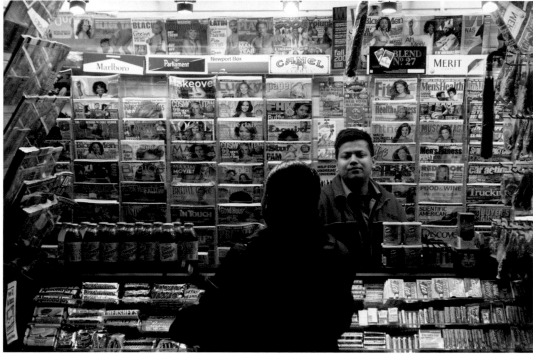

SANBORN
In a routine that harkens back to an earlier, gentler pace, Tom Hoover delivers freshly bottled milk on his Friday morning route. The Hoover Dairy, a family-owned business, has been in operation since 1920.
Photo by Michael Groll

ROCHESTER

Volunteer assistant bander Kelly Dockery of the Braddock Bay Bird Observatory releases a captured bird back into the wild. Since 1985, the nonprofit ornithological research and conservation center has been tracking the numbers and types of birds that pass through Braddock Bay on Lake Ontario. During spring and fall migrations, 130 species of songbirds stop to refuel.

Photos by Avital Greener

For four years, avid birder Patricia O'Kane has taken a two-week vacation to volunteer at the Braddock Bay Bird Observatory. From 5:30 a.m. to 2:30 p.m. each day, O'Kane removes birds such as thrushes, kingbirds, and sharpshin hawks from nets set up over their feeding spots. She then records their species, gender, and age, and releases them.

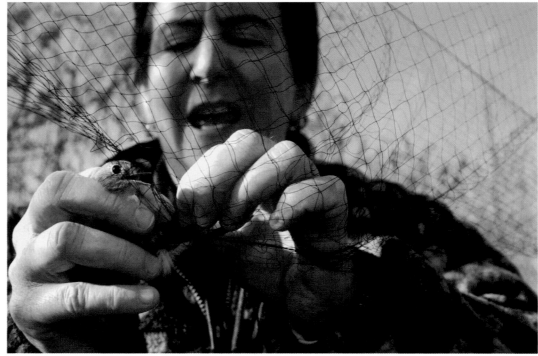

MANHATTAN
Walking up to 10 dogs at a time requires strength, according to professional dog walker Stuart Parsons, shown here with seven charges passing the Dakota Apartments on the Upper West Side. "If they take off after a squirrel, you're going for a ride."
Photo by Martha Cooper

MANHATTAN
Animal nannies: Dog walkers earn around $75 an hour for group walks, $25 for solos. The city dogs, accustomed to leashes and sidewalks, and pleased as punch to be outside, generally get along with each other.
Photo by Jill Enfield

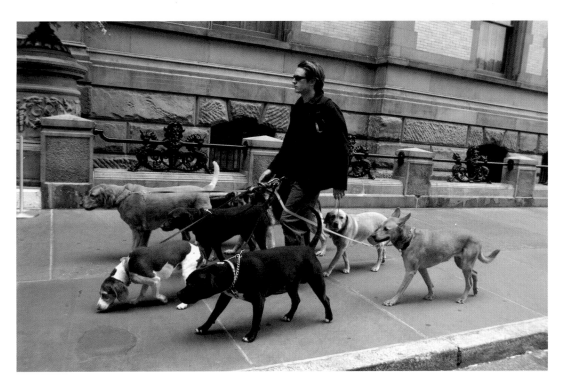

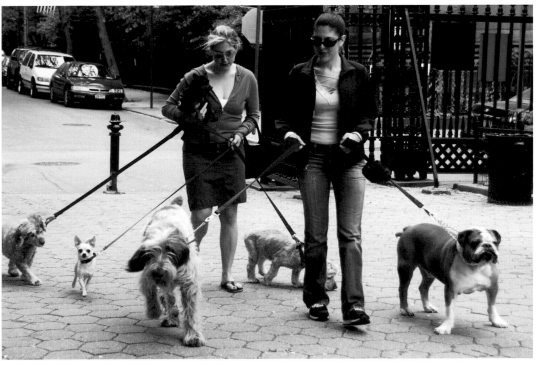

ROCHESTER

Magnus handily nabs a ball tossed by Emily Miller, owner of Dogs at Play Daycare. The 11-year-old rottweiler is king of the kennel, in part because of his imposing size but mostly because he's the owner's pet.

Photo by Carlos Ortiz, Democrat and Chronicle

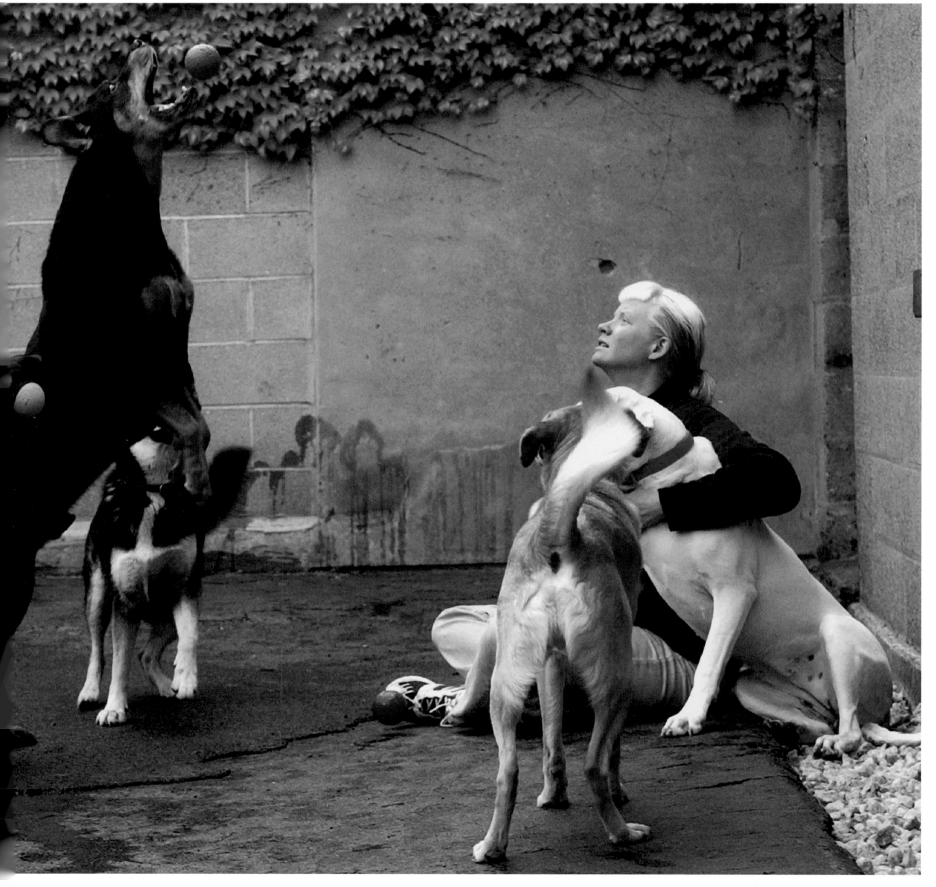

BRONX
At the La Casa Grande Tobacco Company in the Bronx's own Little Italy, Francisco Rosario rolls an LCG Reserve Cigar. In addition to the retail business, La Casa Grande hires out its tobacconists to hand-roll fresh cigars at weddings and special events. One of the year's highlights was a party for the cast of *The Sopranos*.
Photo by David Burnett, Contact Press Images

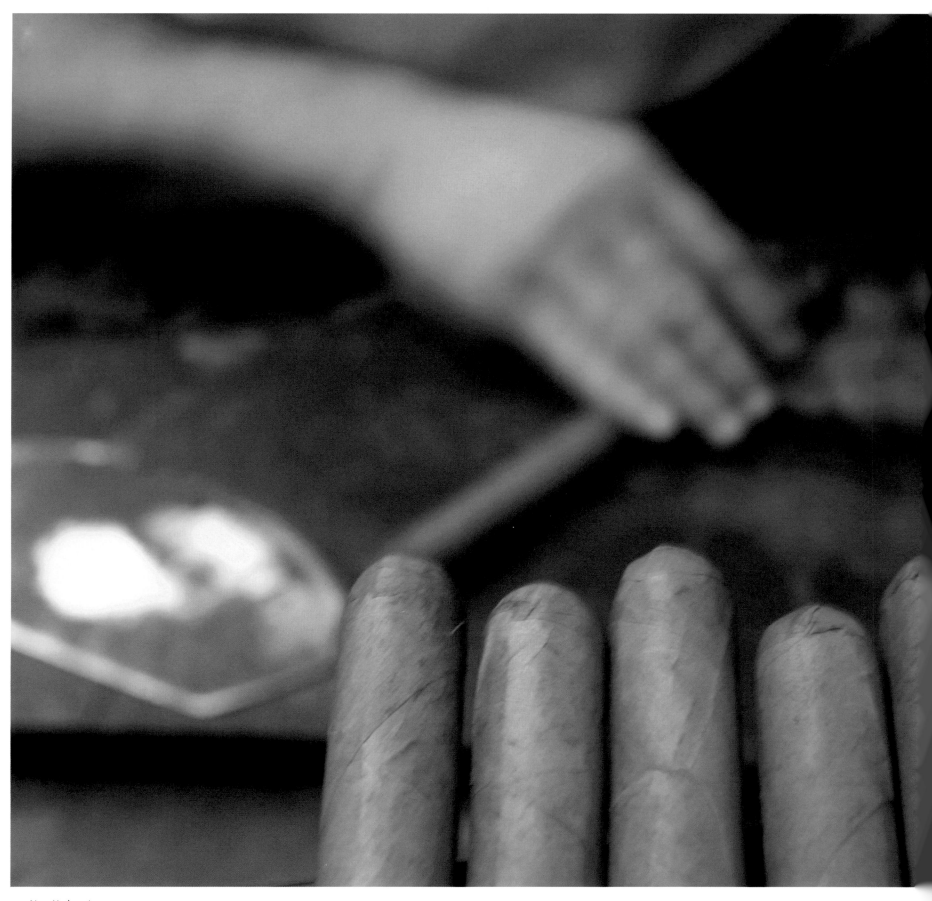

At the National Baseball Hall of Fame and Museum, assistant registrar Mary Bellew removes a protective sanitary sock from the bat that Texas Ranger Rafael Palmiero used to hit his 500th home run on May 3, 2003. She's placing it in a case used for special presentations, as she always does when artifacts are received. The museum has more than 1,700 bats in its collection.
Photo by Shepard Sherbell, Corbis SABA

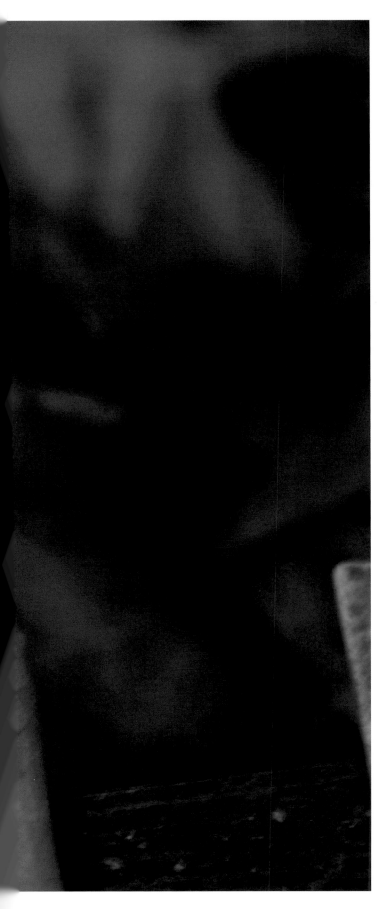

BUFFALO

A worker casts 15 tons of molten copper alloy at Outokumpu American Brass—one of the Finland-based company's largest factories in the United States. The alloy is cooled and cut up into sheets for use by various telecommunications and auto-motive customers.
Photo by Michael Groll

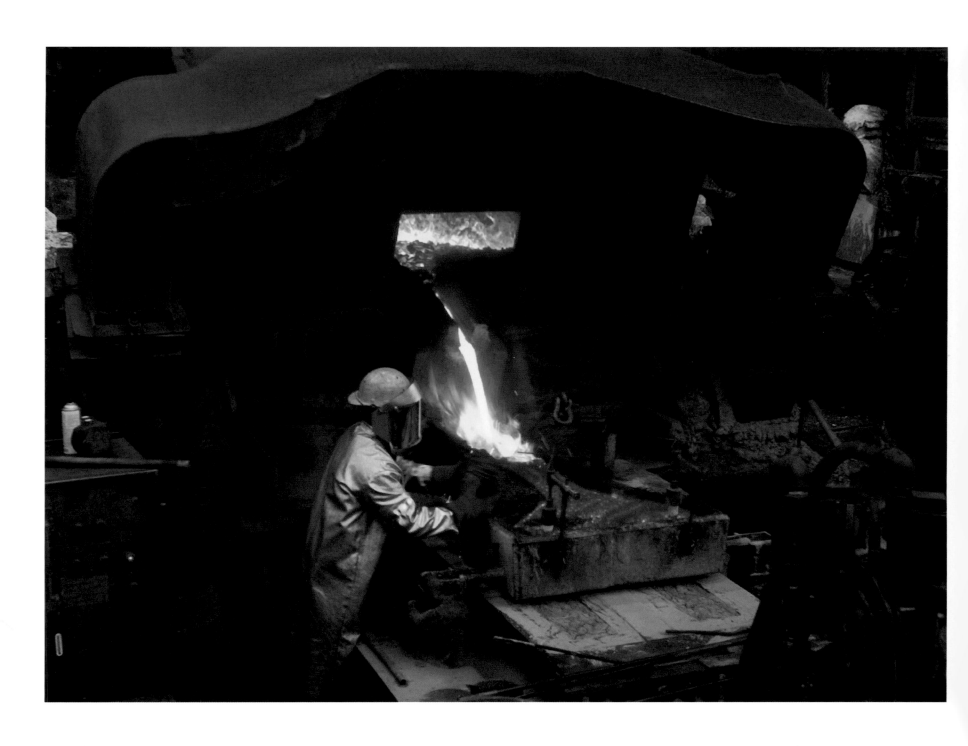

GREENPORT

"Glass blowing is like a team sport," says Sven Hokanson, an apprentice at Boar Glass. Hokanson works with his brother, Bengt, a glass master, at the end of the creation process, when the glass is removed from the punty and put into an annealer. There, the 2,000-degree glass will be cooled to room temperature at a constant rate to prevent cracking.

Photo by Douglas Kirkland

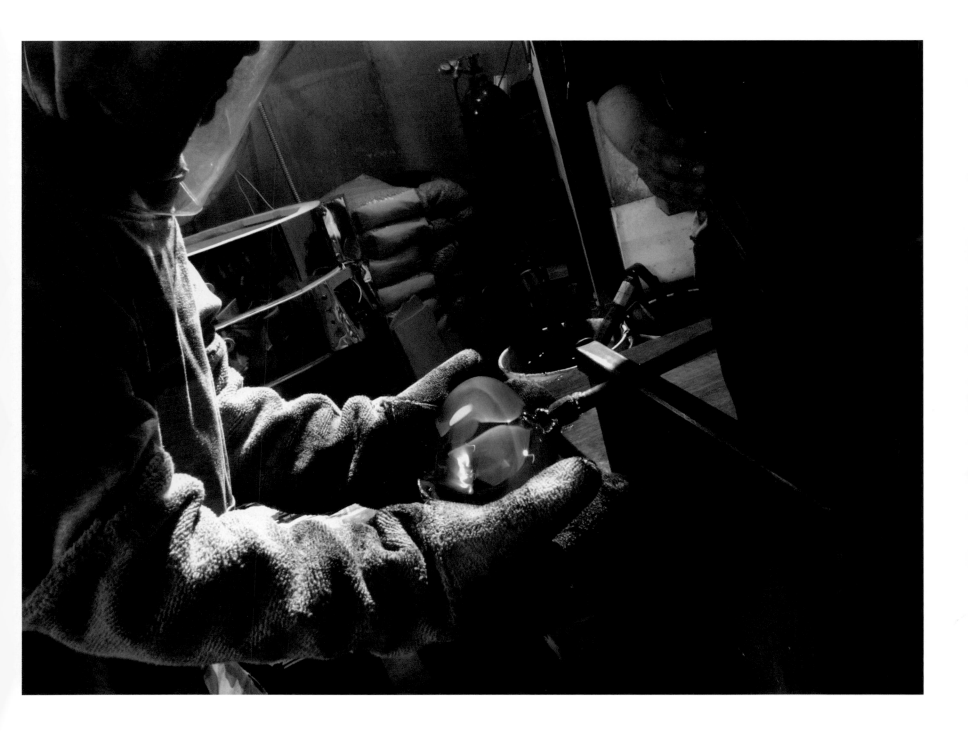

LANSING

For 40 years, caretaker Arthur Leonard has lived and worked at the North Lansing Cemetery, where several Revolutionary War veterans are buried. Until 2001, when the years started catching up with him, Leonard dug the cemetery's new graves.

Photo by Kevin Rivoli

MANHATTAN

Head gardener Eric Pauze is proud of his seventh-floor gardens at Rockefeller Center. Under his care, his lawn was named one of the 10 best in America by lawn mower manufacturer Briggs & Stratton. The gardens are designated state land-marks and cannot be changed, so every year Pauze and staff must plant pink geraniums and painstakingly measure and trim the hedges to their proper height.

Photo by Philip Greenberg

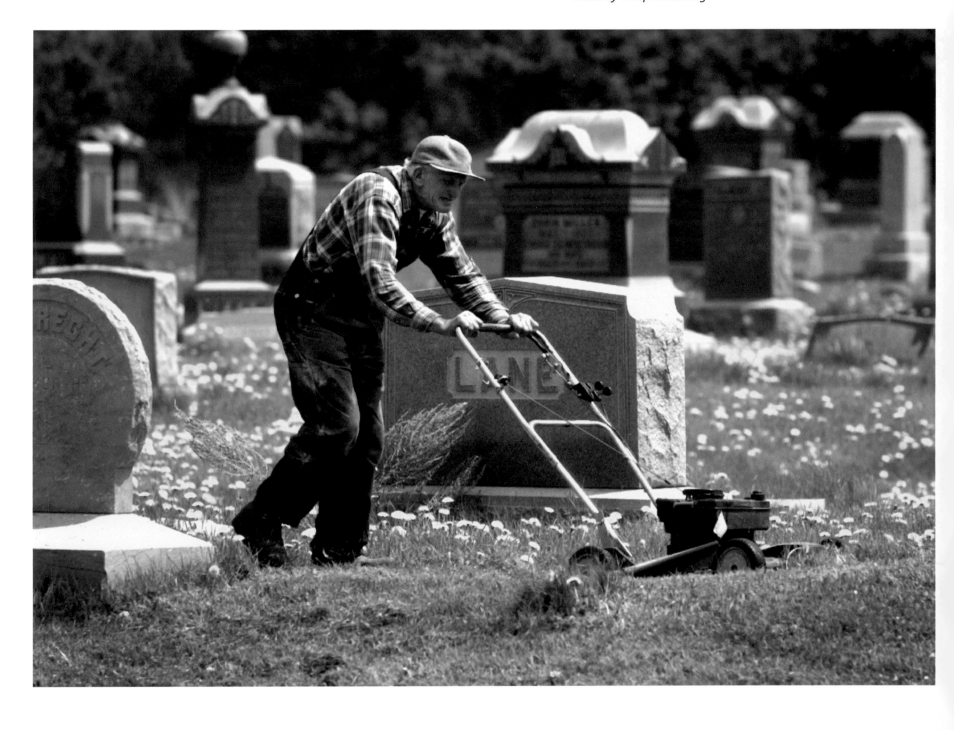

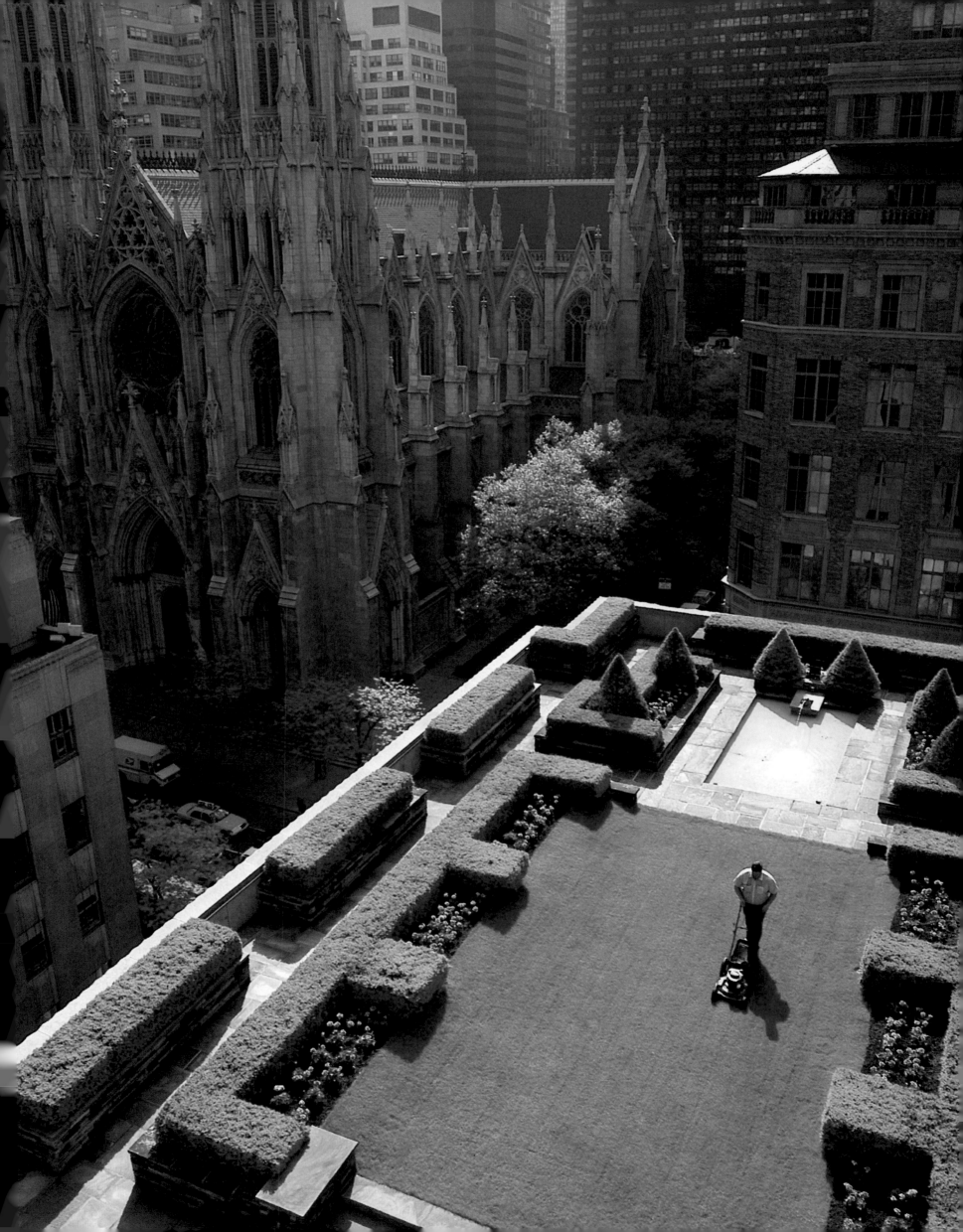

NEW SQUARE

To wear a yarmulke is to signal humility and acknowledge that God is above. In some Hasidic groups, everyone wears the exact same style, usually manufactured by one or more yarmulke makers within their group. Simon Fromowitz is one of those responsible for creating head coverings for the New Square Hasidic sect.

Photo by Mark Greenberg, WorldPictureNews

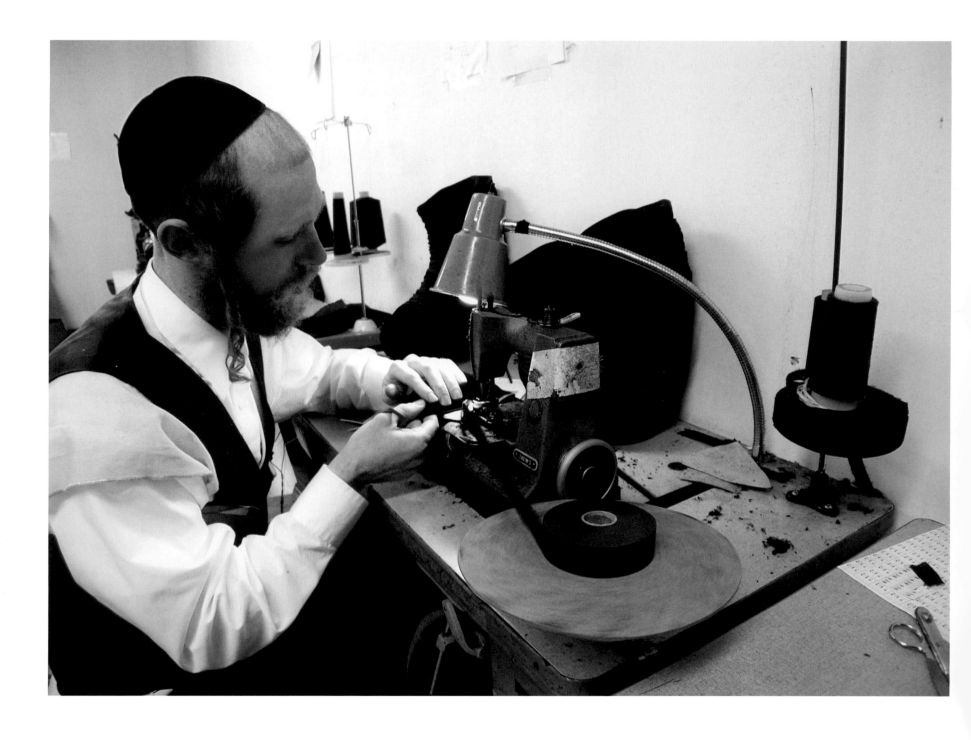

FRANKLIN SQUARE

For 37 years at Luigi's Shoe Repair on Nassau Boulevard, Luigi Piscitelli has been making old shoes walk like new.

Photo by Frank Koester

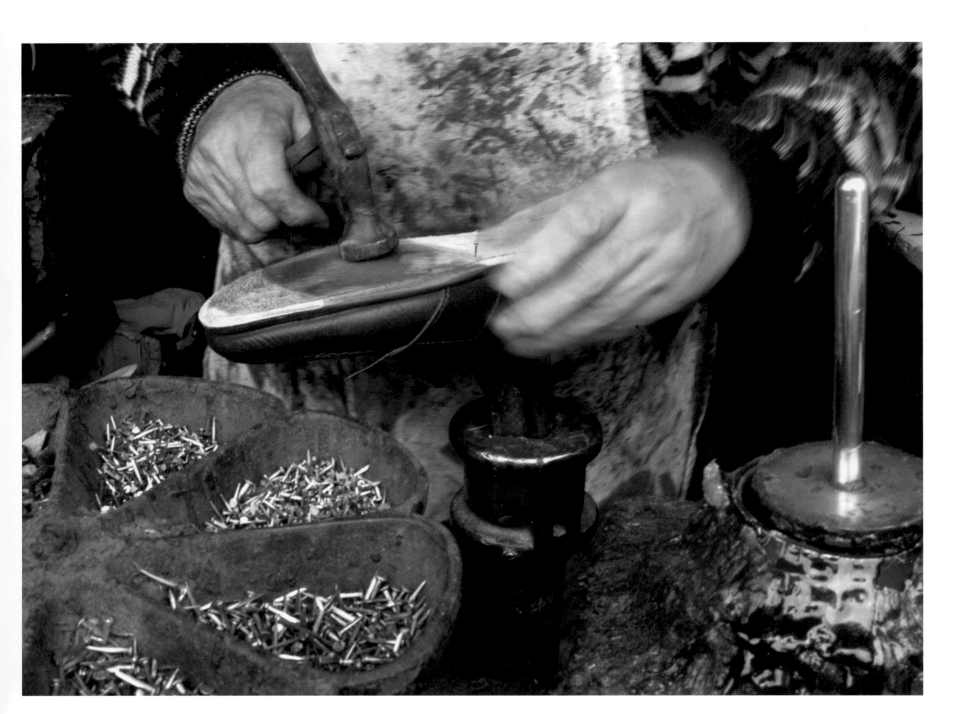

CORNING

At the daily Flameworking Live! demonstration at the Corning Museum of Glass, Li Zhang and her daughter Jeanne Wu watch entranced as John Hargrave torches and transforms borosilicate glass tubes into penguins and elephants and pigs. Hargrave, a resident artist at the museum, began his flamethrowing career in 1983 as a crafter of scientific instruments.

Photo by Susan Stava

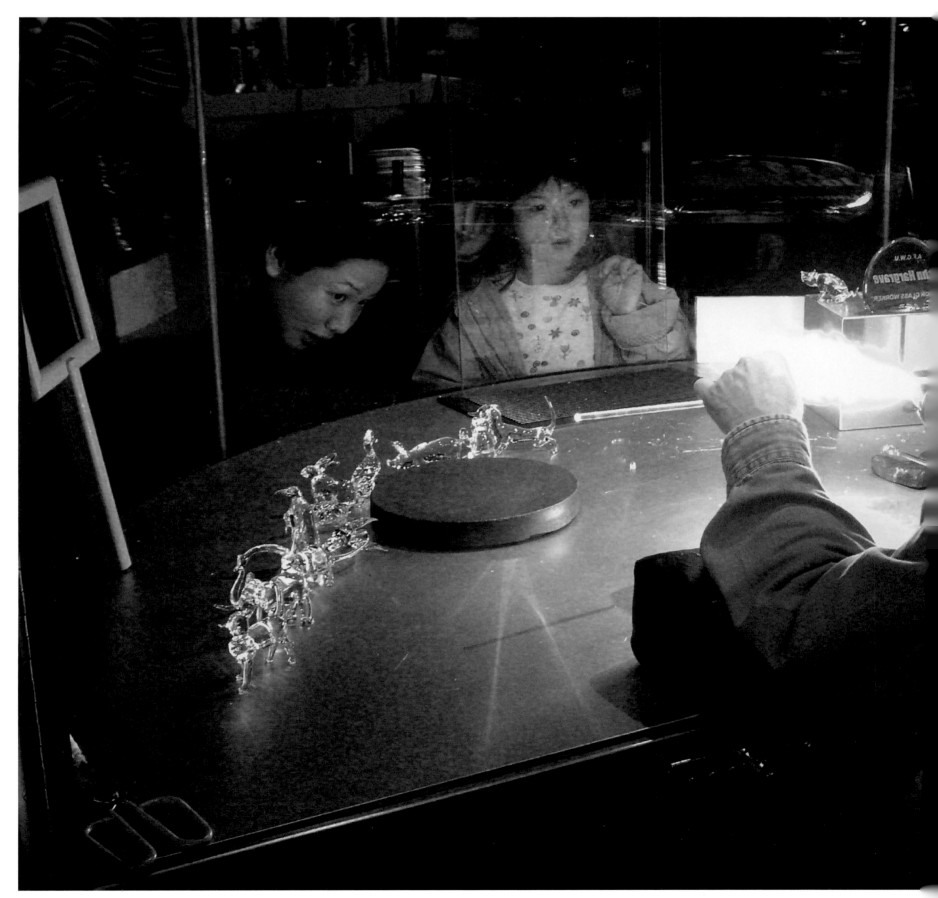

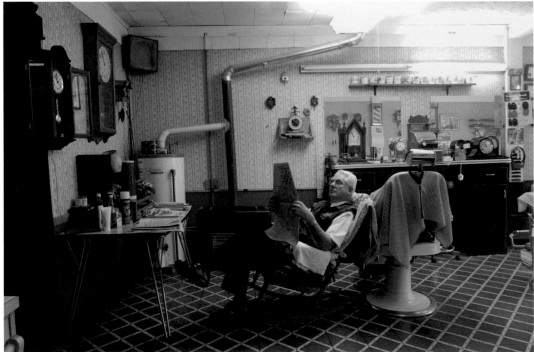

EAST AURORA
On a rainy morning, Bob Grover of Grovers Barber Shop catches up on the news while waiting for customers.
Photo by Michael Groll

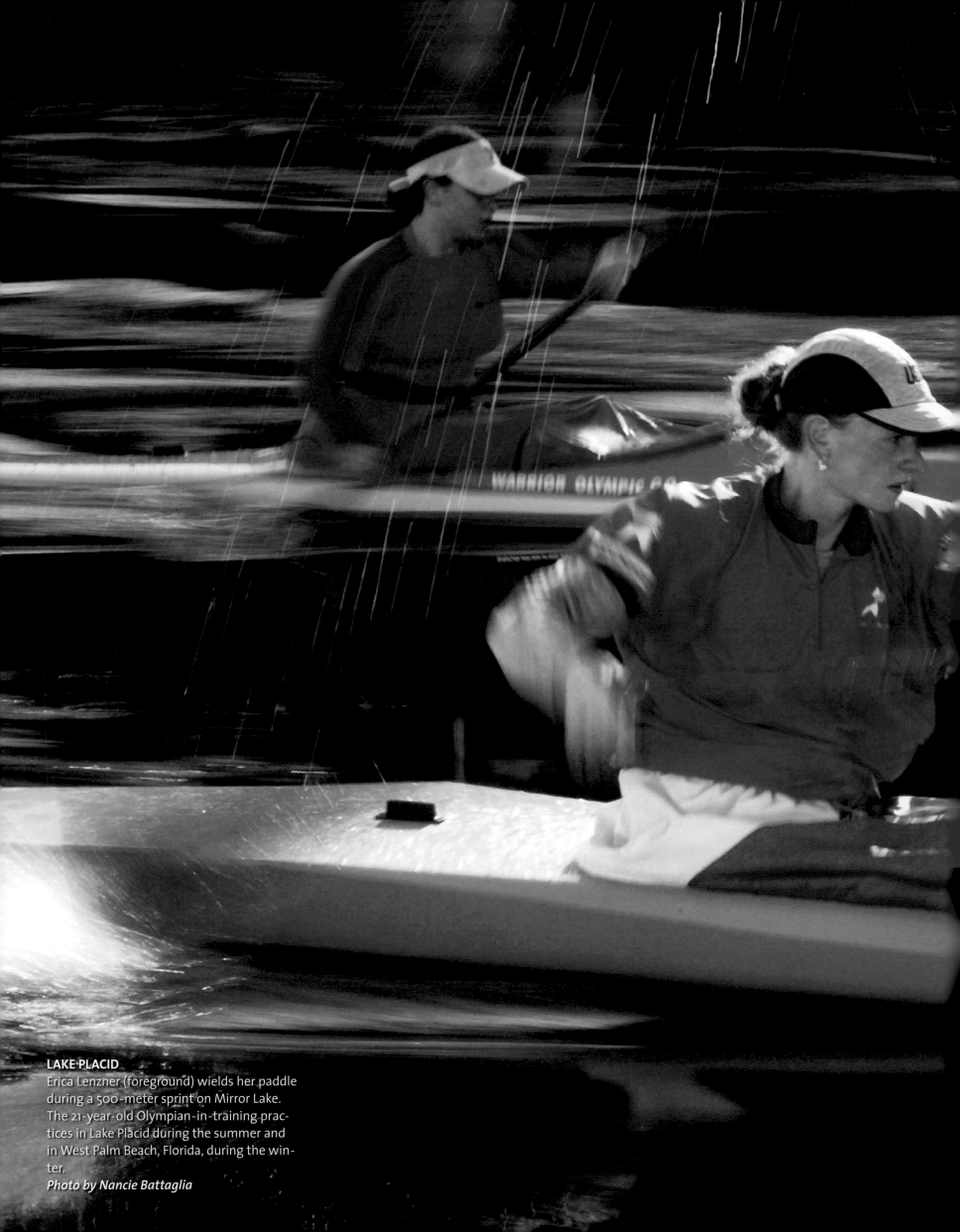

LAKE PLACID
Erica Lenzner (foreground) wields her paddle
during a 500-meter sprint on Mirror Lake.
The 21-year-old Olympian-in-training prac-
tices in Lake Placid during the summer and
in West Palm Beach, Florida, during the win-
ter.
Photo by Nancie Battaglia

New York At Play

WILMINGTON

Champion angler Mckenzie Ward, 3, waits for her prize brown trout to be weighed at the Stevens Lake Kids Fishing Derby. This 18-inch beauty nabbed Mckenzie first place and a new fishing pole.

Photos by Nancie Battaglia

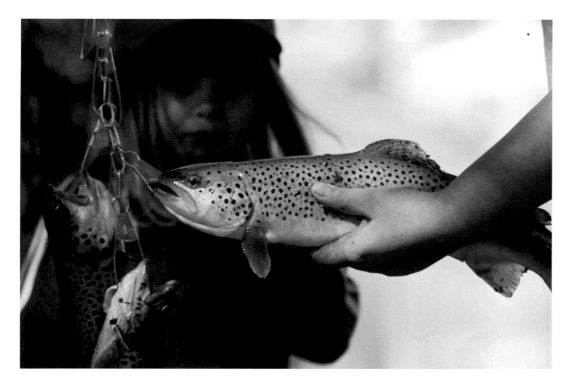

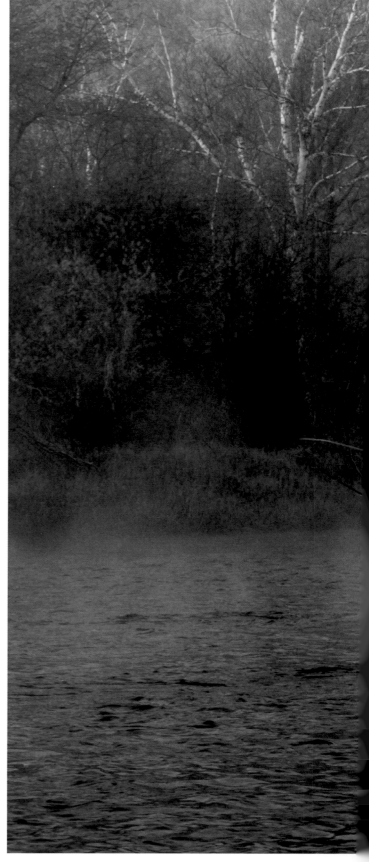

WILMINGTON

The morning air is slightly cooler than the Ausable River, causing a thin fog to form on its surface. Fly-fishing guide Rachel Finn casts for brown trout until the mist burns off, four hours later.

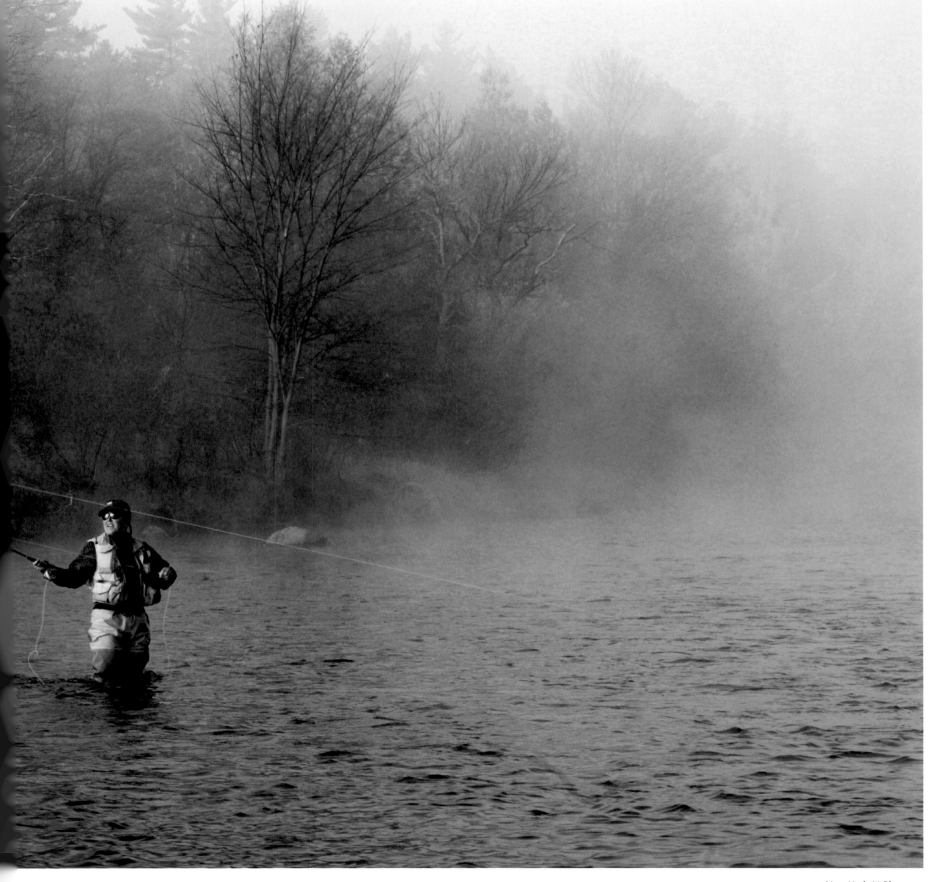

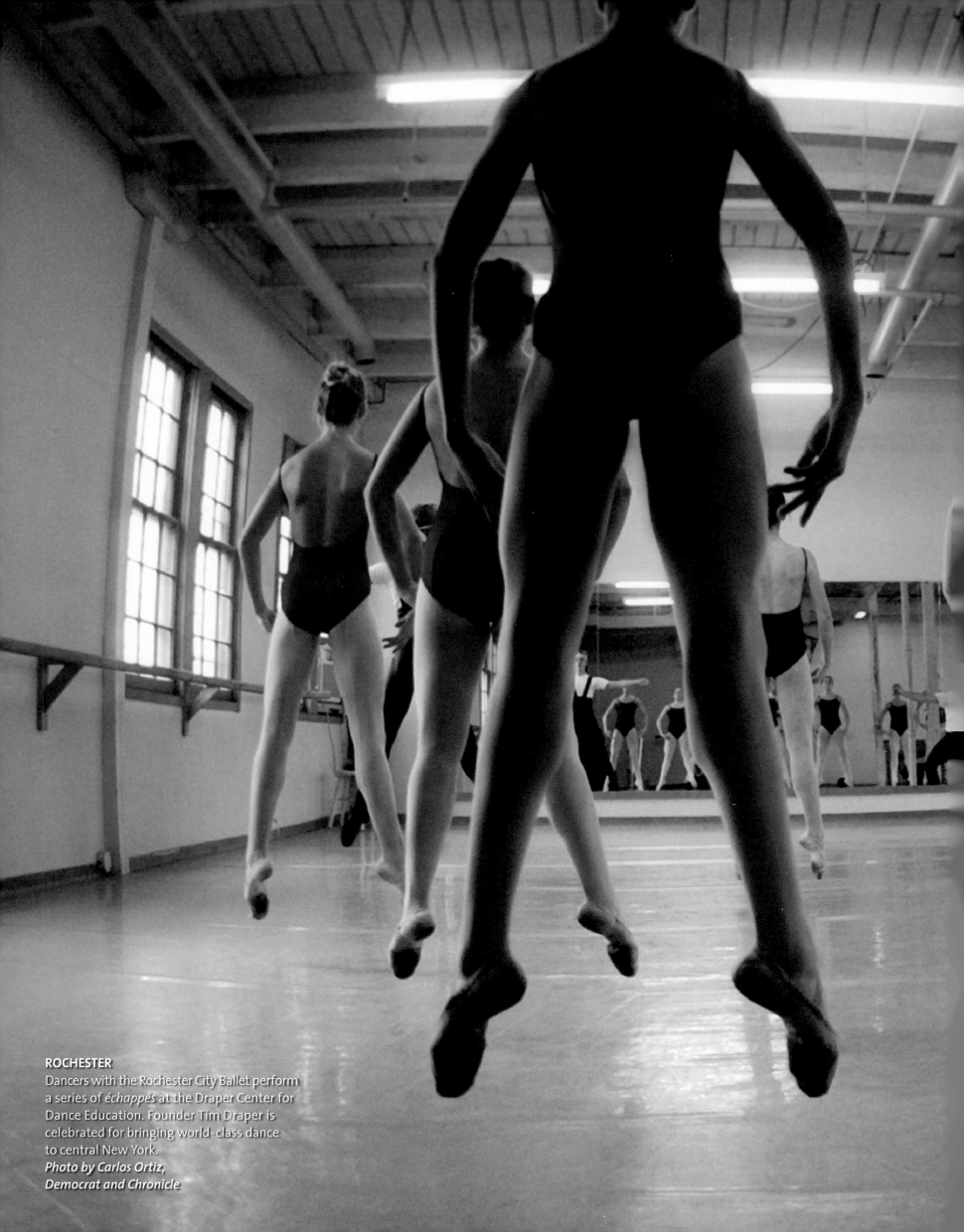

ROCHESTER
Dancers with the Rochester City Ballet perform a series of *échappés* at the Draper Center for Dance Education. Founder Tim Draper is celebrated for bringing world-class dance to central New York.
Photo by Carlos Ortiz,
Democrat and Chronicle

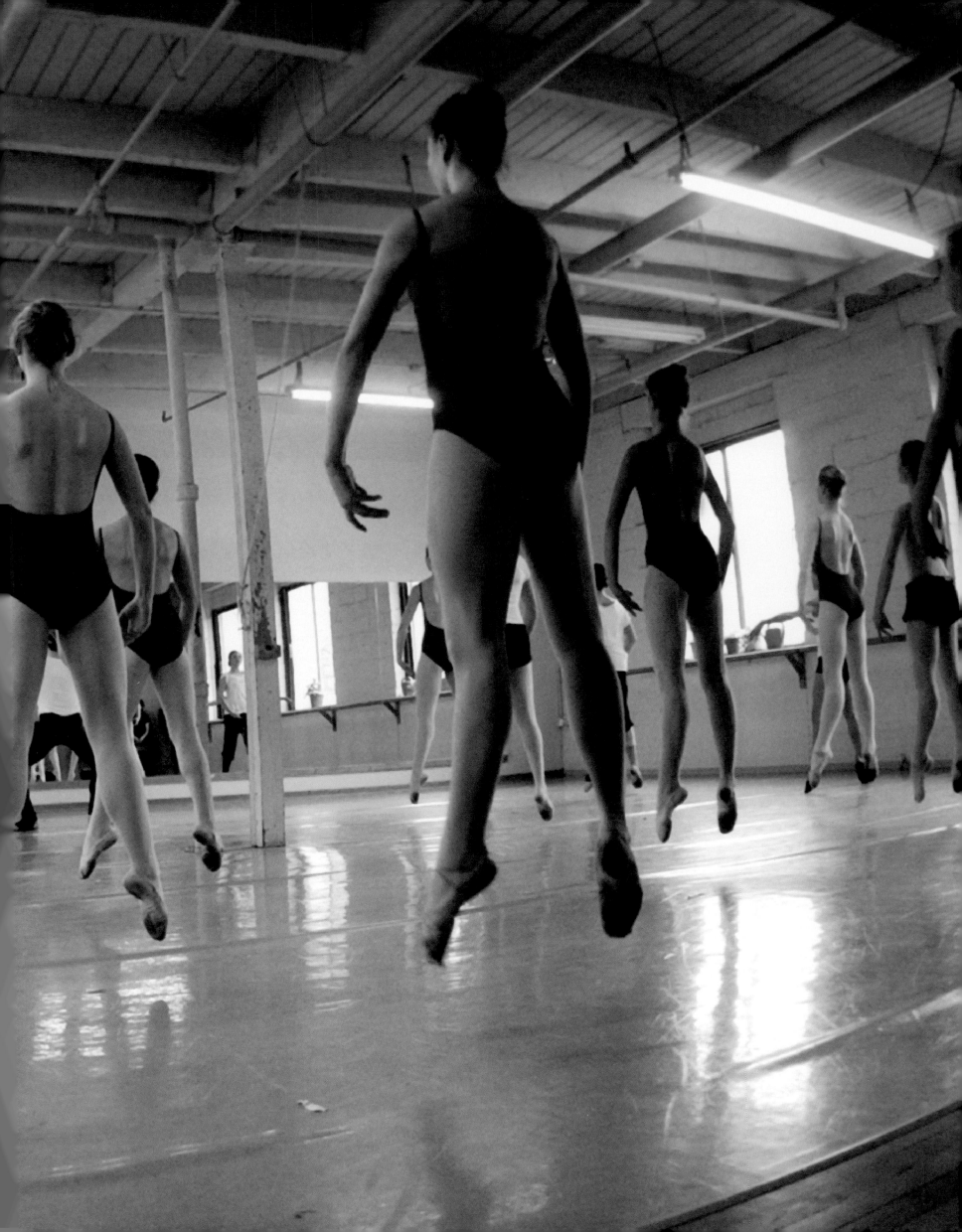

VERONA

There was no "pot o' gold" waiting for Shirley Oatman after she played this video slot machine at the Turning Stone Casino Resort. Nonetheless, the Oneida resident took home $202.
Photo by Michael J. Okoniewski

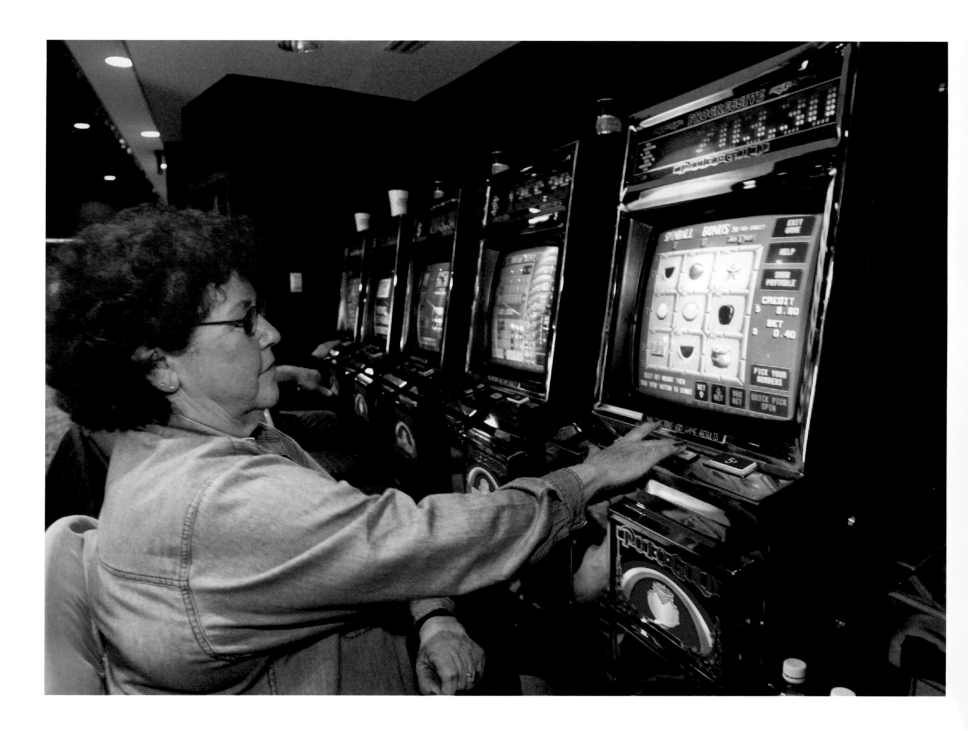

VERONA

The Turning Stone Casino Resort was the first legal Native American casino allowed in the state 10 years ago. Run by the Oneida Indian Nation, the resort attracts 4.5 million visitors a year. All proceeds are used to provide housing, health care, education programs, and other services to the Nation's approximately 1,000 members.

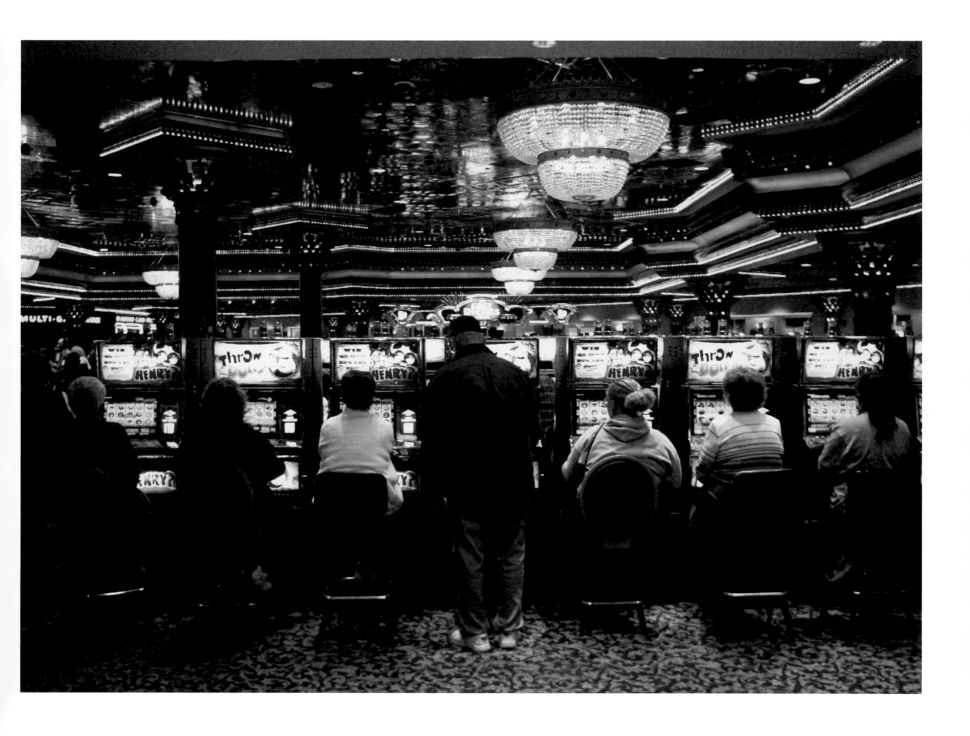

AURELIUS
Fish-eye's view: In their front row seats at a Finger Lakes Drive-In showing of *Finding Nemo*, Jeremy Chetney and Becky Grader relish a rare moment of rest. The couple works four jobs between them to save money for their first baby, due in 2004.
Photo by Kevin Rivoli

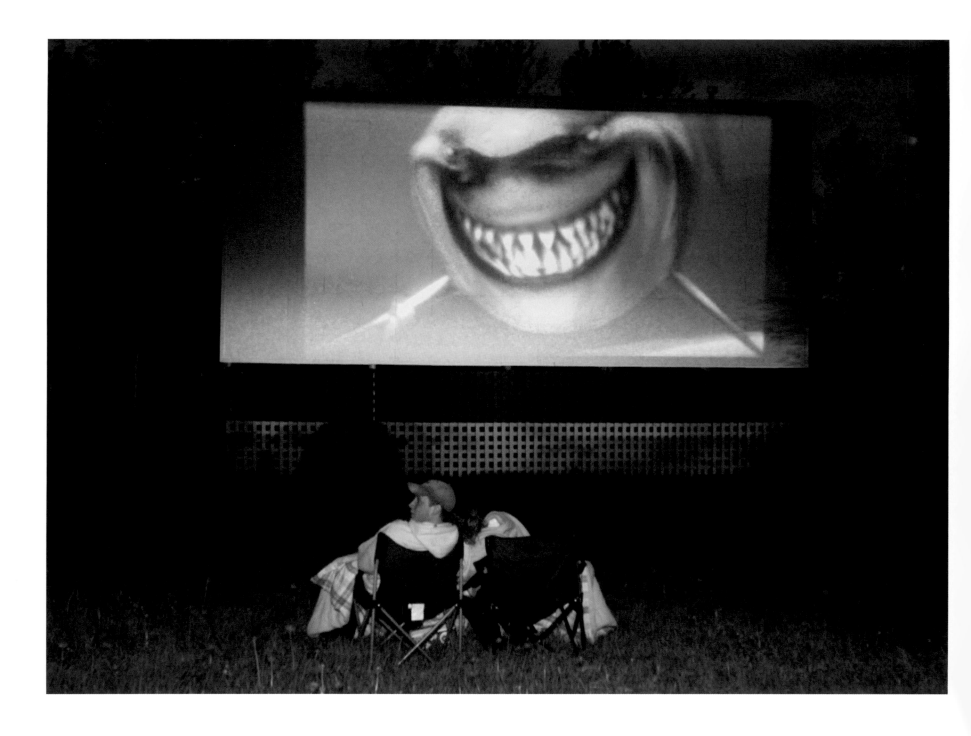

BROOKLYN

At the annual Red Hook Earth and Surf Parade, this canoe on wheels, supplied by the Gowanus Dredgers Canoe Club, serves as a float for neighborhood kids. The club is dedicated to cleaning up the infamous Gowanus Canal, one of the most polluted waterways in the U.S.

Photo by Andrew Lichtenstein

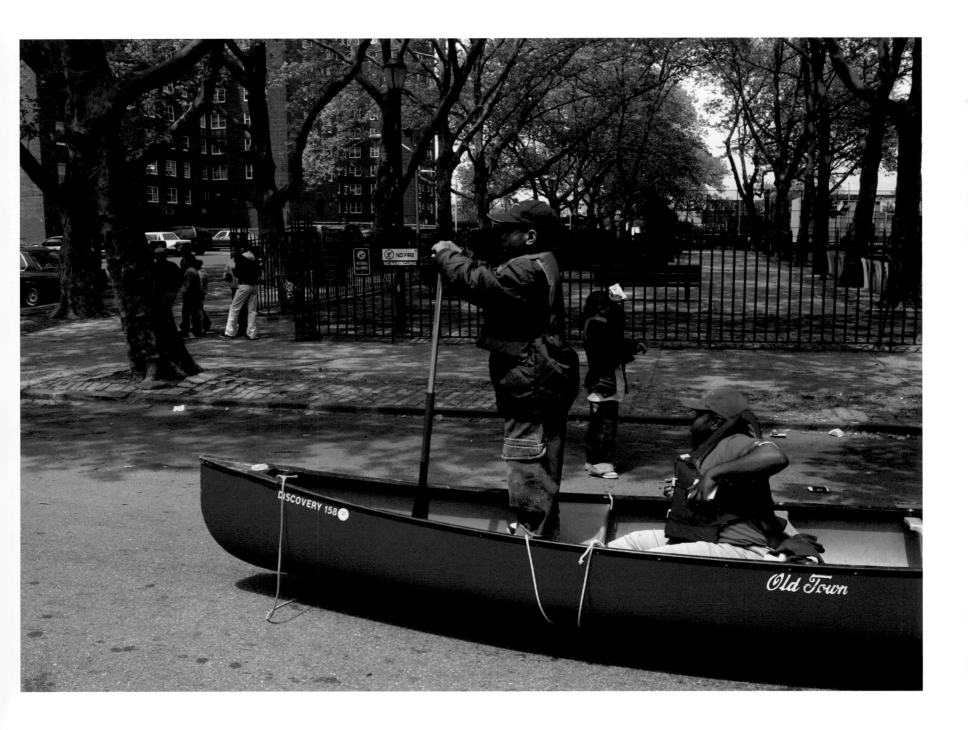

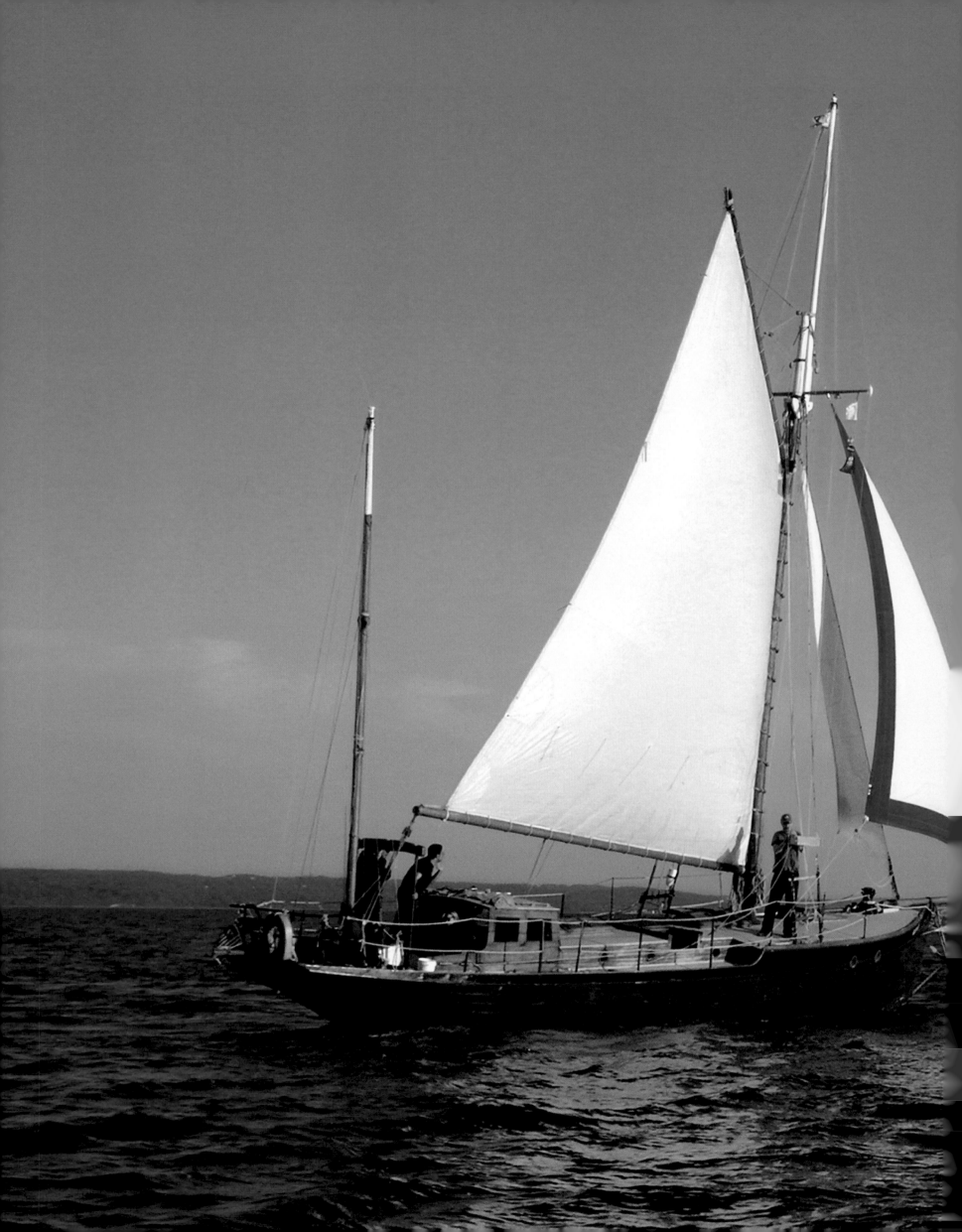

CROTON-ON-HUDSON
Taking advantage of a light morning breeze, a classic, gaff-rigged yawl tacks upstream off Croton Point on the Hudson River. In the 1970s, the ongoing cleanup of the Hudson's riverbed began at Croton Point, after more than two decades of PCB contamination from General Electric's Ft. Edward plant, 150 miles upriver.
Photo by Peter Freed

MONTAUK
A shortboarder works his way through the impact zone to the lineup in search of a ride on one of Montauk's famous rights.
Photo by Gordon M. Grant

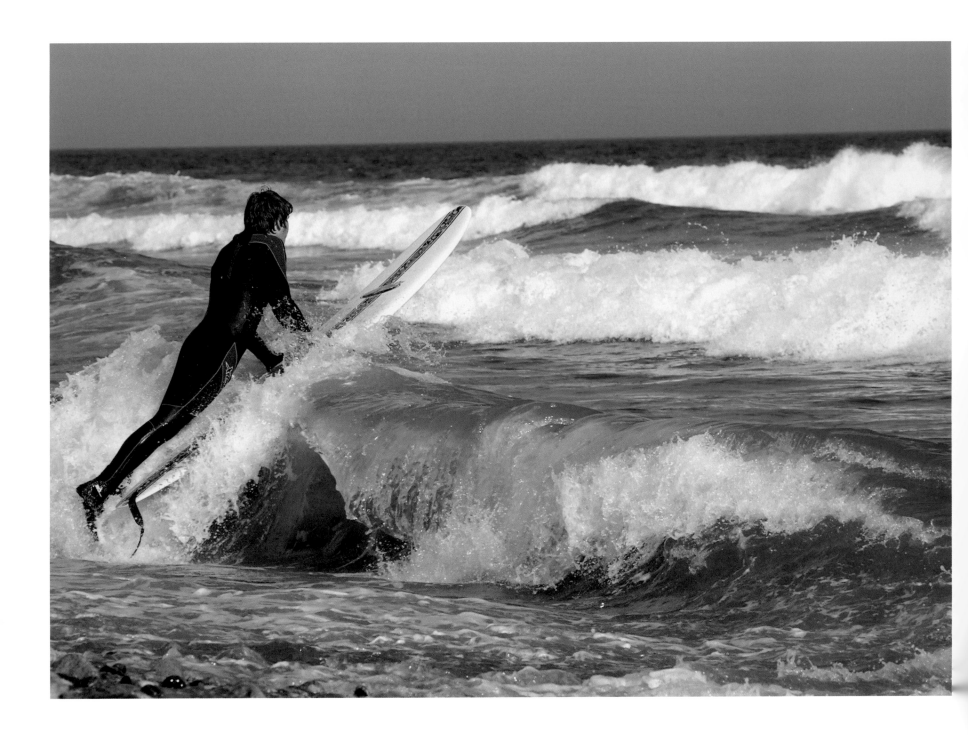

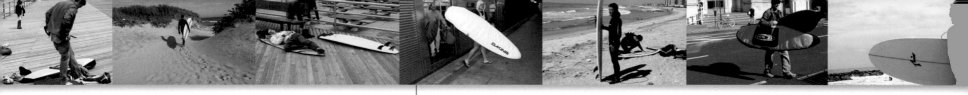

QUEENS

Subway surfing. Two hours on the A-train and a short walk to the edge of Queens bring Manhattan surfers to Rockaway Beach's seasonal swell. Catching a wave is easy compared to convincing subway riders to move over for an 8-foot board.
Photo by Elizabeth Gilbert

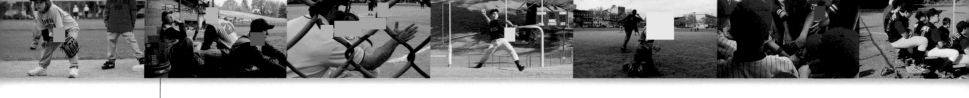

COOPERSTOWN

Cooperstown High splits a doubleheader with
Westmoreland High at Doubleday Field. The field
is named for Abner Doubleday who, it was thought,
devised the national pastime in Cooperstown in
1839. The myth—Doubleday wasn't in Cooperstown
that year and never referenced baseball in his
diaries—lasted until 1953. On review, Congress
credited Alexander Cartwright, a New York City
bookstore owner, as the inventor of the sport.
Photo by Shepard Sherbell, Corbis SABA

ROCHESTER
Erin Beaumont and Allison Aldrich kick off the first round of high fives after the Amherst Lord Jeffs came from behind to topple the Middlebury College Panthers in the NCAA Division III Women's Lacrosse Championship.
Photo by Carlos Ortiz, Democrat and Chronicle

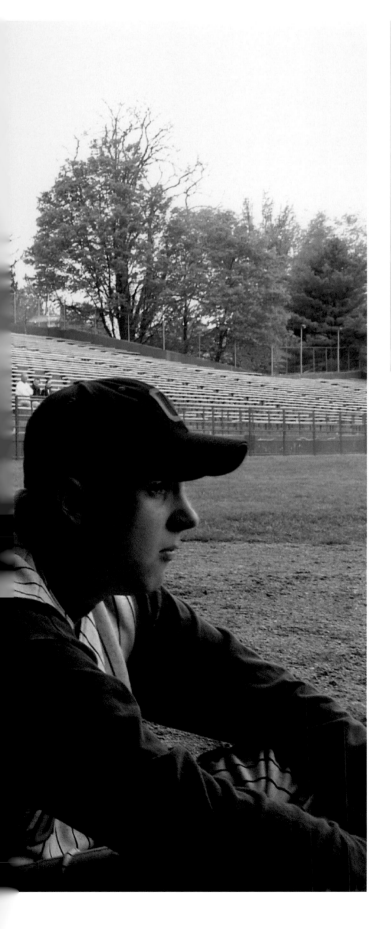

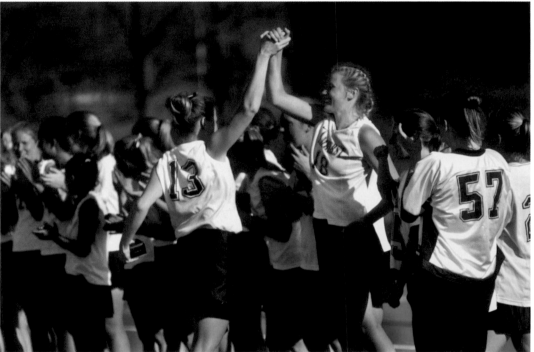

BROOKLYN
A tree grows in Brooklyn. Sort of. On the sands of Coney Island, this faux palm is part of a children's playground.
Photo by Rebecca Letz

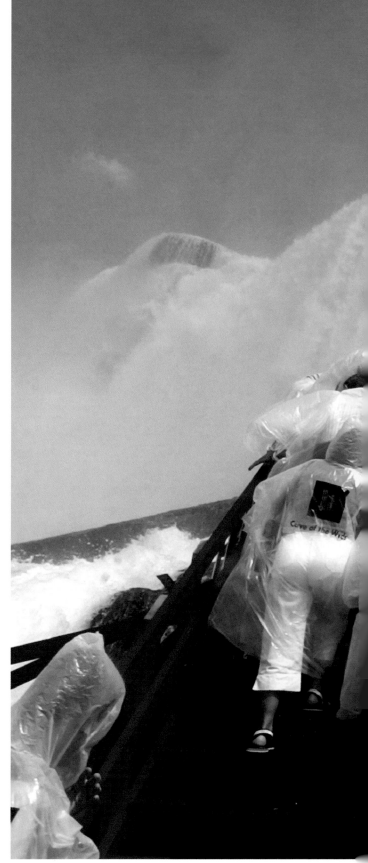

NIAGARA FALLS

That grand cataract known as Niagara Falls is more or less a mammoth interruption of the Niagara River, which funnels Lake Erie into Lake Ontario. Along the way, the rushing, plummeting river generates hydroelectric power for New York and Canada.

Photo by Michael Groll

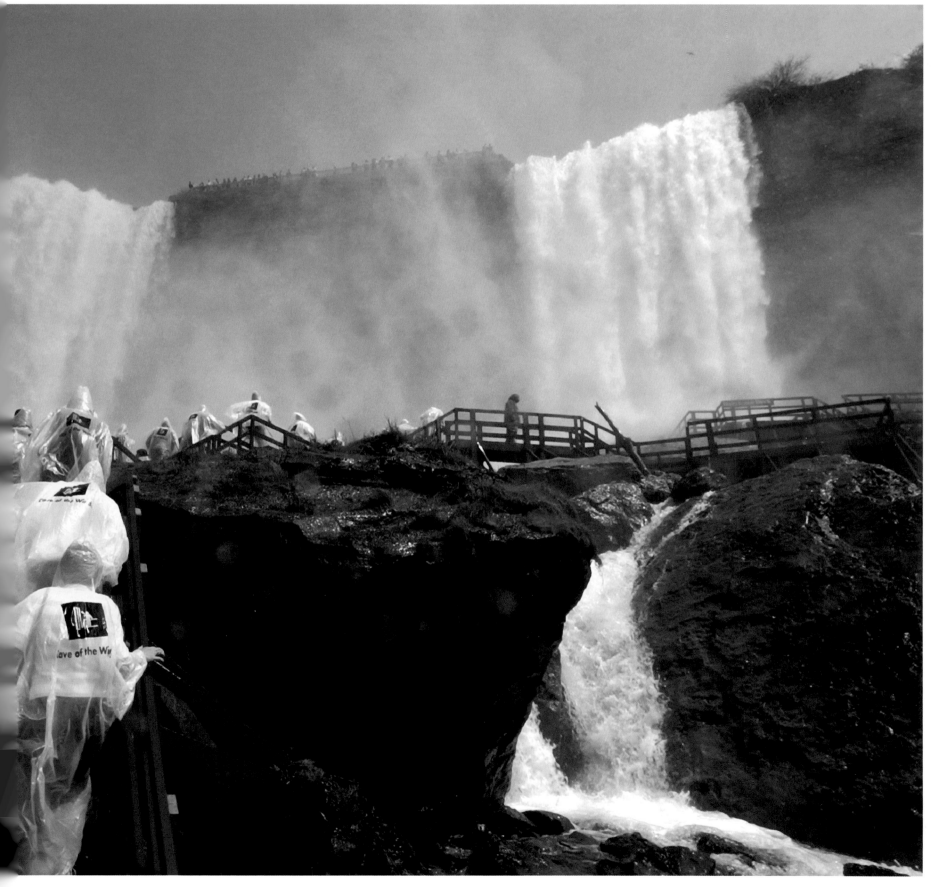

BROOKLYN

With the completion of the subway system in 1920, millions of the city's poorer citizens were able to reach Coney Island on a nickel. And they came in droves—up to a million a day—which precipitated the building of the boardwalk three years later. The original wooden structure was 80 feet wide, two miles long, and cost $3 million.

Photos by Paulo Filgueiras

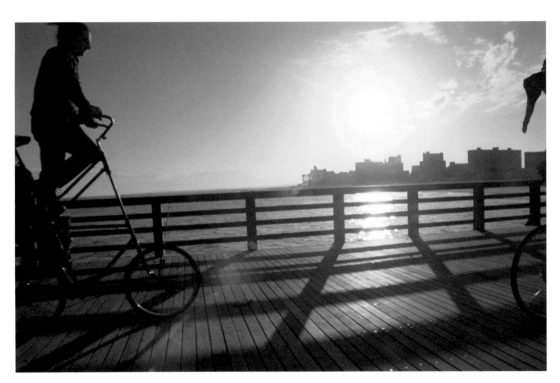

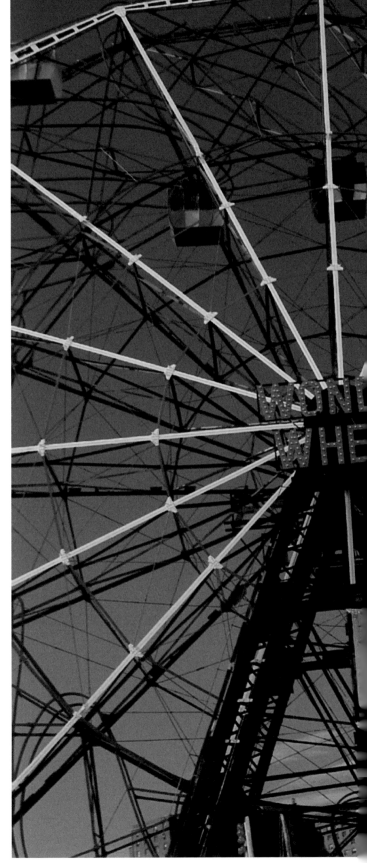

BROOKLYN

Built in 1920, Coney Island's 150-foot-high Wonder Wheel has eight stationary cars and 16 that roll along tracks within the wheel's structure. The one-of-a-kind ride, which has a diameter of 135 feet and can hold 144 people, has a perfect safety record and great views.

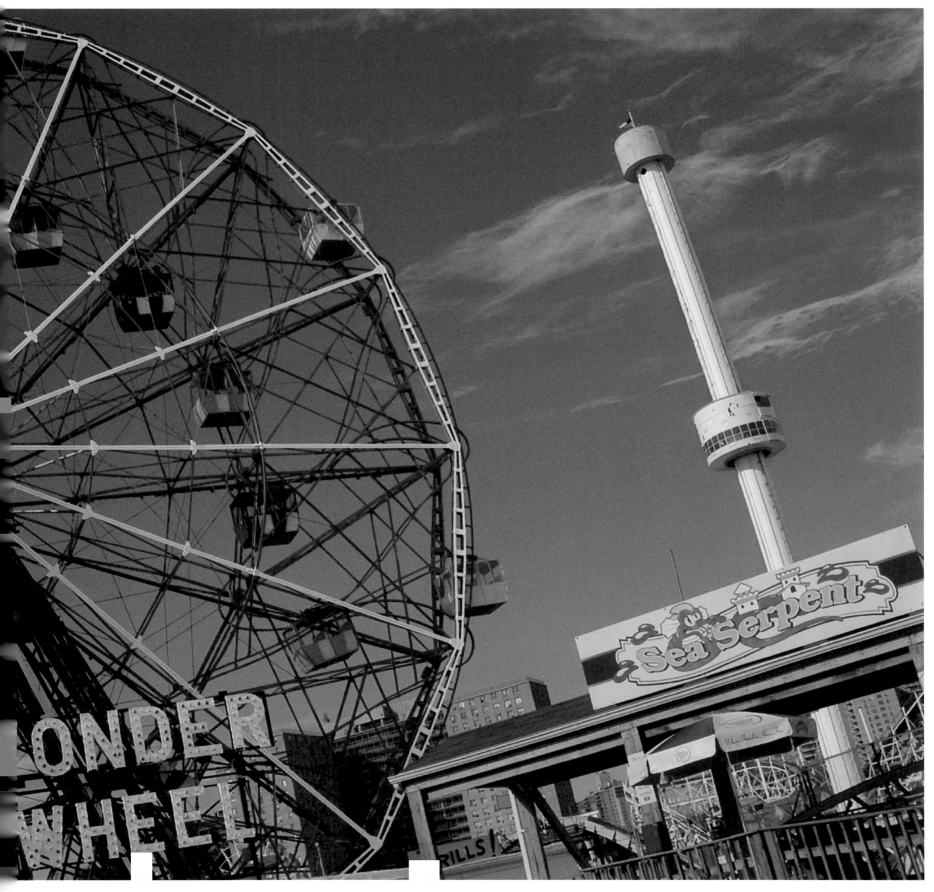

MANHATTAN

Twenty-three feet above Hudson River Park in lower Manhattan, a trapeze student awaits his turn to fly through the air. Lessons at Trapeze School-New York last two hours and are open to anyone, from novices to circus performers. As for the novices, many of them have severe acrophobia and sign up to confront their fears.
Photo by Jonathan Torgovnik

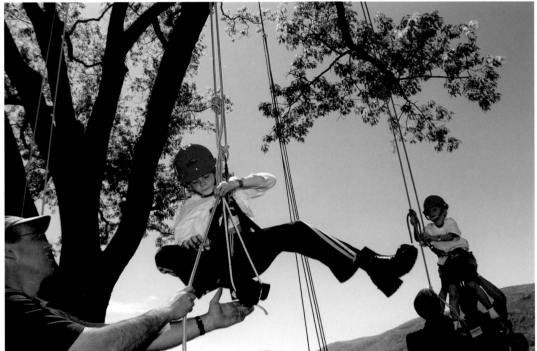

GARRISON

Assisted by arborist Richard Eaton, Sara Allen and August Brosnahan pulley themselves high up into a black oak at the 14th annual Riverkeeper Shad Fest. The daylong party put on by Riverkeeper, a nonprofit environmental group, celebrates the late spring run of the American Shad and ongoing cleanup efforts of the Hudson River.

Photo by Peter Freed

The 'Cuse Road Dawgs roar back to their Midland Avenue headquarters. At the head of the pack is Twan Gyder and his fiancée, Dona Bigby. All of the club members have road names. For instance, the club's president, Kenneth Orr (in red helmet), is known as Kayo the Hitman—but only because he is a martial arts aficionado.
Photo by Michael J. Okoniewski

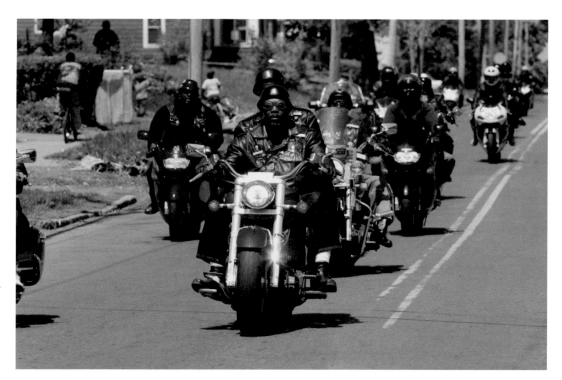

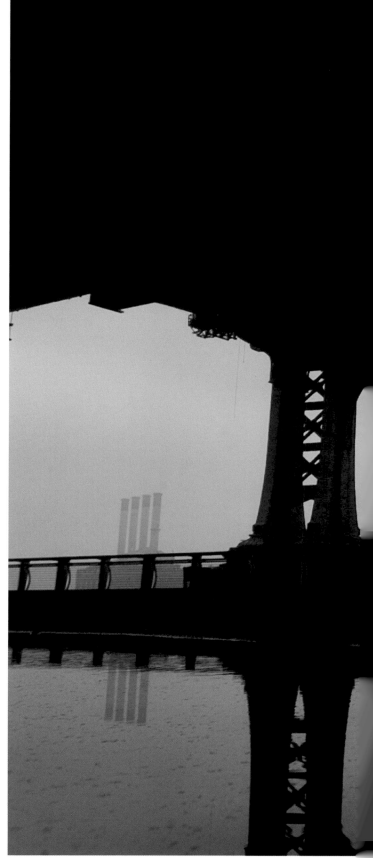

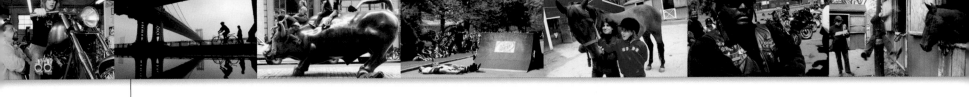

MANHATTAN

When it opened in 1909, the two-deck, $31 million Manhattan Bridge, just north of the Brooklyn Bridge, carried four trolley tracks, four subway tracks, and a pedestrian walkway. Serious cracks caused by trains were found in the steel super-structure in 1978. Ongoing reconstruction has so far cost $646 million.

Photo by Philip Greenberg

MANHATTAN

Guests at the Marriott Marquis Hotel's Fitness Center have plenty to distract them from the drudgery of climbing artificial stairs or cycling in place: a bird's-eye view of Times Square and 16 TV channels.

Photo by Lou Manna, Olympus Camedia Master

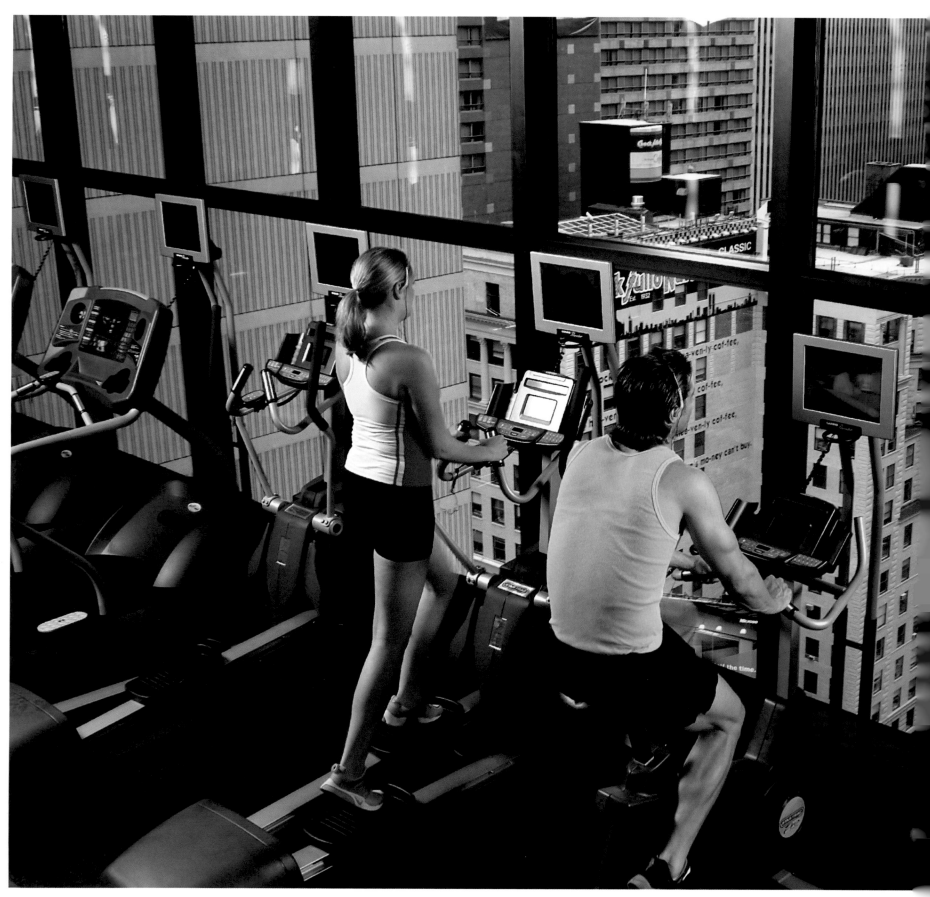

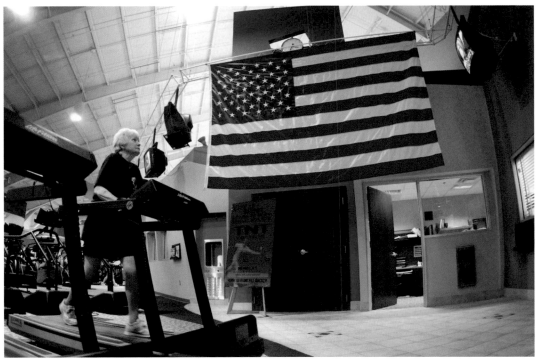

"I can't remember the last time I had ice cream,"
says fitness addict Evelyn Roland. The 86-year-
old great-grandmother paces through her daily
one-mile routine on the treadmill at the Mid-
Town Athletic Club. "My mother lived to be al-
most 100, and I figure that if I take care of myself,
I've got the genes to get there too," she says.
Photo by Carlos Ortiz, Democrat and Chronicle

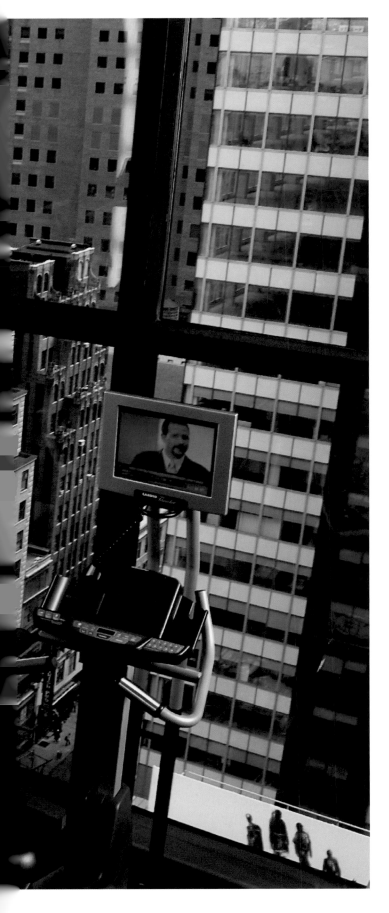

WEST POINT
Cadets at the U.S. Military Academy at West Point lock heads in a rugby scrum during the Intramural Brigade Finals on Target Hill Field. The academy's varsity rugby squad has reached the NCAA Final Four six times in the past decade.
Photo by Chris Ramirez

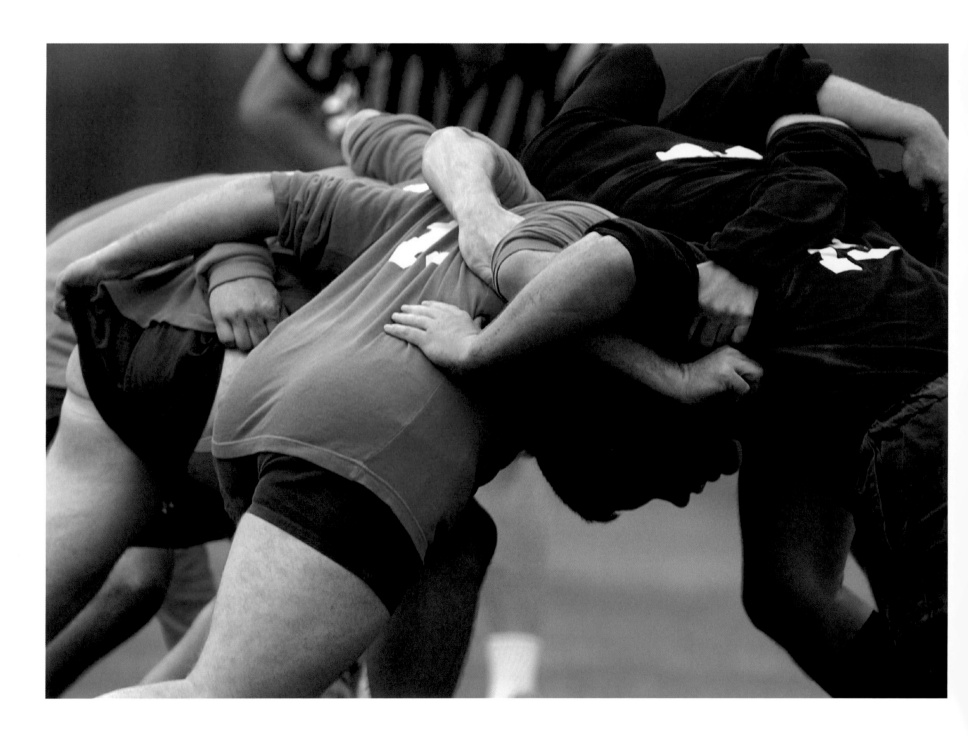

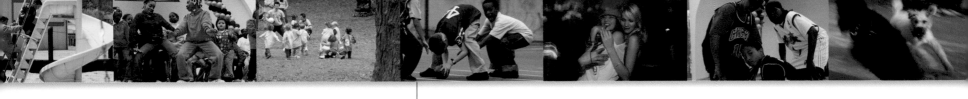

BROOKLYN

Just before taking the snap from center Arthur Dorrington, quarterback Alex Fevry takes a page from the playground playbook and calls an audible at PS 321 in Park Slope. Graydon Schunkewitz is the lone defending lineman.

Photo by Angela Jimenez

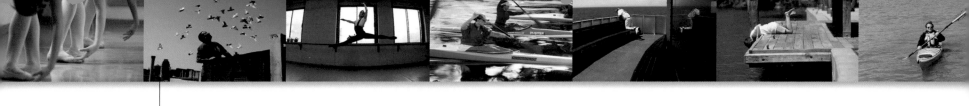

BRONX

Pigeon flocks swooping above the jumbled streets and rooftops of the Bronx are a common sight. José Rodriguez raises his 400 pigeons for their flocking and homing instincts. "Mumblers" (as some call pigeon flyers) compete with each other by trying to get their pigeon flocks to hijack other flocks and bring them home. At the end of the day, the guy with the most pigeons wins.
Photo by Martha Cooper

ROCHESTER

After spending seven winter months cooped up in libraries and classrooms at the Rochester Institute of Technology, information technology student Frank Duarte escapes to Ontario Beach Park to blow off some steam.

Photo by Carlos Ortiz, Democrat and Chronicle

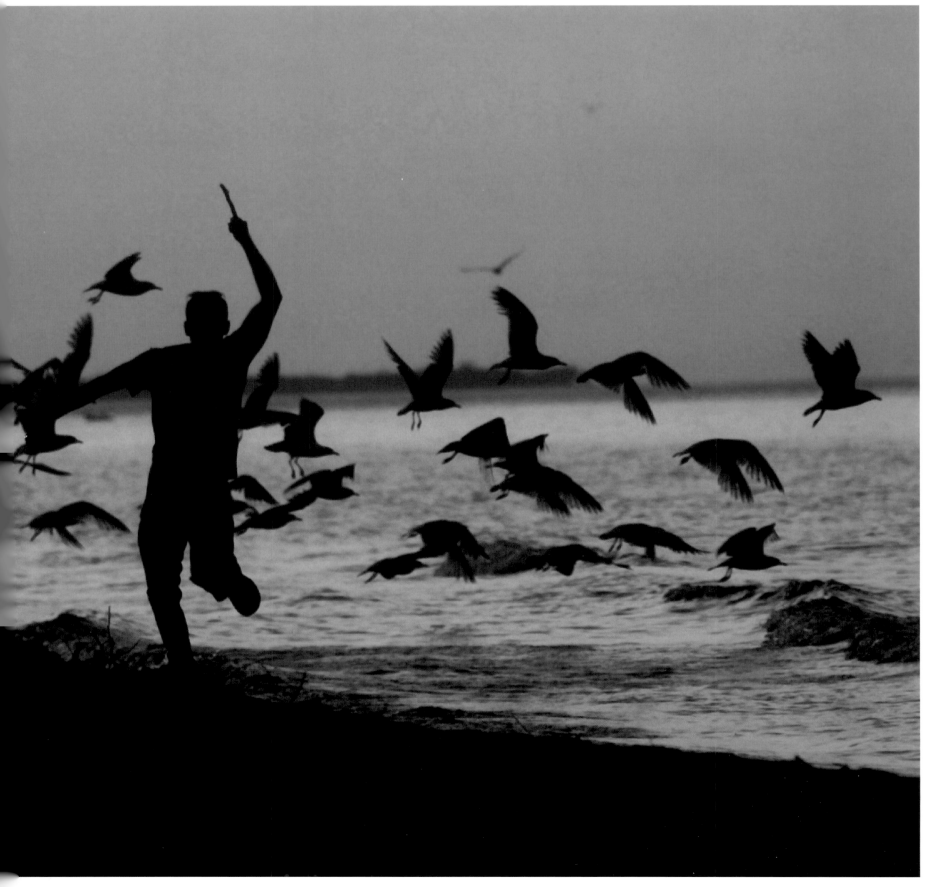

WOODSTOCK

Outside a gallery run by the Woodstock Artists Association, Lincoln Wilson and David Charles get into the action. It looks like Charles (right) is getting aggressive with his queen.

Photo by Lynn Goldsmith

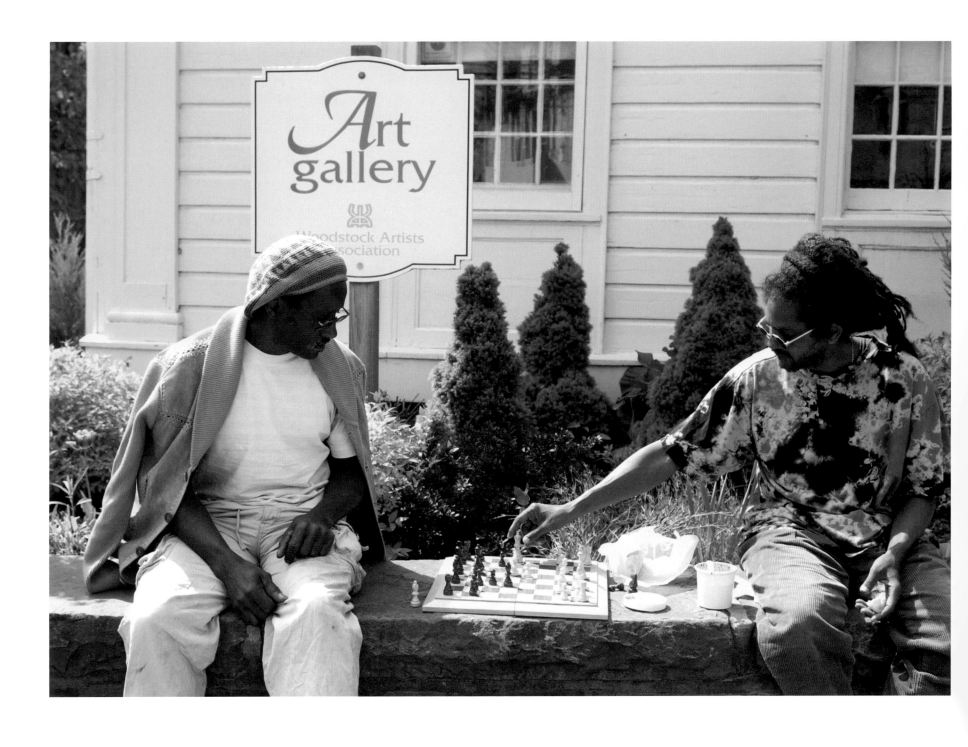

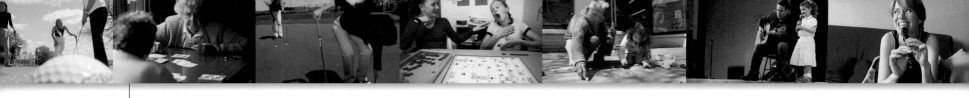

AUBURN

Margaret Fabian mulls over her hand before making a move against Anna McElroy at the Boyle Center. The friends met three years ago at the adult-living complex and have been getting together ever since for daily rounds of gin rummy.
Photo by Kevin Rivoli

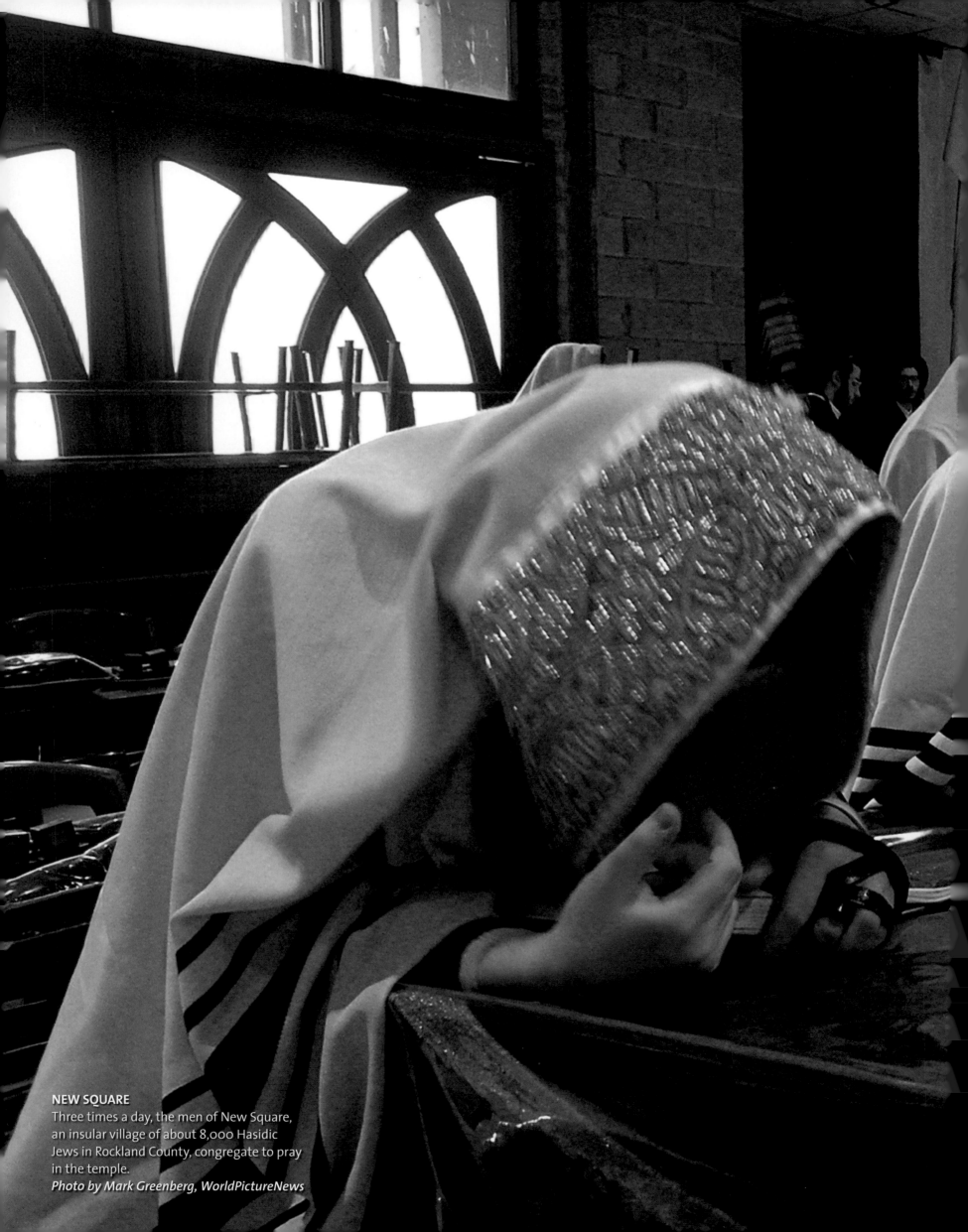

NEW SQUARE
Three times a day, the men of New Square, an insular village of about 8,000 Hasidic Jews in Rockland County, congregate to pray in the temple.
Photo by Mark Greenberg, WorldPictureNews

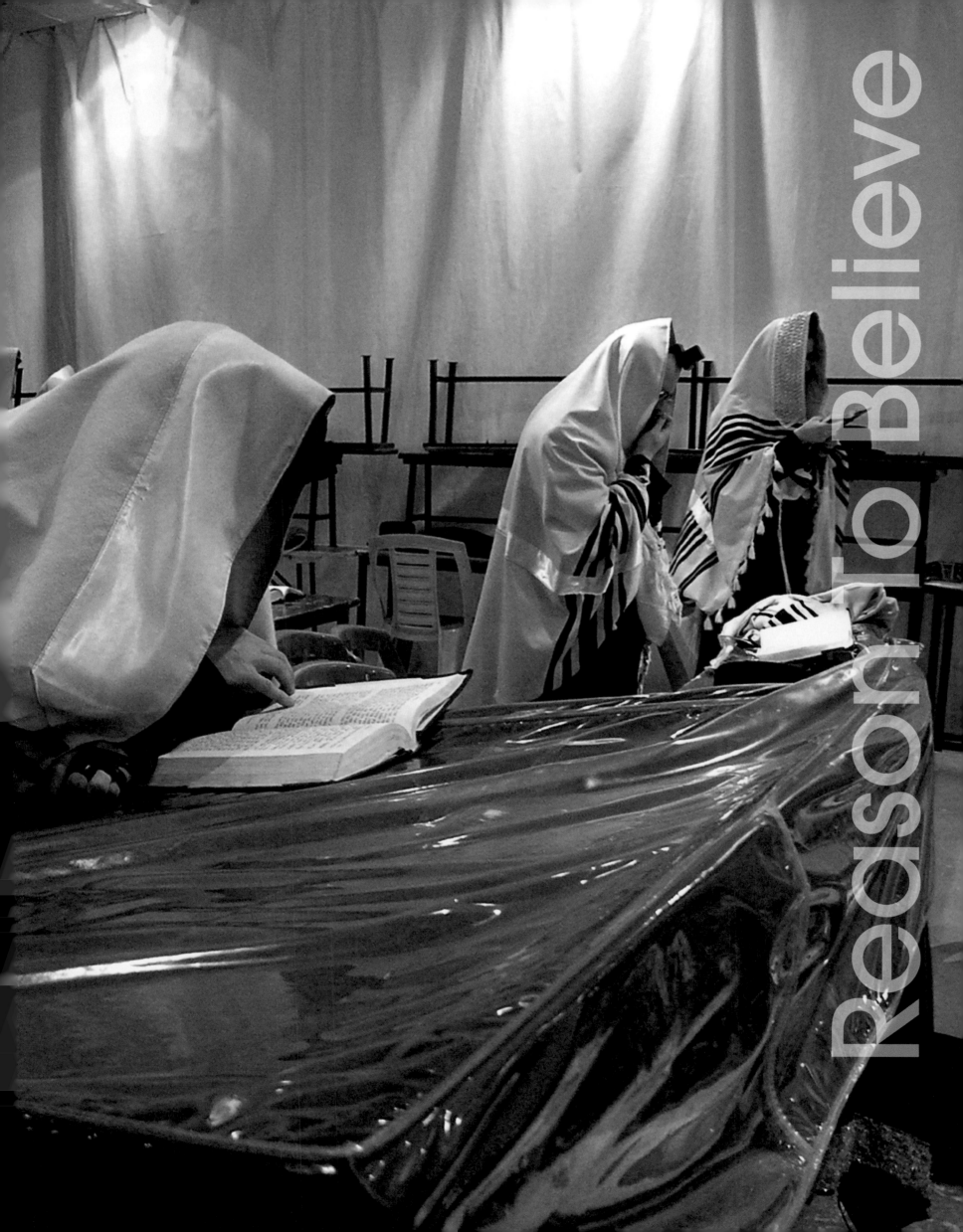

BROOKLYN

In the Saints Chapel of Our Lady of Mount Carmel Church, a devotee lights a candle and offers intercessory prayers. Mother Cabrini, St. Michael the Archangel, the Sacred Heart of Jesus, and the Blessed Virgin are standing by to help.
Photo by Andrew Lichtenstein

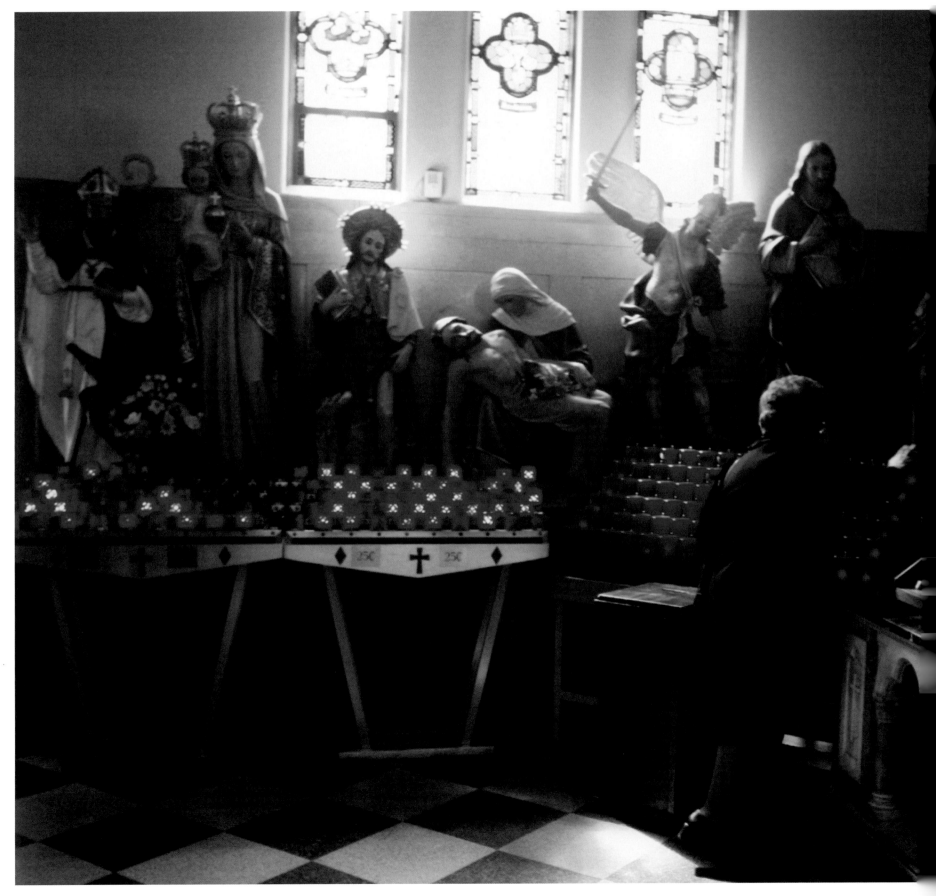

NEW HYDE PARK

The candle-lighting ceremony at Raquel "Rocky" Sherman's bat mitzvah is her chance to let special friends and family members know how much they mean to her. Before each person comes up to light a candle, they're introduced with a short poem that Rocky wrote.

Photo by Dennis Gartner

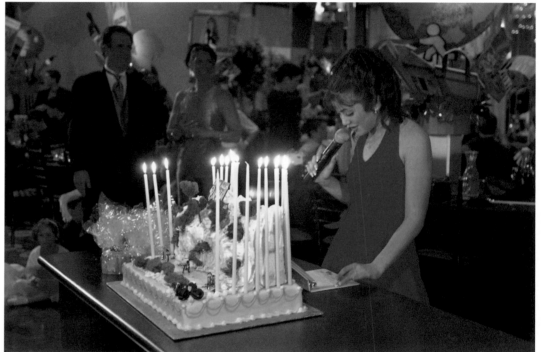

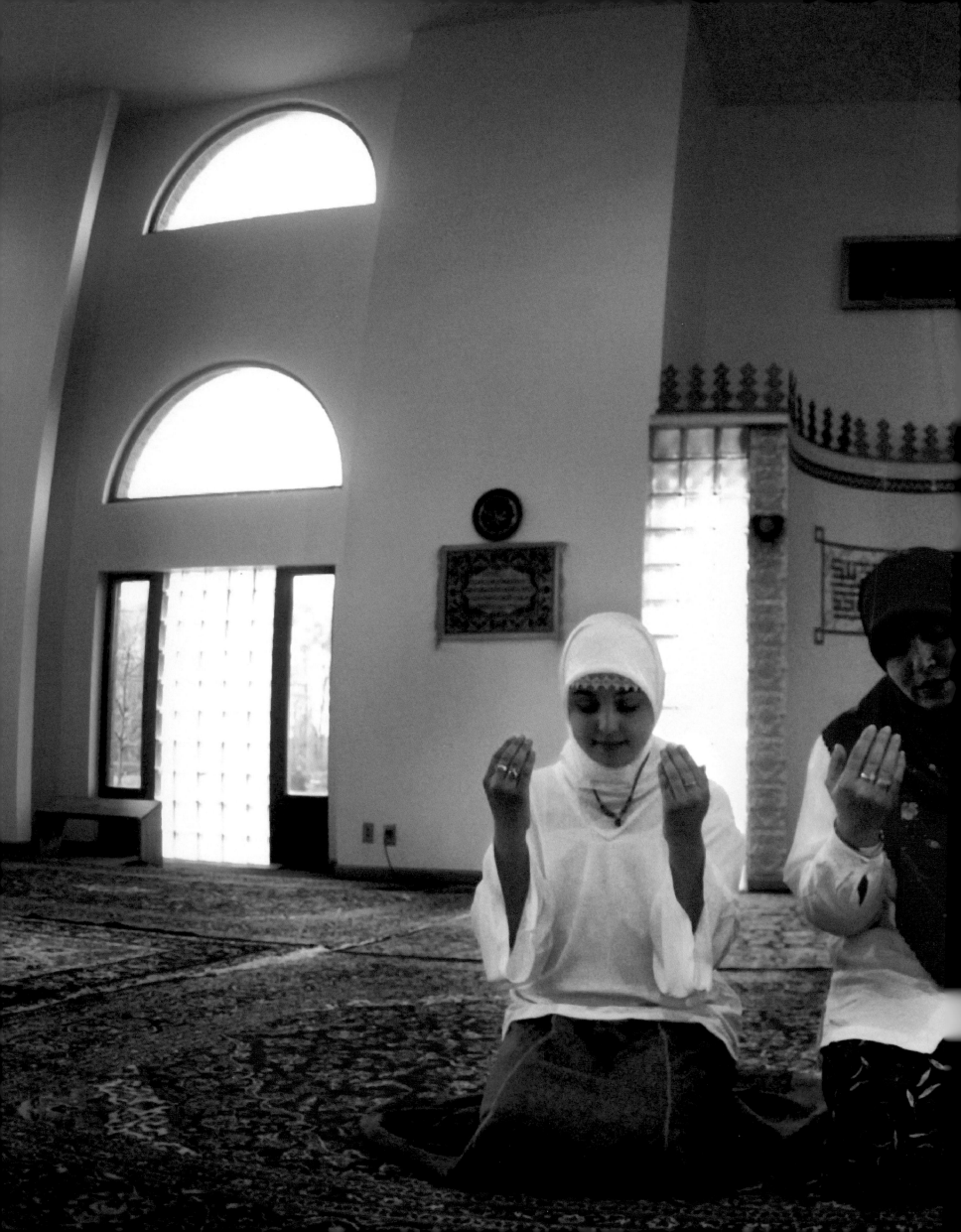

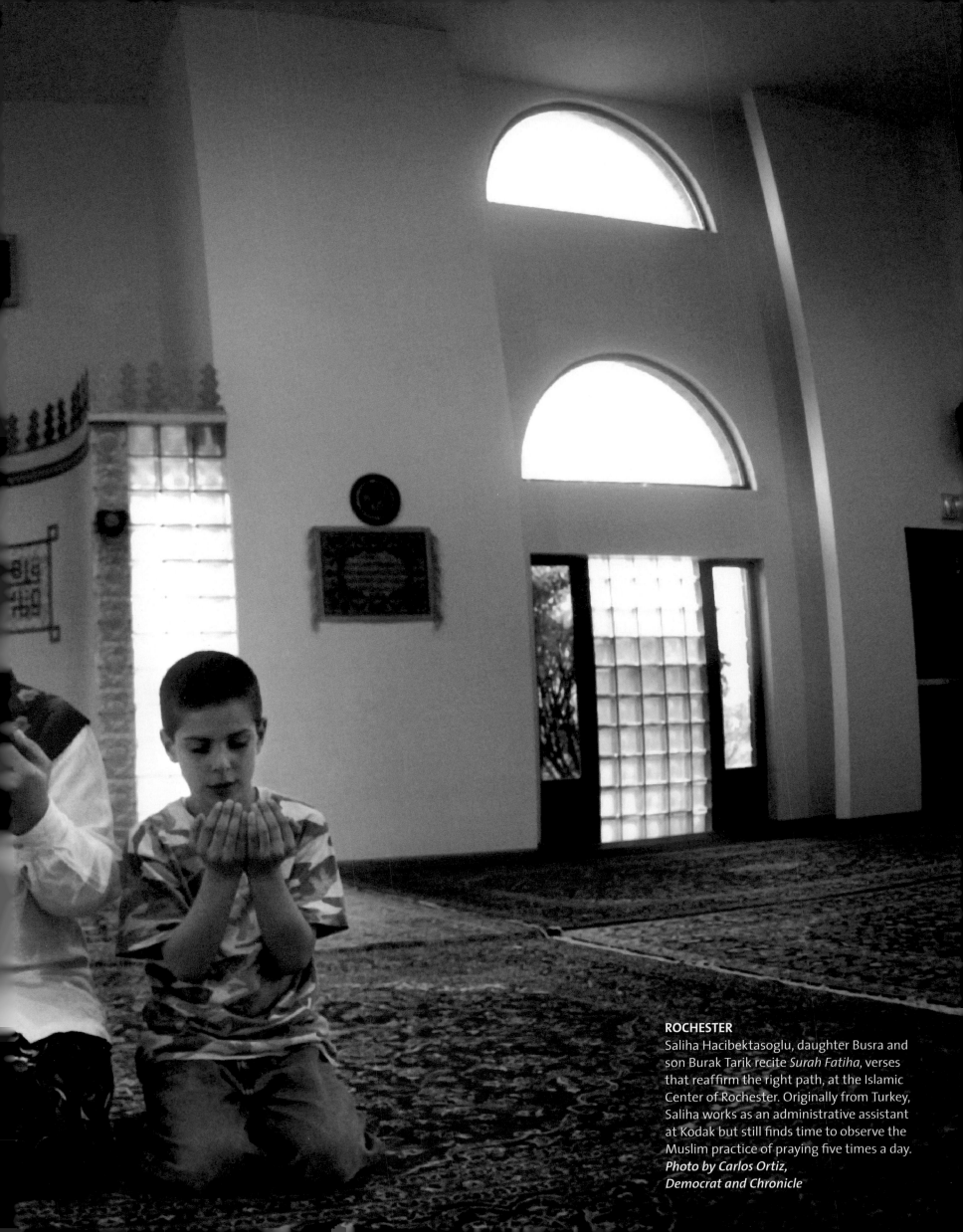

ROCHESTER
Saliha Hacibektasoglu, daughter Busra and son Burak Tarik recite *Surah Fatiha*, verses that reaffirm the right path, at the Islamic Center of Rochester. Originally from Turkey, Saliha works as an administrative assistant at Kodak but still finds time to observe the Muslim practice of praying five times a day.
Photo by Carlos Ortiz,
Democrat and Chronicle

ONEIDA

Chan Mason motors back from his tiny, midpond Cross Island Chapel, which must be the state's smallest church. The 6-by-9-foot chapel boasts electricity, two small stained glass windows, and enough square footage for three people—say, a minister, a bride, and a groom.
Photo by Michael J. Okoniewski

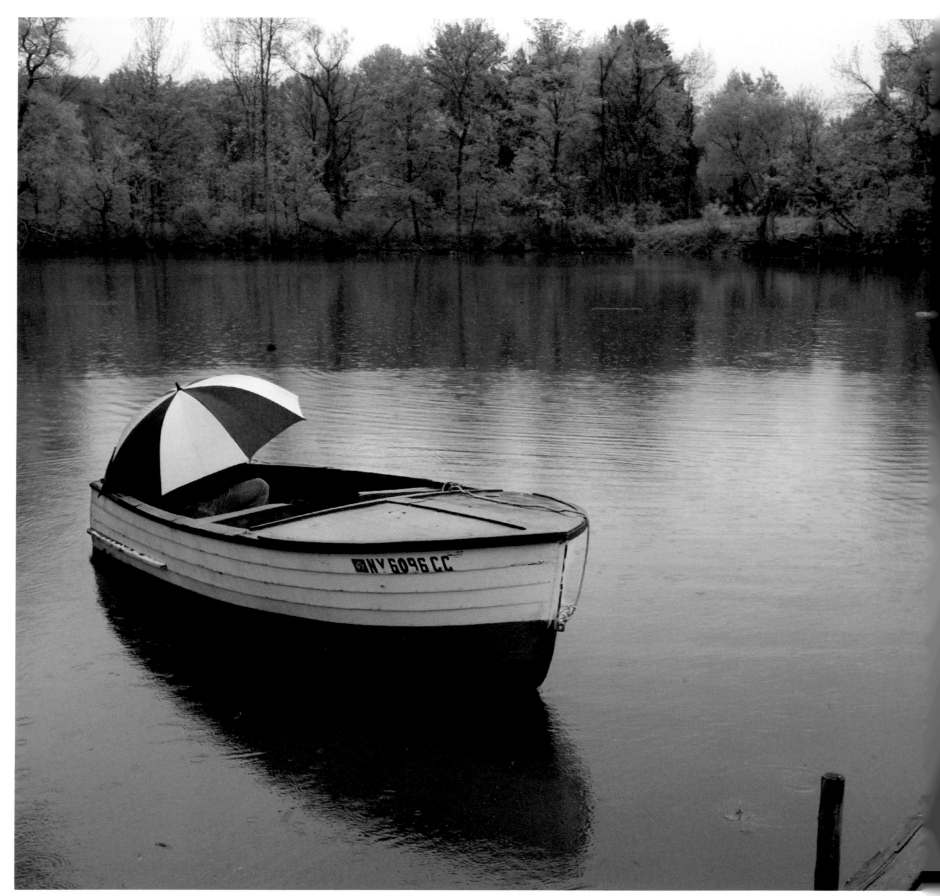

ALDEN

In the western town of Alden, Saint Paul's United Church of Christ has been offering prayers since 1874 and encouraging dandelions since Lord knows when.
Photo by Michael Groll

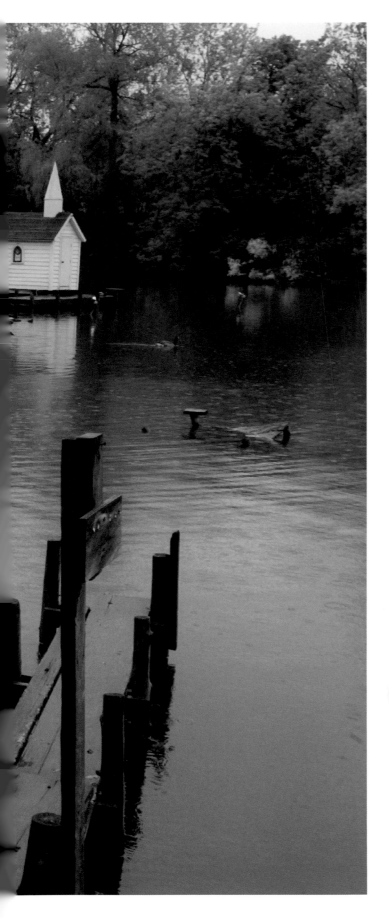

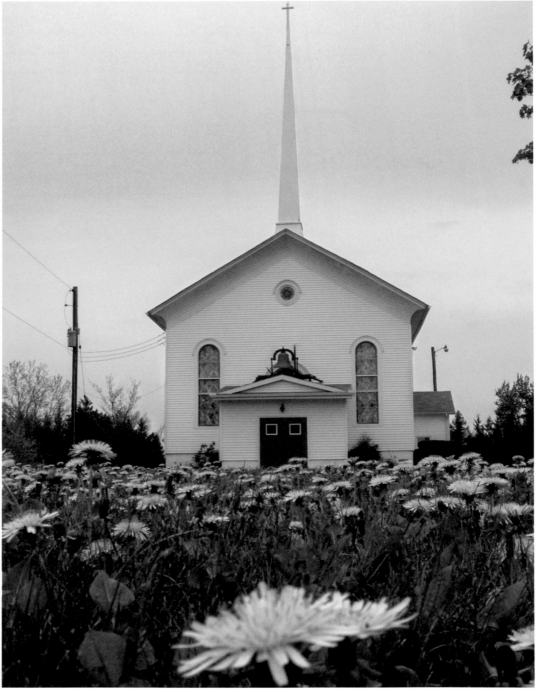

BRONX
No expense was spared for Nikkia and Amanda Colon's first communion. The sisters wait in their chiffon and lace finery for their portraits to be taken at St. Jerome's Church.
Photo by Nina Berman

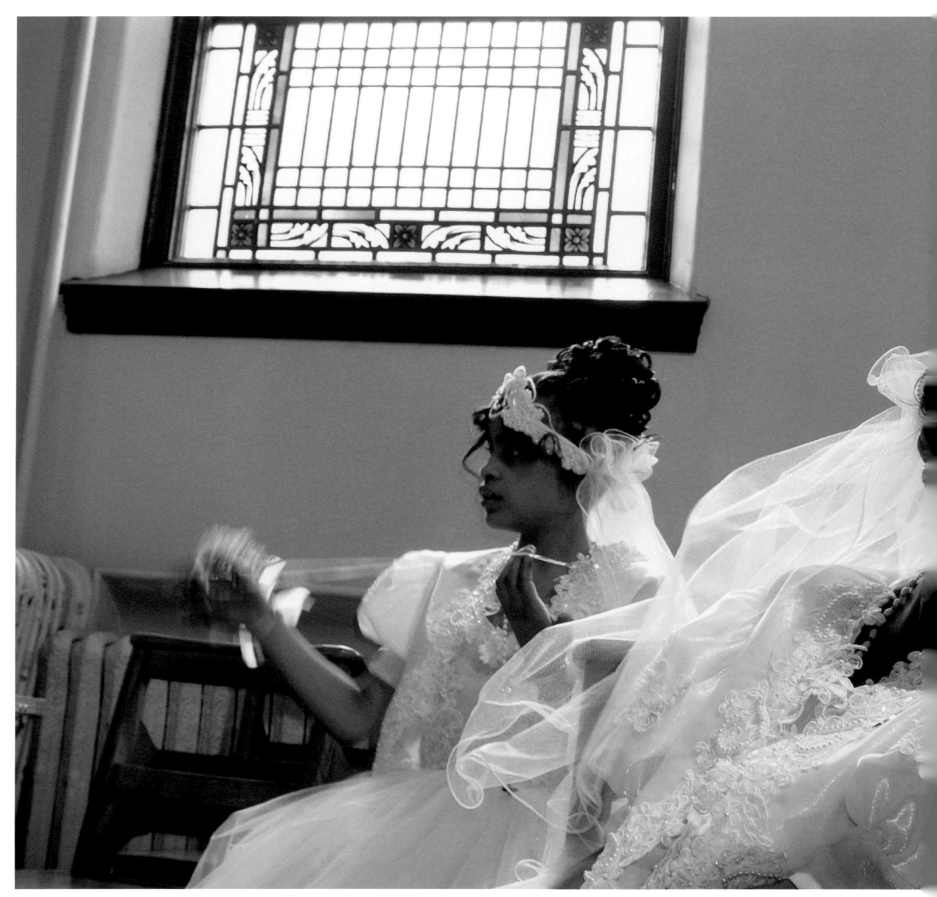

GLENMONT

St. Michael's Shrine is designed for commuters on Route 9W. The drive-up prayer station is tucked into the edge of the woods just off the two-lane highway south of Albany.
Photo by Patrick Harbron

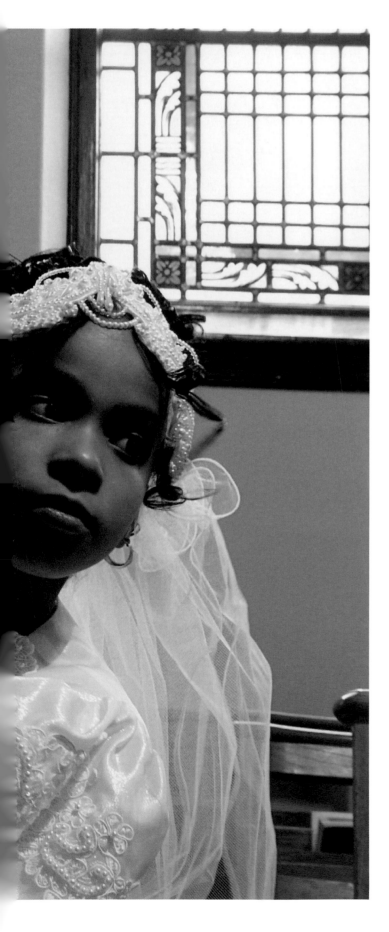

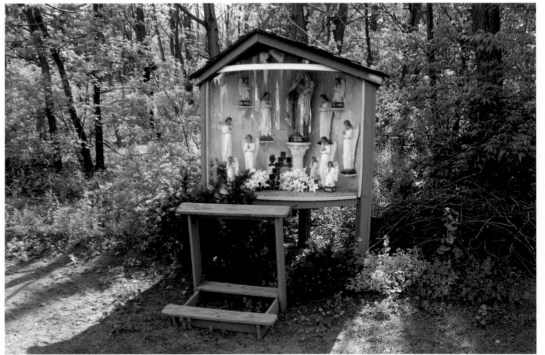

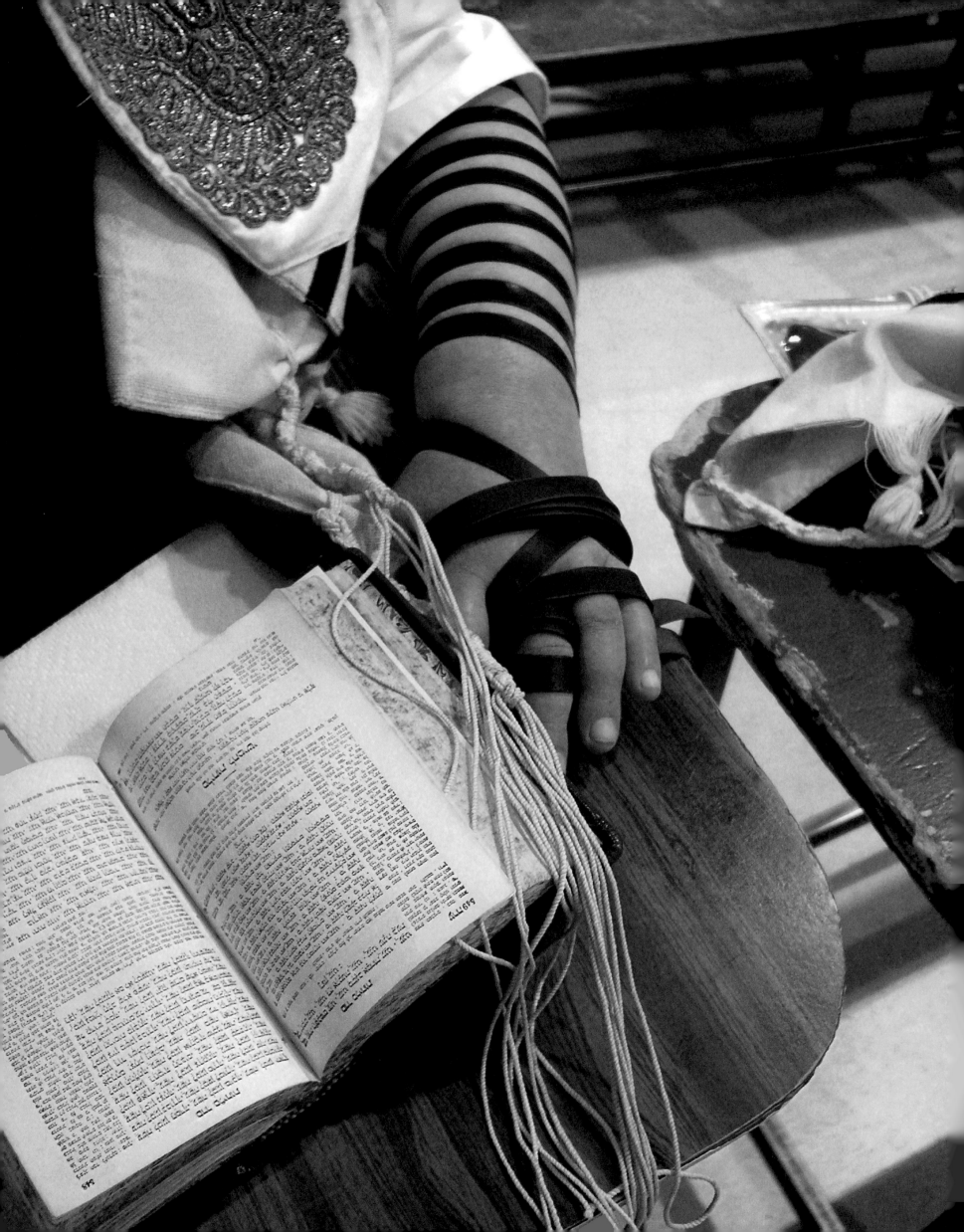

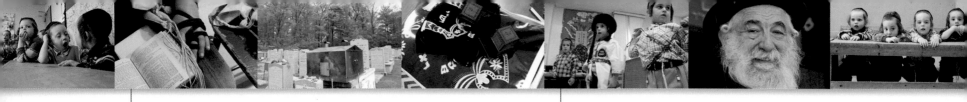

NEW SQUARE

In the Hasidic community of New Square, 30 miles outside of New York City, life is devoted to study and prayer. Men don prayer shawls, called tallises, with tzi-tzit at the end that are used for kissing the Torah. The black straps are part of the tefillin—two black boxes, one for the head and one for the arm, that contain scripture.
Photos by Mark Greenberg, WorldPictureNews

NEW SQUARE

In the Hasidic world, men and women are separated from each other at synagogue, and the same goes for children in school. These kindergartners attend a yeshiva, or religious school, for boys.

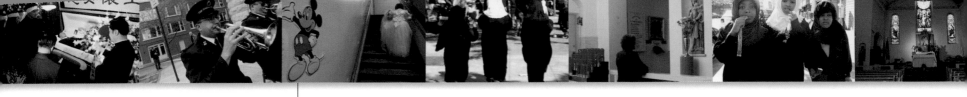

BUFFALO

Worried that *quinceañera* coming-of-age parties were disappearing because of the prohibitive cost, teachers at the Herman Badillo Bilingual Academy #76 rallied the community. Local businesses donated dresses and food so that Claribel Lugo and other students might experience a 15th birthday party as it would be celebrated in their native Latin America.

Photo by Mark Mulville, The Buffalo News

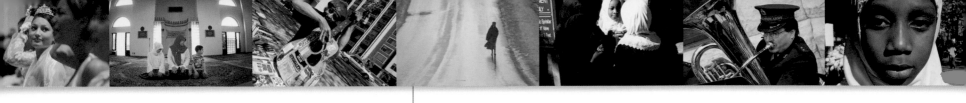

LEON
Walking is a regular mode of transportation among the Amish in rural Conewango Valley. The children walk up to two miles to school in all weather. They can normally count on company; families of up to 16 children are common.
Photo by Michael Groll

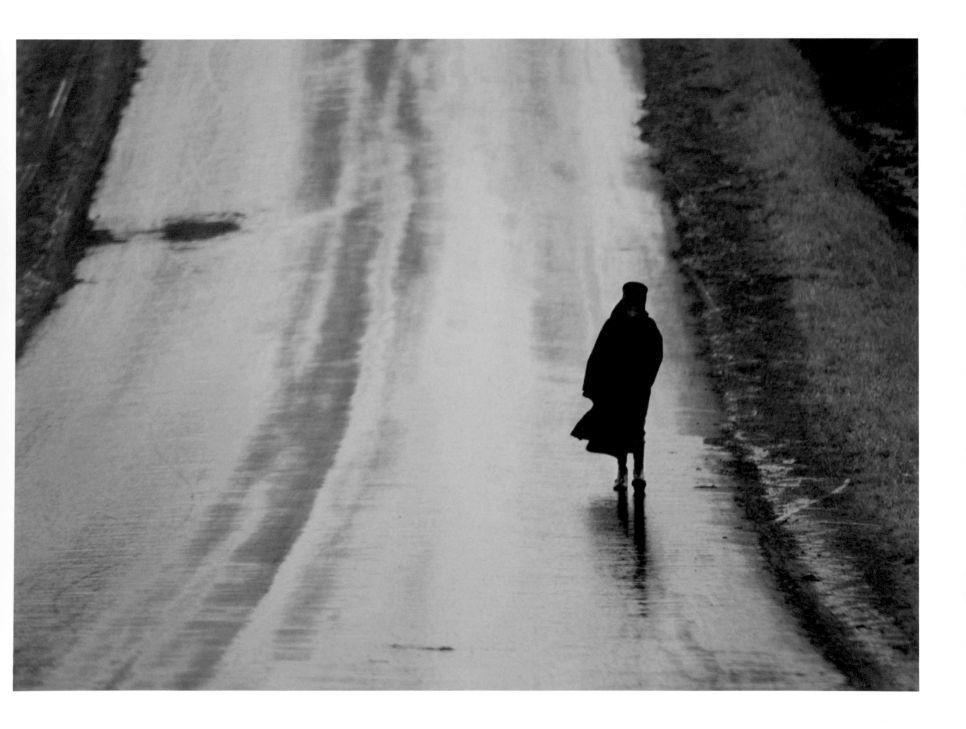

MANHATTAN

Installed as the American archbishop in 1999, Demetrios Trakatellis is spiritual leader to some 1.5 million Greek Orthodox Christians. A linguistic scholar as well as a theologian, the archbishop speaks Greek, English, French, German, Hebrew, Latin, Aramaic, and Coptic.

Photo by Joyce Tenneson

GARDEN CITY

The Gothic Cathedral of the Incarnation is a monument to Alexander Turney Stewart, who built Garden City out of a barren meadow in the 1870s. Stewart built stately houses, put in water-works and sewage systems, and planted 6,500 maple trees. He died before his planned community caught on with the public, so his widow commissioned the cathedral to memorialize his efforts.

Photo by Dave Kaye

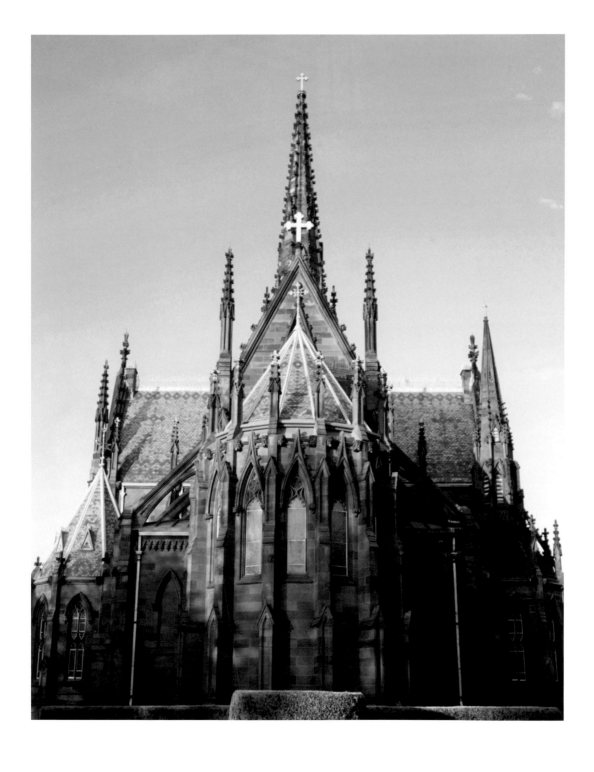

MANHATTAN

In Manhattan's Southern District Court, natural-ization applicants take the Oath of Allegiance and become Americans. Since 1998, the New York City district office of U.S. Citizenship and Immigration Services has processed more than 750,000 new U.S. citizens.

Photos by Mark Greenberg, WorldPictureNews

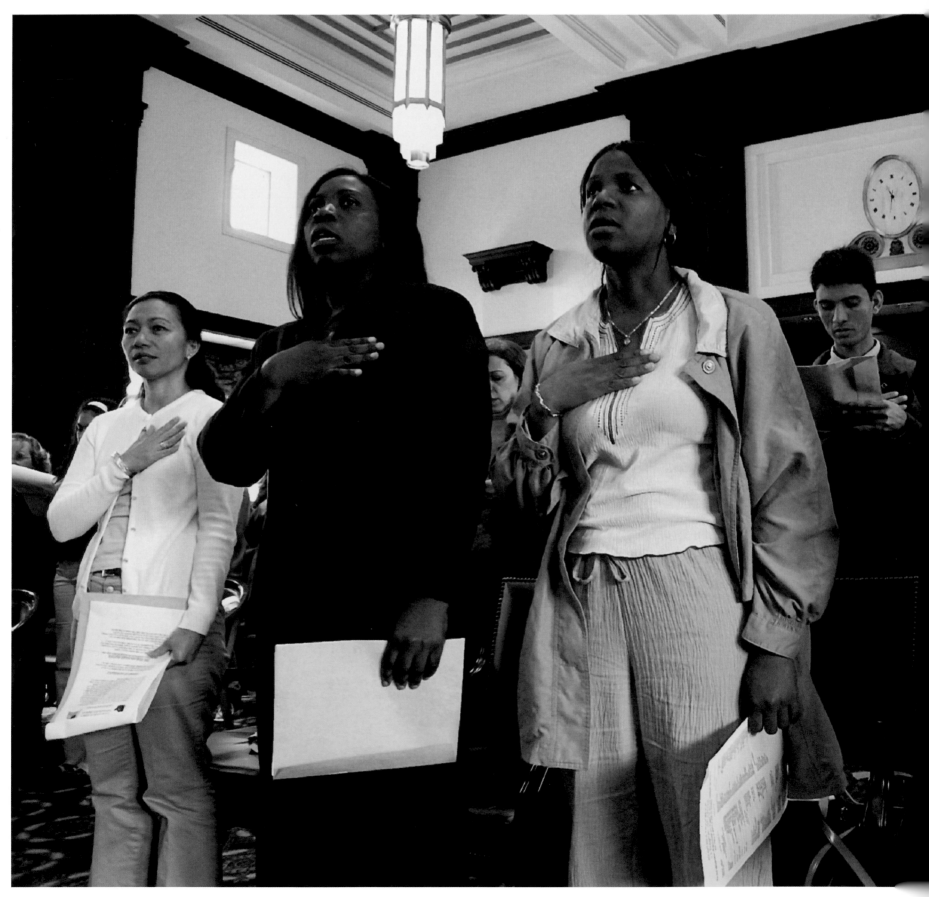

MANHATTAN
Second generation: A son gets a question
answered by an immigration official to help his
mother complete her naturalization papers.

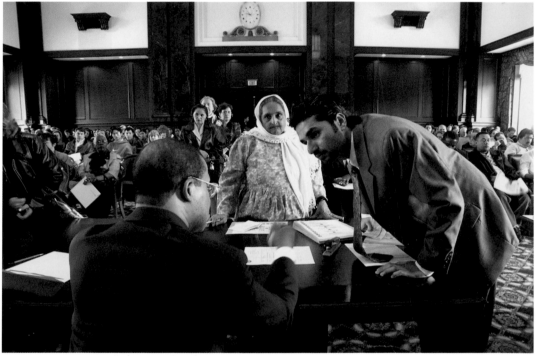

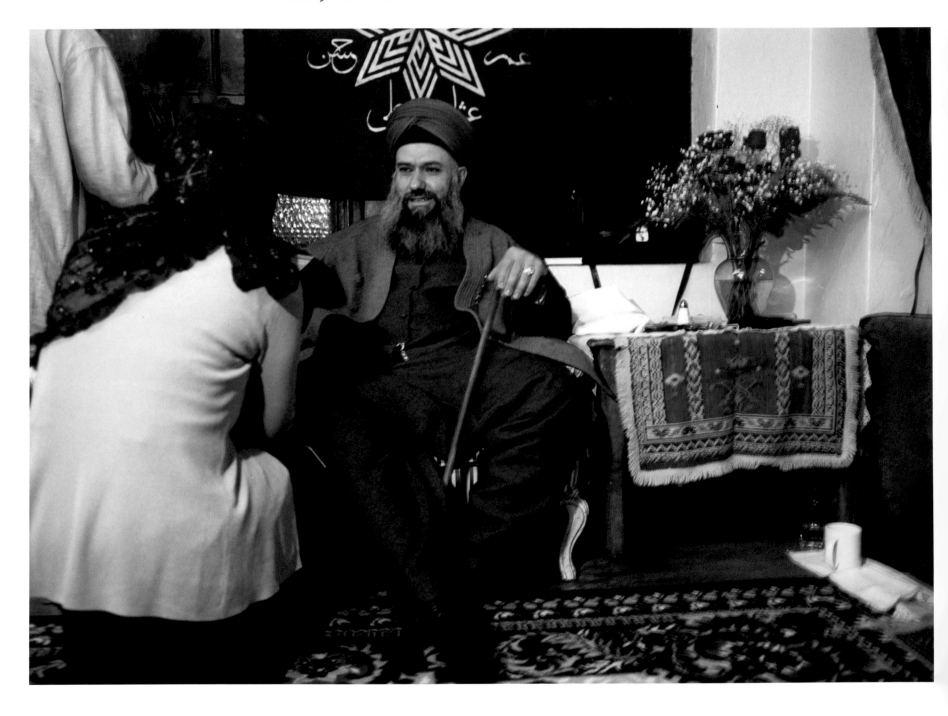

MANHATTAN

At the Osmanli Naks-i'bendi Hakkani Sufi Associ-
ation, Sheykh Abdul Karim meets with a follower
after leading a Friday night *zikir*, or chanting ses-
sion. In addition to praying five times daily, prac-
titioners of the Islamic order engage in additional
worship to endear themselves to Muhammad.
New York–based Sheykh Abdul Kerim travels the
world preaching his prophet's words of submis-
sion and faith.
Photo by Brian Palmer

MANHATTAN

"I sign thee with the sign of the cross and confirm thee with the chrism of salvation," says Bishop Patrick J. Sheridan before confirming Epiphany School seventh-grader Michael Paciello. Catholic confirmation is given when children are old enough to deliberate the meaning of their faith.
Photo by Lou Manna, Olympus Camedia Master

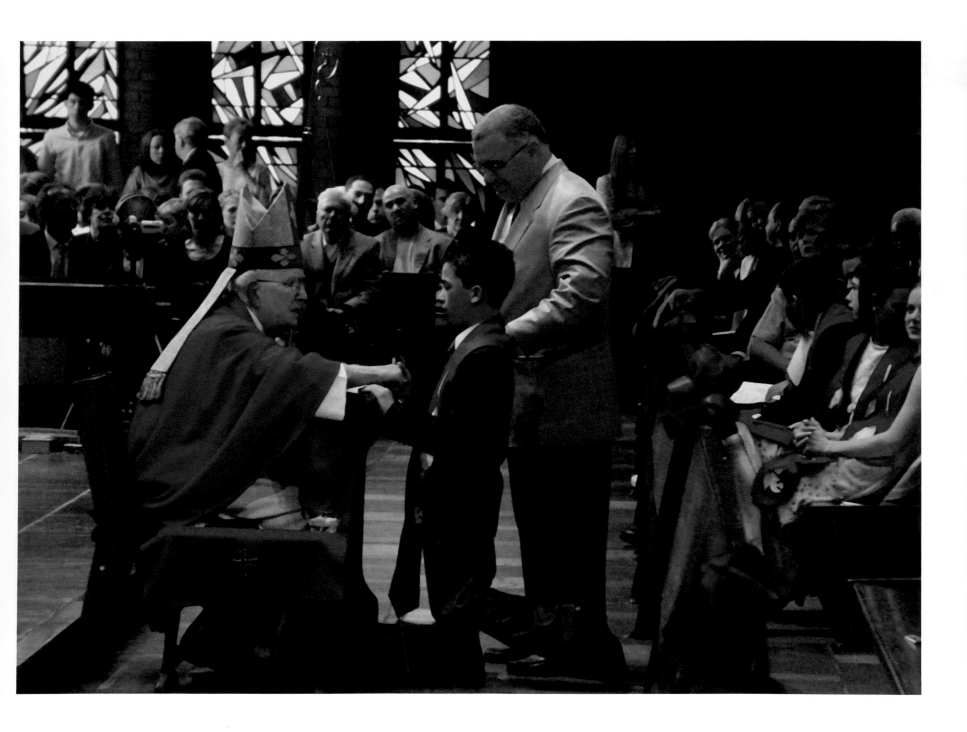

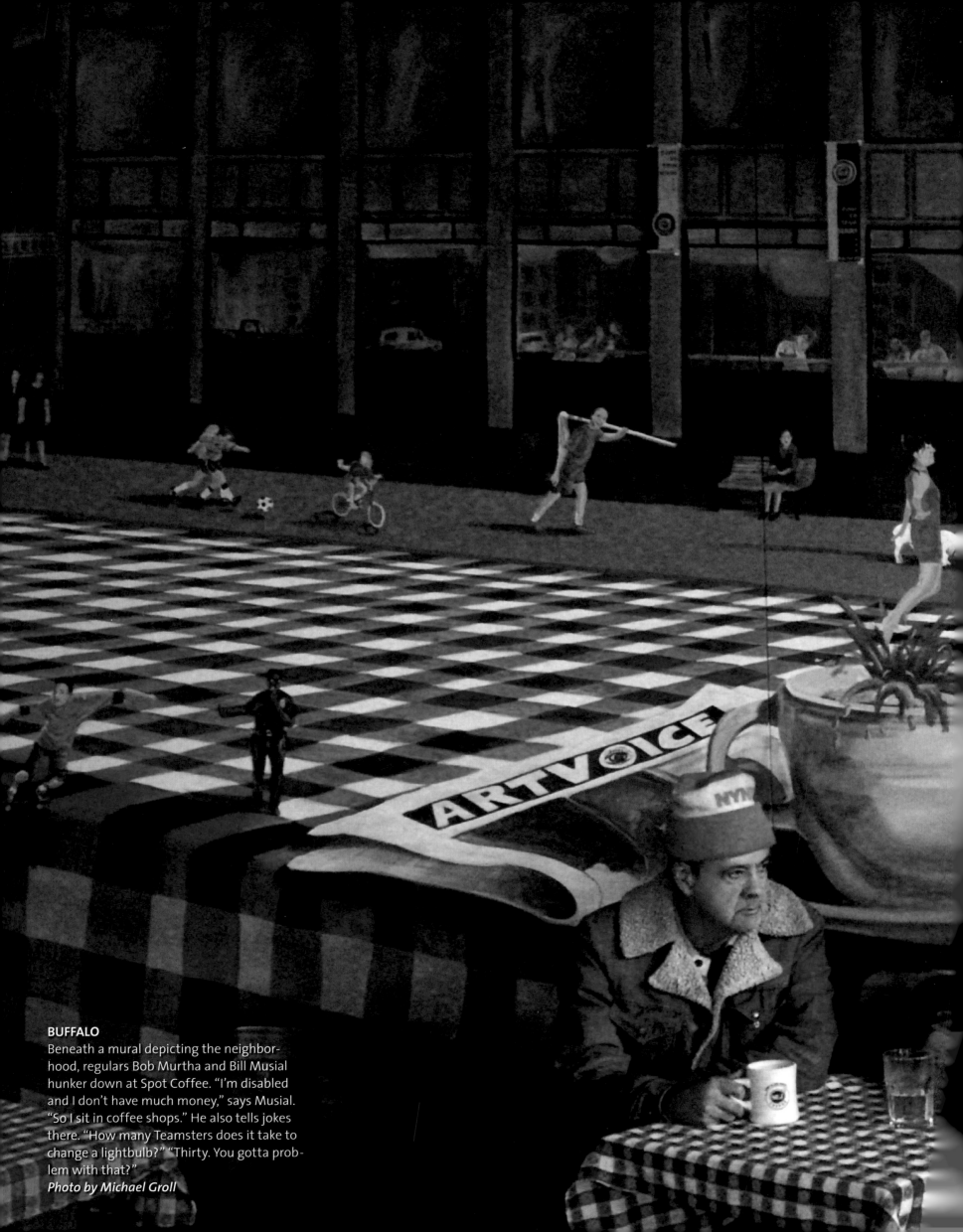

BUFFALO
Beneath a mural depicting the neighborhood, regulars Bob Murtha and Bill Musial hunker down at Spot Coffee. "I'm disabled and I don't have much money," says Musial. "So I sit in coffee shops." He also tells jokes there. "How many Teamsters does it take to change a lightbulb?" "Thirty. You gotta problem with that?"
Photo by Michael Groll

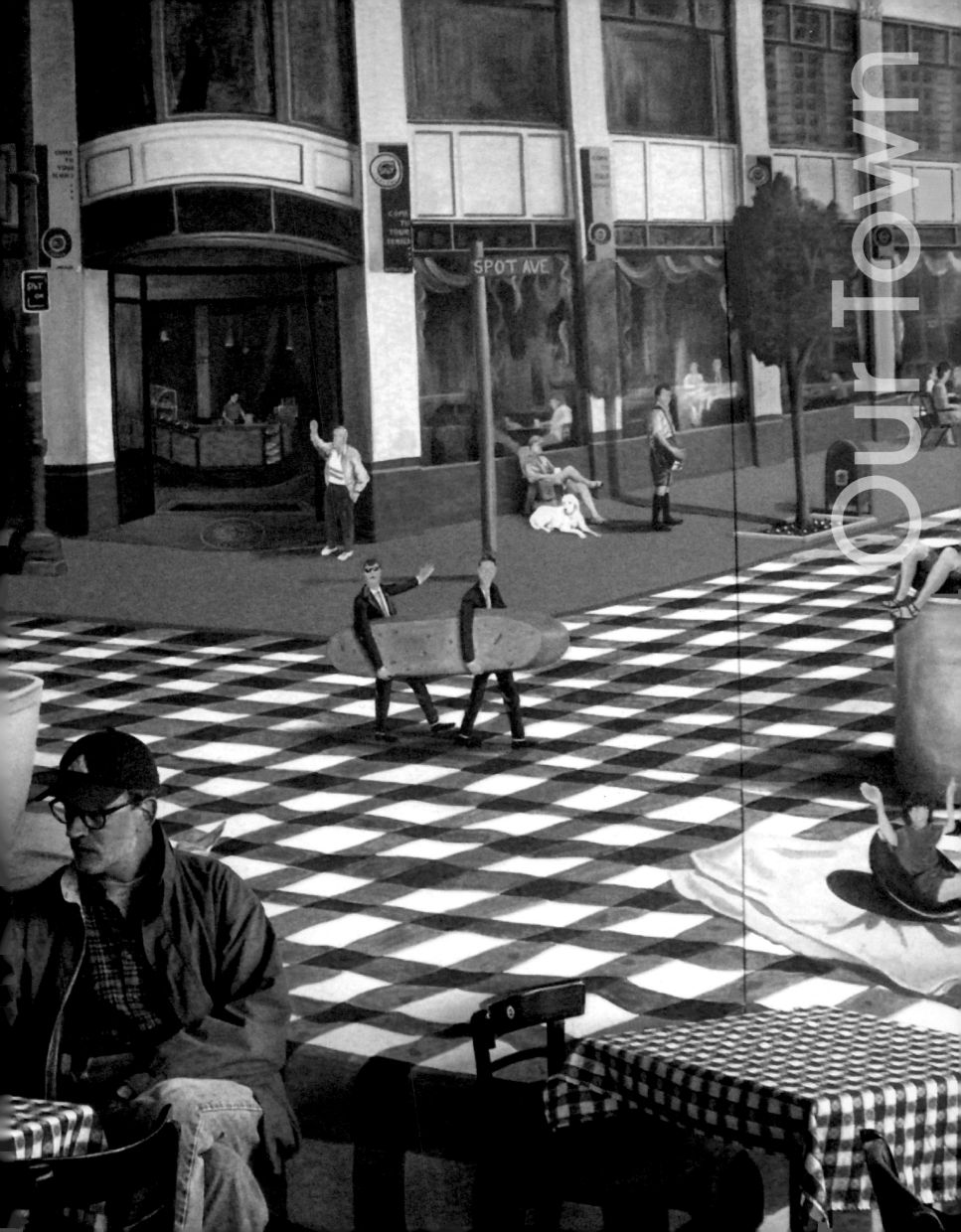

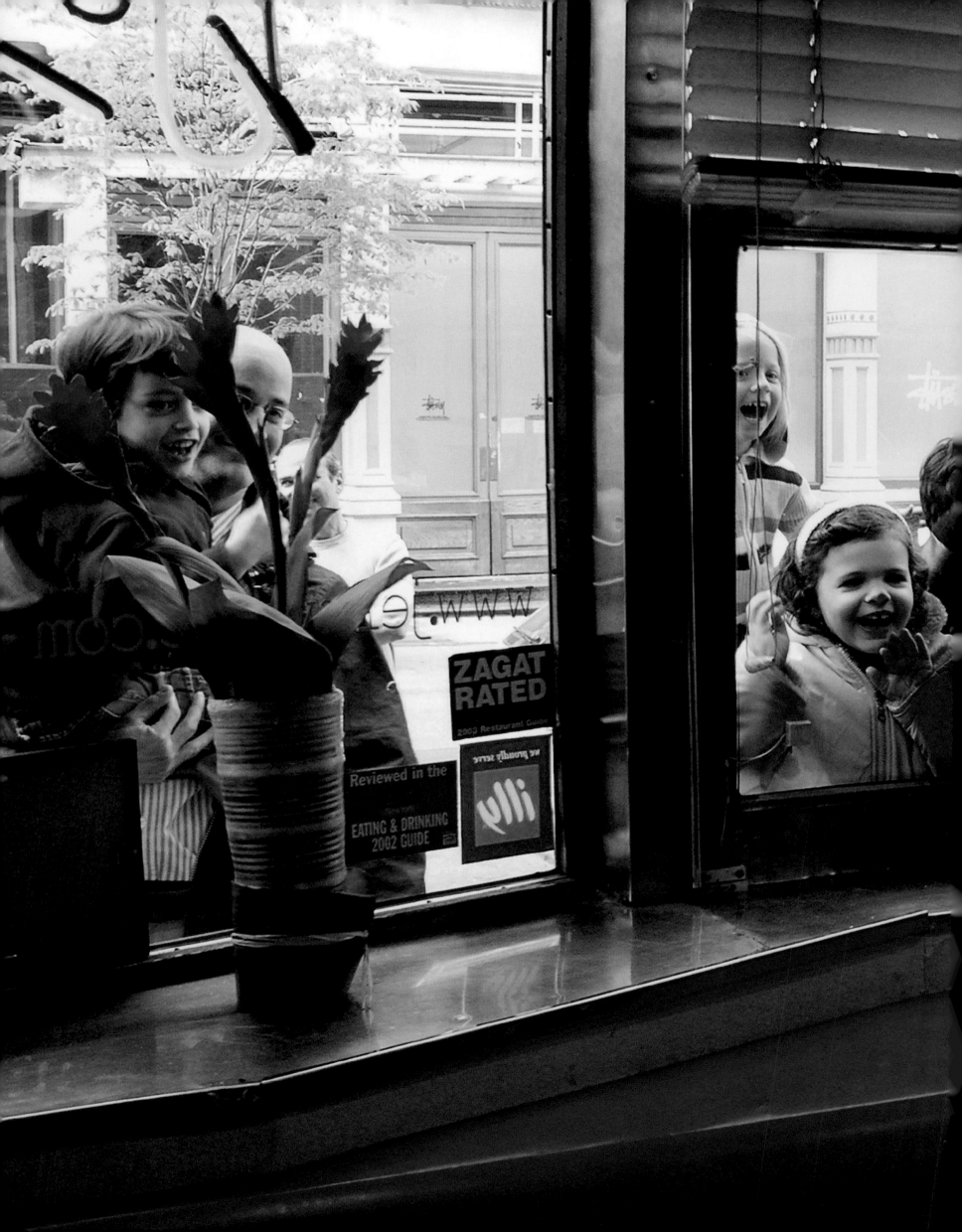

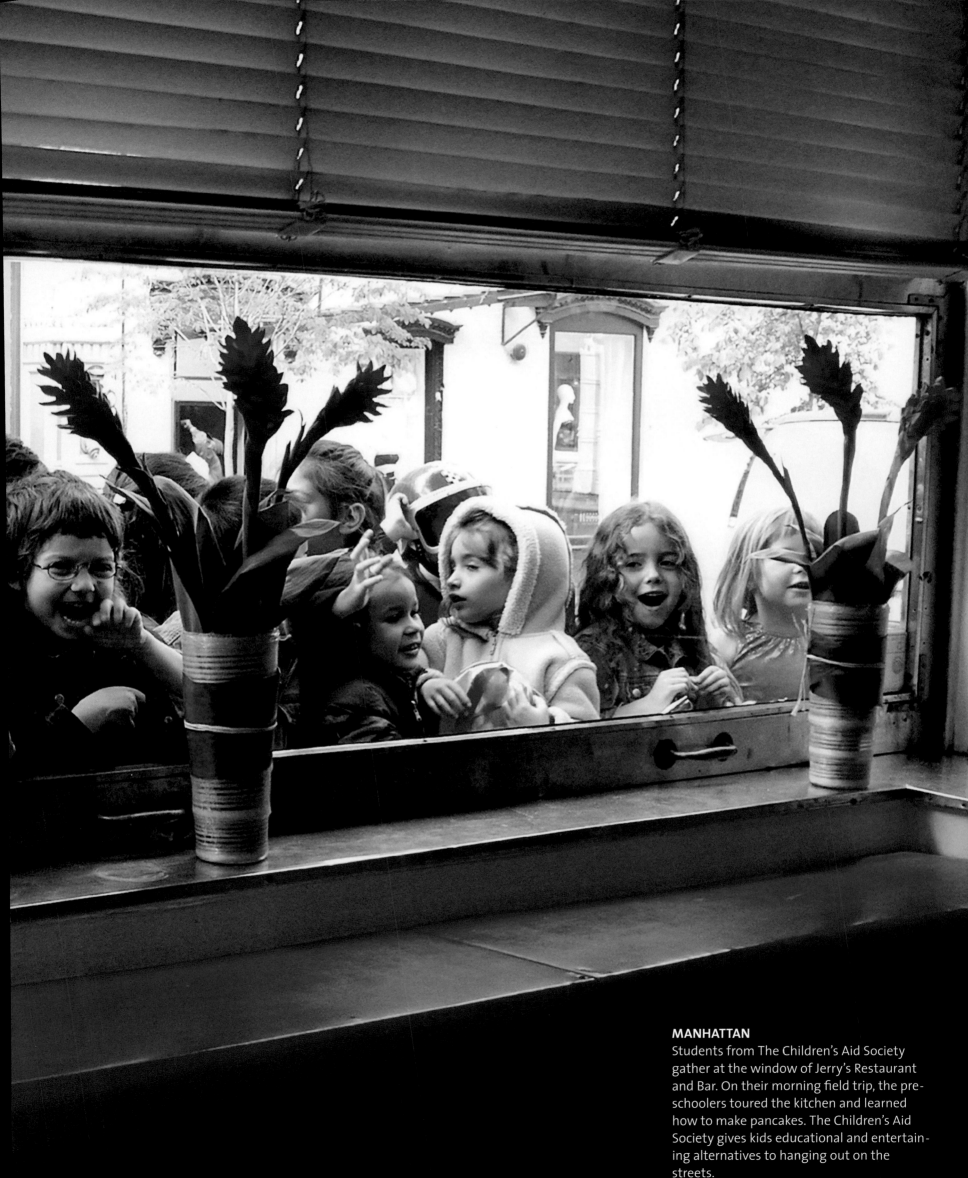

MANHATTAN
Students from The Children's Aid Society gather at the window of Jerry's Restaurant and Bar. On their morning field trip, the preschoolers toured the kitchen and learned how to make pancakes. The Children's Aid Society gives kids educational and entertaining alternatives to hanging out on the streets.

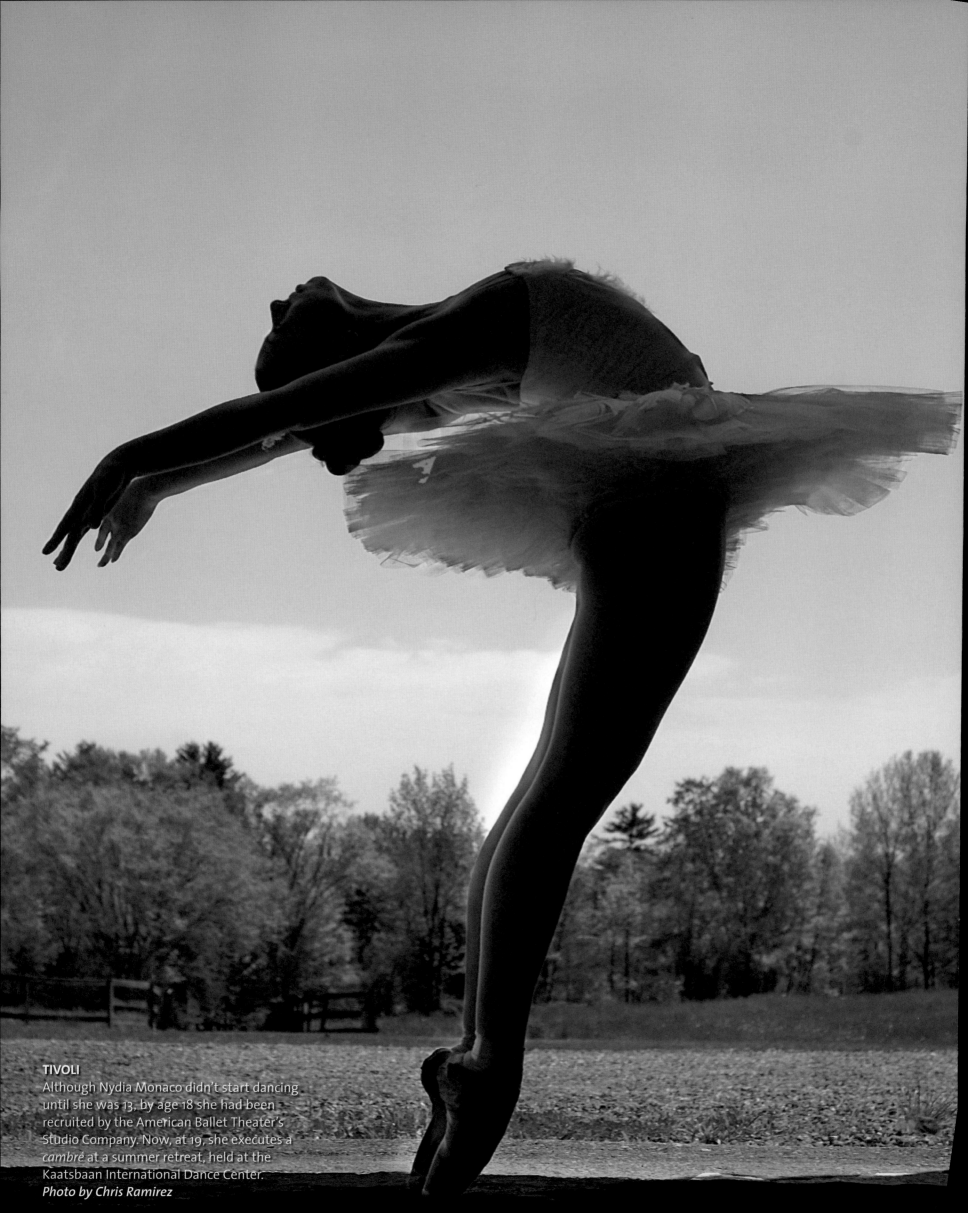

TIVOLI
Although Nydia Monaco didn't start dancing until she was 13, by age 18 she had been recruited by the American Ballet Theater's Studio Company. Now, at 19, she executes a *cambré* at a summer retreat, held at the Kaatsbaan International Dance Center.
Photo by Chris Ramirez

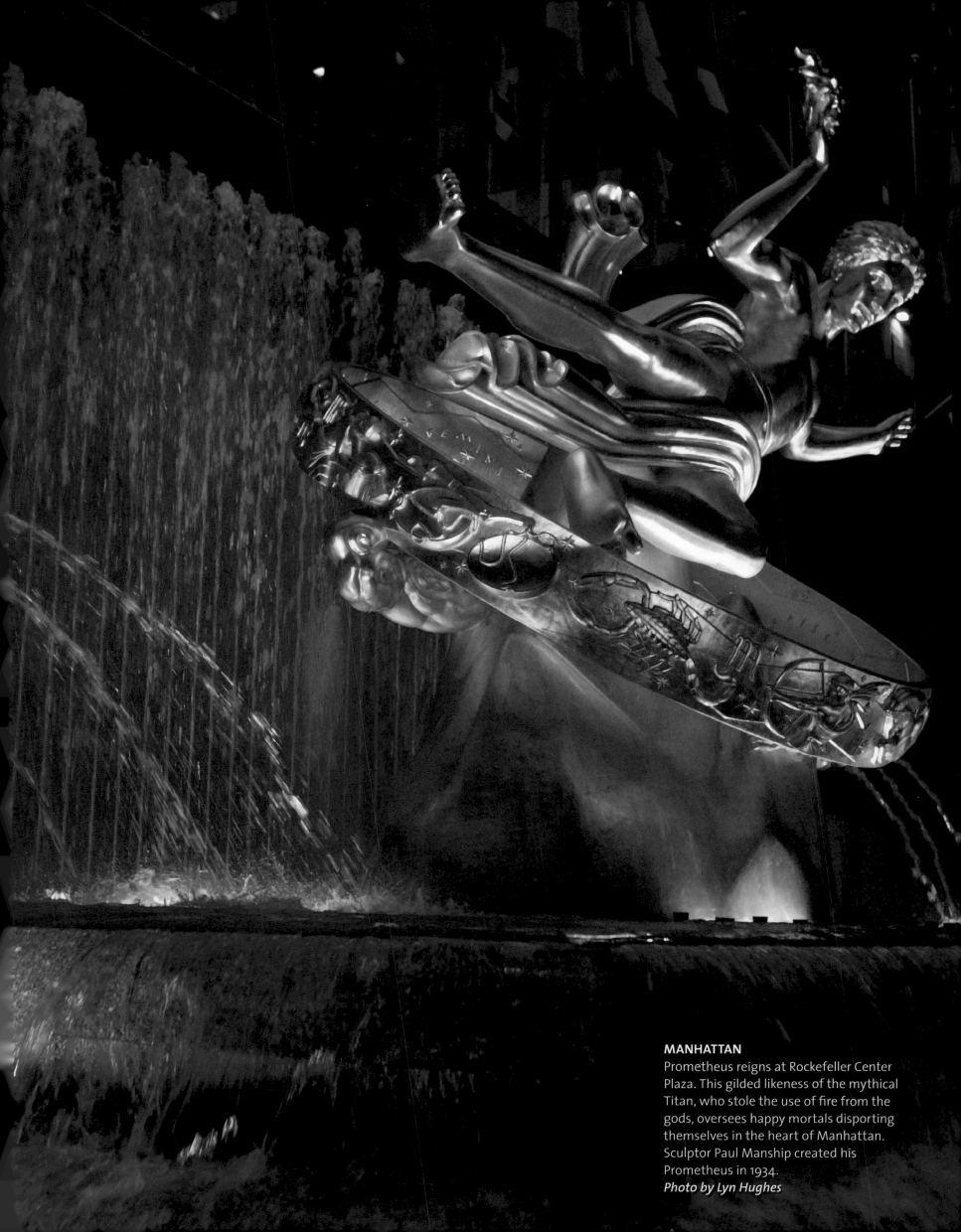

MANHATTAN
Prometheus reigns at Rockefeller Center
Plaza. This gilded likeness of the mythical
Titan, who stole the use of fire from the
gods, oversees happy mortals disporting
themselves in the heart of Manhattan.
Sculptor Paul Manship created his
Prometheus in 1934.
Photo by Lyn Hughes

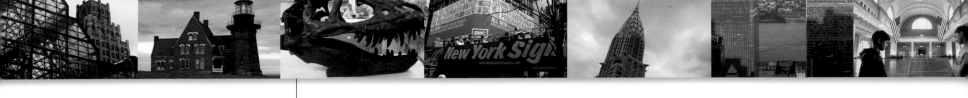

ROCHESTER

At the Rochester Museum & Science Center's paleontology lab, Director of Collections George C. McIntosh is hard at work on plans to restore the Natural Science Hall. The skull cast is an Albertosaurus, the older cousin of the T-rex that ruled North America more than 80 million years ago.

Photo by Carlos Ortiz, Democrat and Chronicle

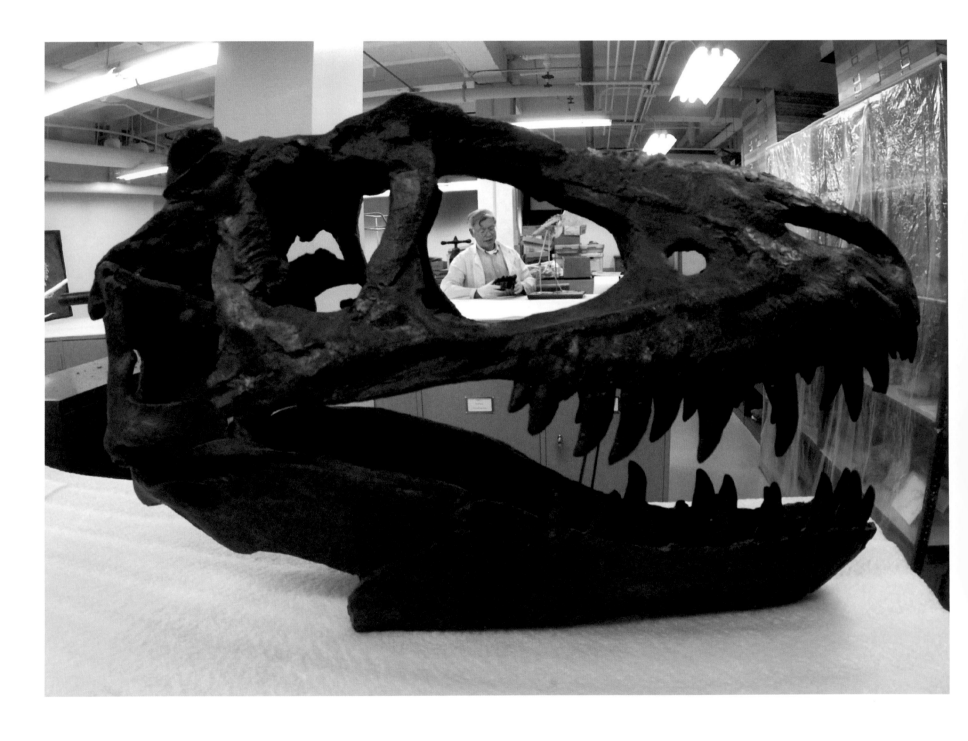

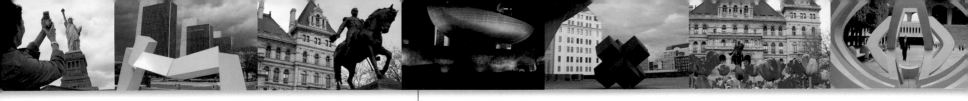

ALBANY

The Center for Performing Arts, aka the Egg, is a focal point of Empire State Plaza, the state government complex built in the 1960s by former Governor Nelson Rockefeller. Wallace K. Harrison, architect for the United Nations and Lincoln Center, designed the poured-concrete structure, which contains two theaters.
Photo by Patrick Harbron

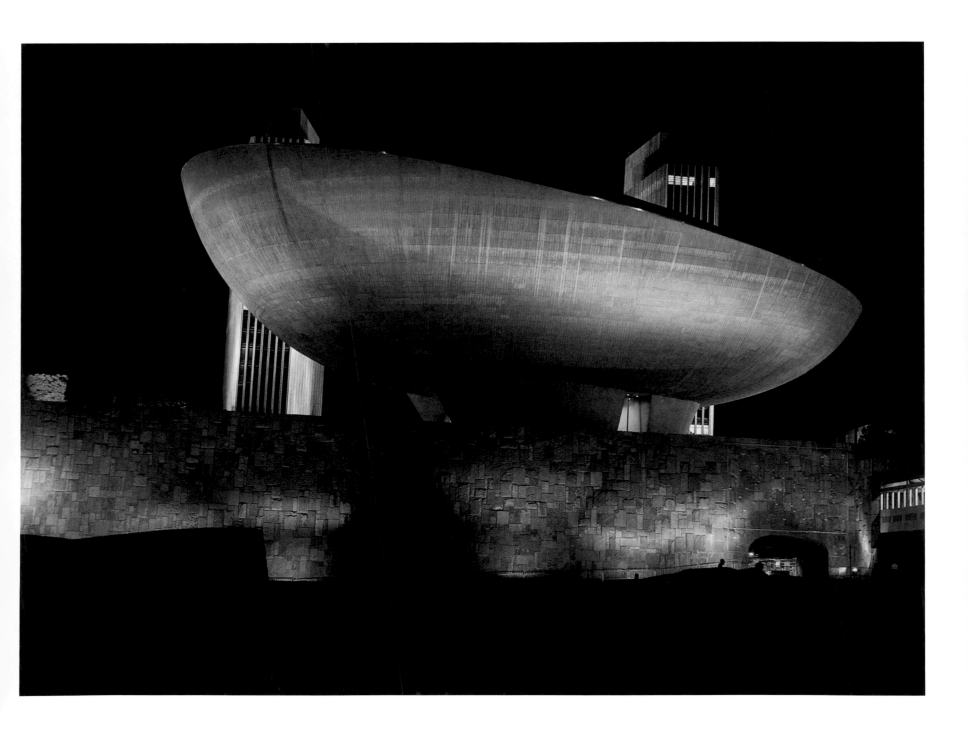

MOUNT SINAI

Mirror, mirror, at the fair, who's that clown with yellow hair? Why, it's Cubby the Clown, aka Maureen Schneider, a 21-year veteran of children's parties and corporate events. The fair is the 14th annual Music and Arts at the Beach—Cedar Beach, that is.

Photo by John Griffin

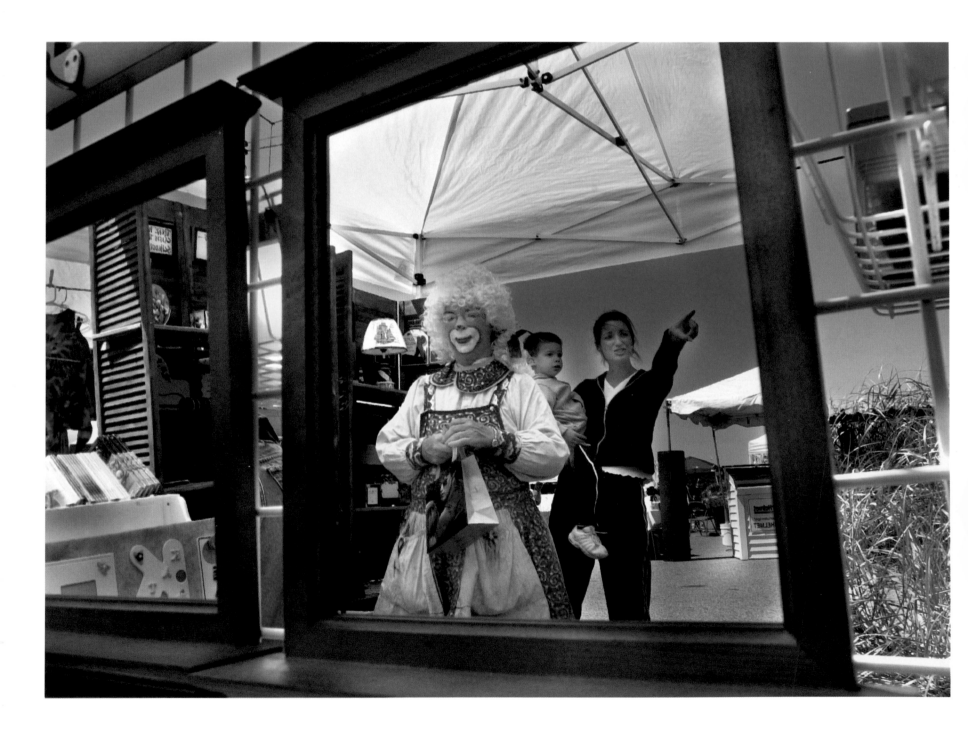

QUEENS

It's an early Saturday evening in Jackson Heights, home to many ethnic groups, including East Indians. Their community is so well established that compatriots from New York State, New Jersey, and Pennsylvania arrive on weekends to shop for everything from saris and bangles to Bengali CDs and Bollywood DVDs.
Photo by Frank Fournier, Contact Press Images

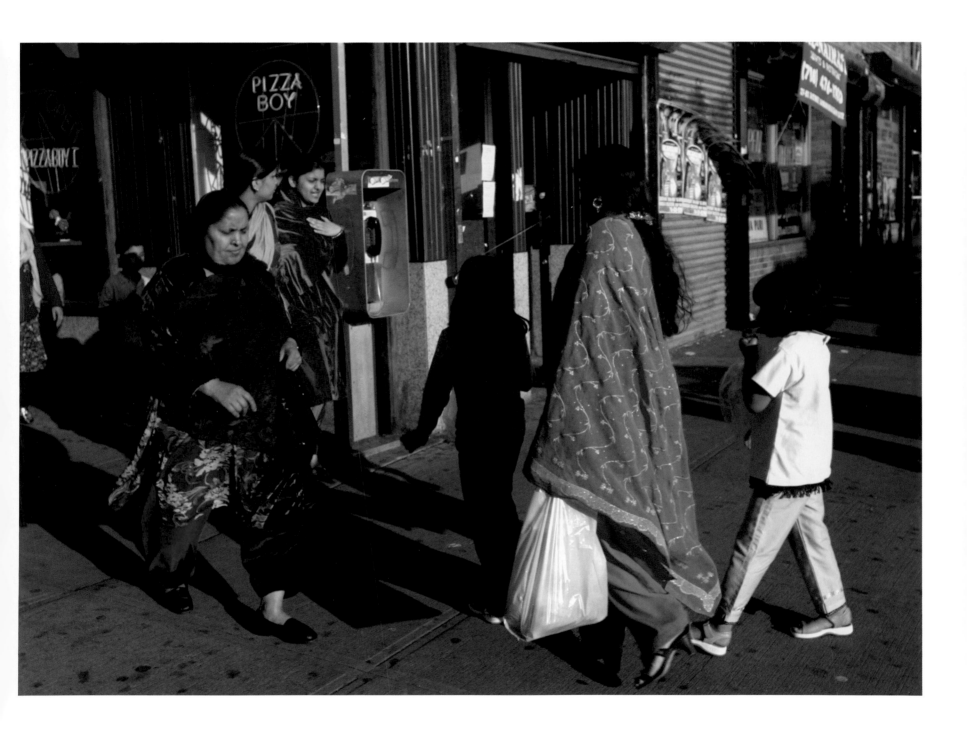

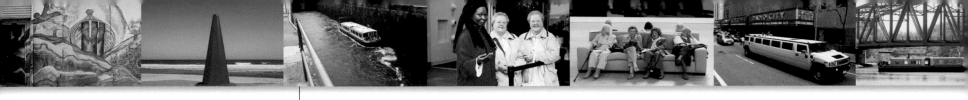

PITTSFORD

The *Sam Patch* bides its time in Lock 32 of the Erie Canal. The replica 19th-century canal boat is used to educate the public about the history of New York's 524-mile canal system. The Erie Canal, opened in 1825, connected the Hudson to the Great Lakes, transforming New York City into the busiest port in America.
Photo by Susan Stava

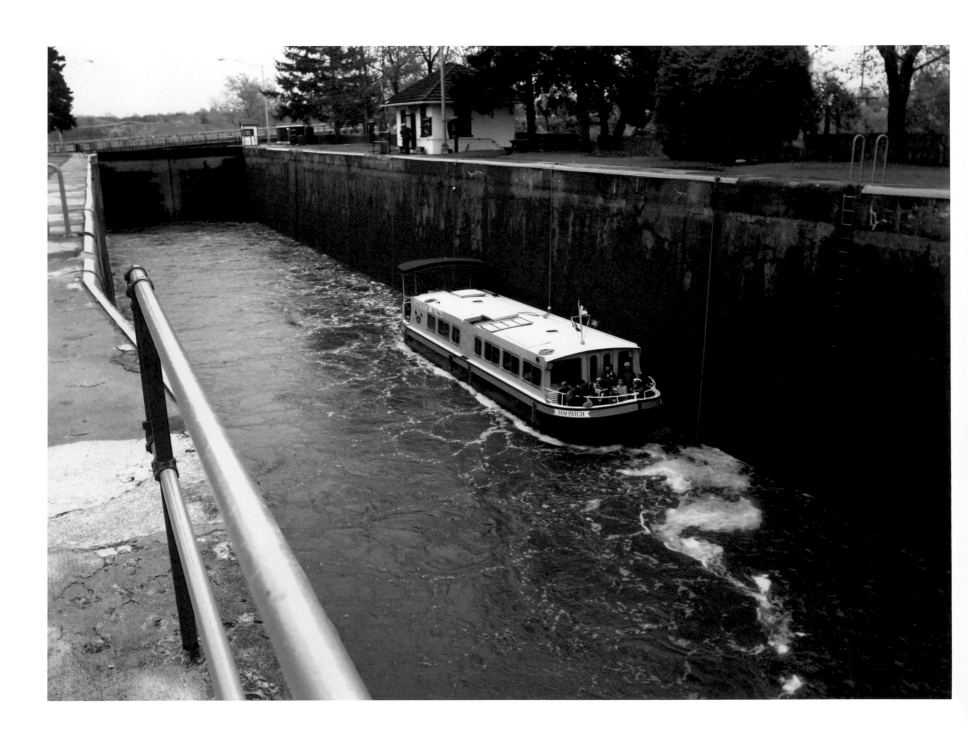

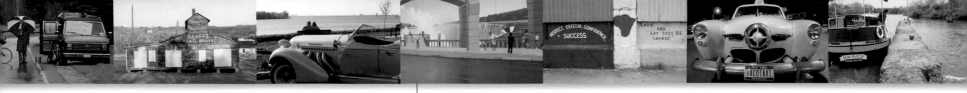

NIAGARA FALLS

These falls are painted on a factory outlet mall,
but the upturned umbrella is real. So is the woman
trying to manage it on a rainy, windy day.
Photo by Darren Levant

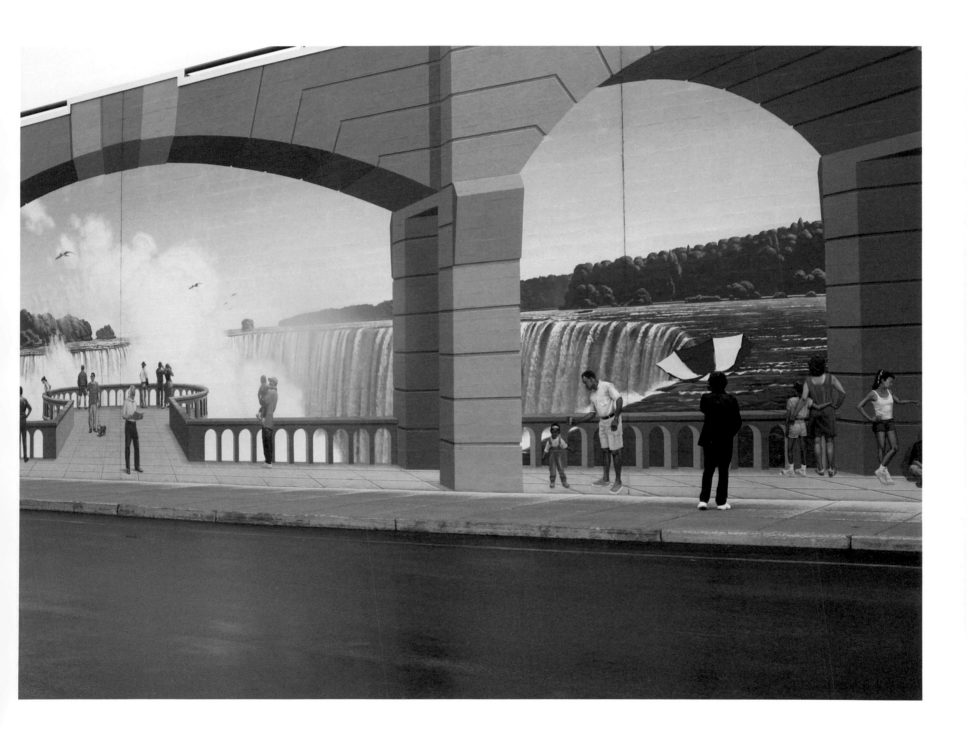

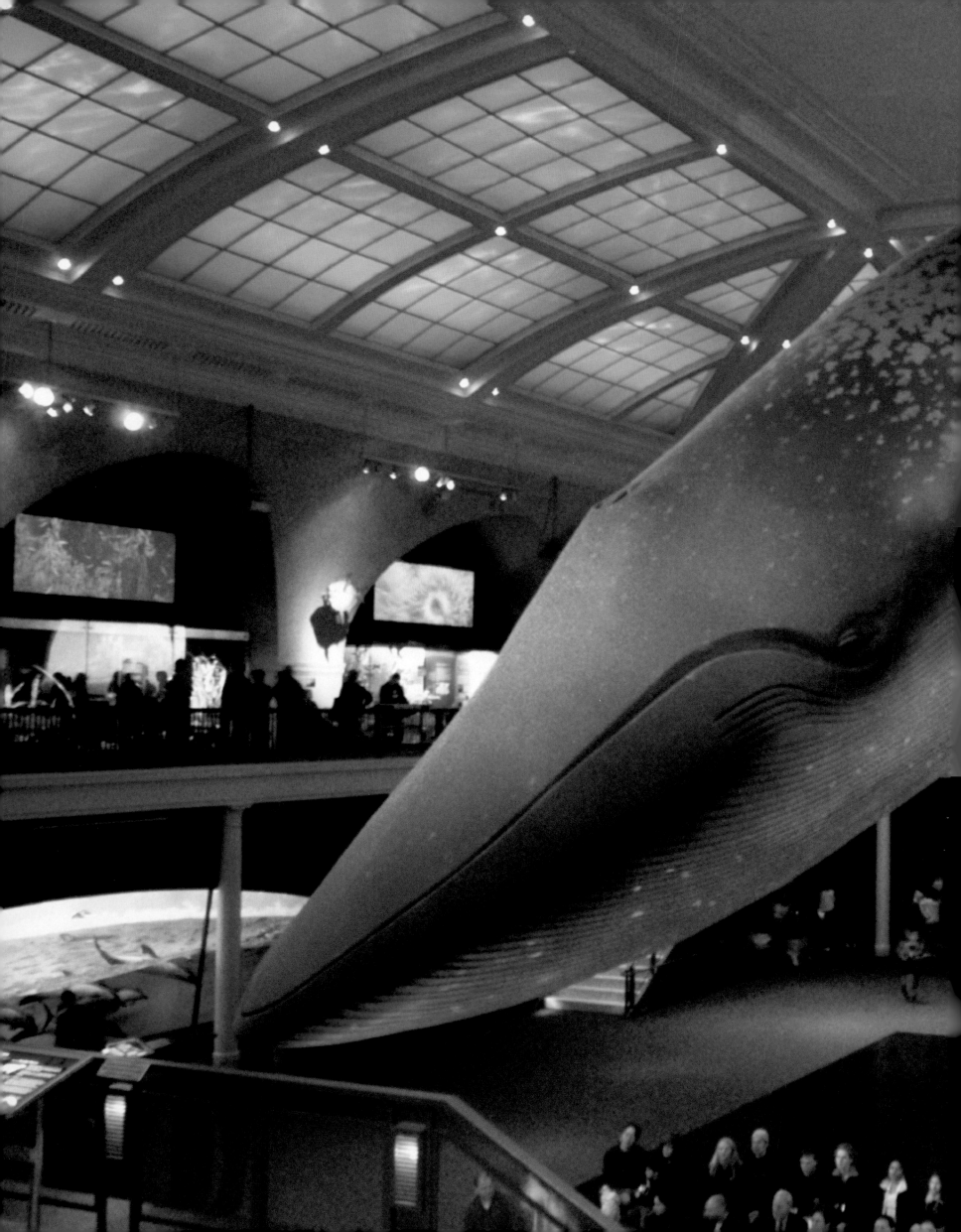

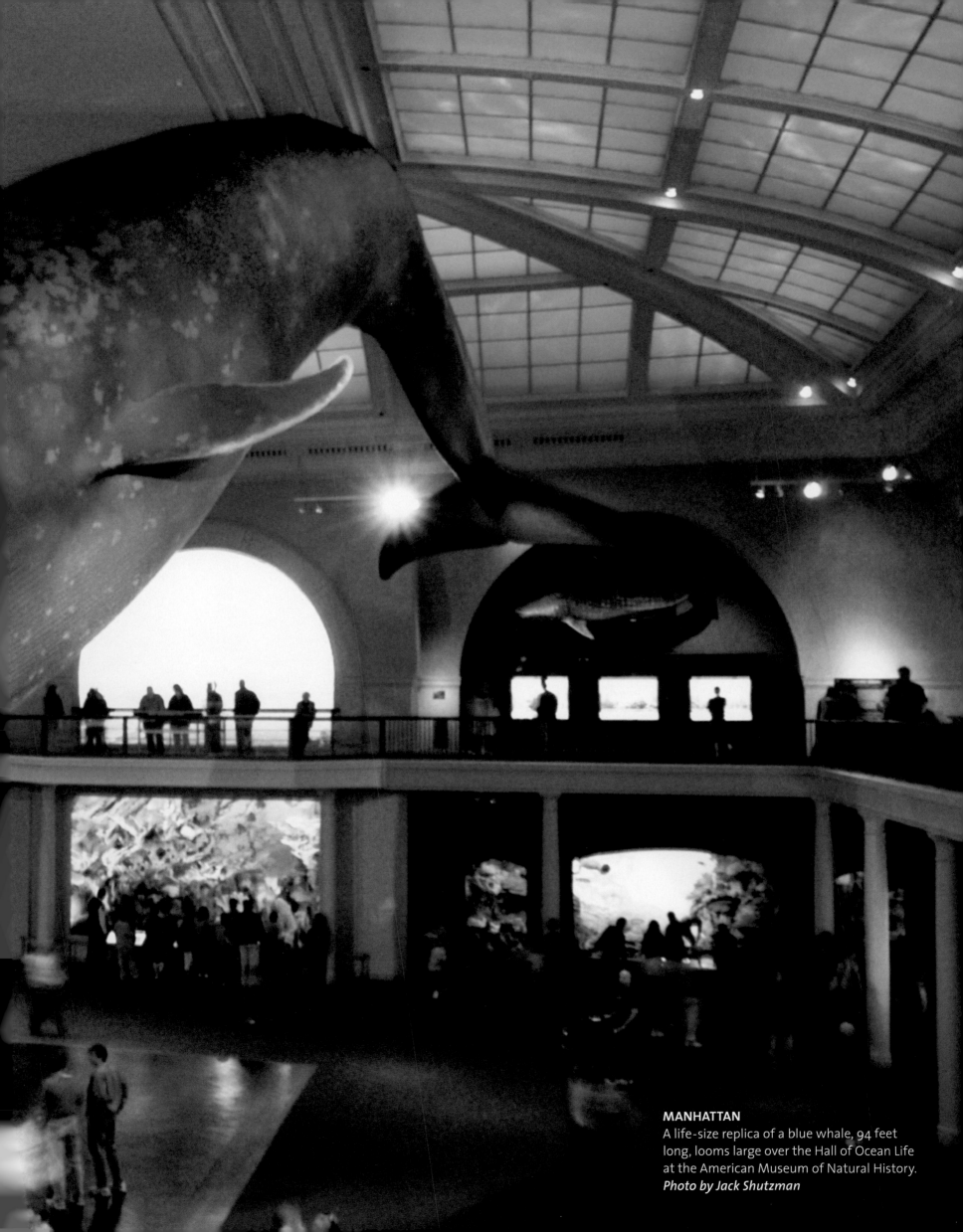

MANHATTAN
A life-size replica of a blue whale, 94 feet long, looms large over the Hall of Ocean Life at the American Museum of Natural History.
Photo by Jack Shutzman

MANHATTAN

Thirty years ago, armed muggers, hustlers, and petty thieves were commonplace at Times Square, but two decades of relighting, revamping, and redeveloping the old pleasure dome have pushed back its fearsome shadows. Now, a lone woman can wait atop her luggage for a Sunday-night rendezvous with a friend in relative peace.
Photo by Gus Powell

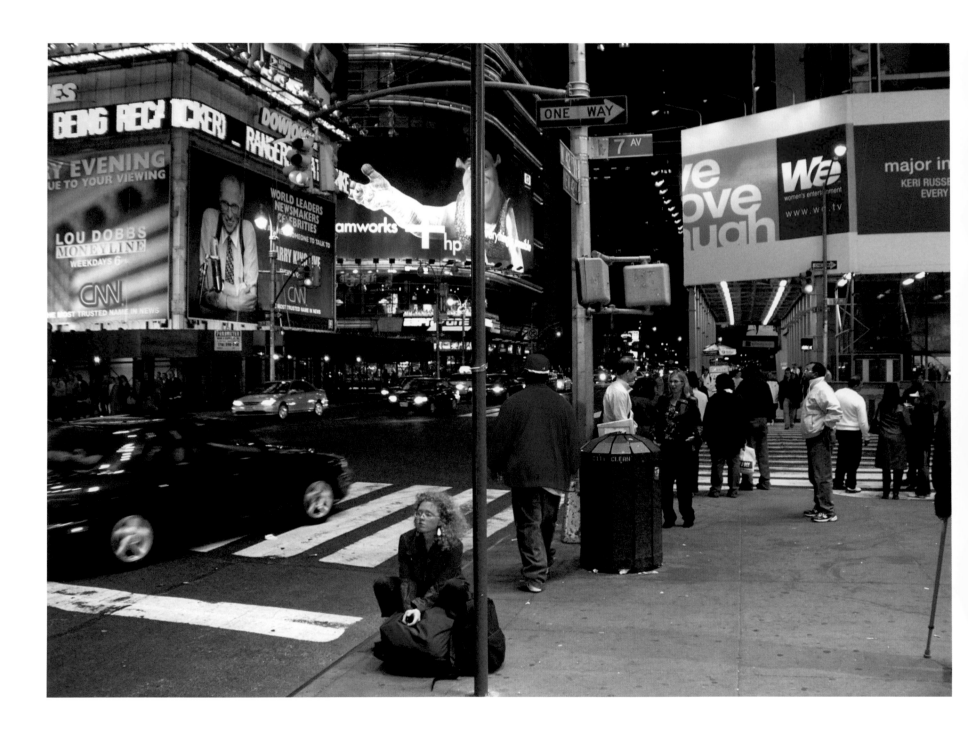

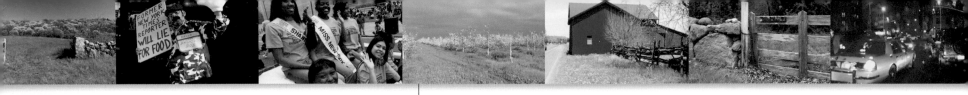

KINDERHOOK
Far from the Big Apple, little apples blossom. This
orchard, along Route 9 in upstate New York, is
part of Golden Harvest Farms.
Photo by Patrick Harbron

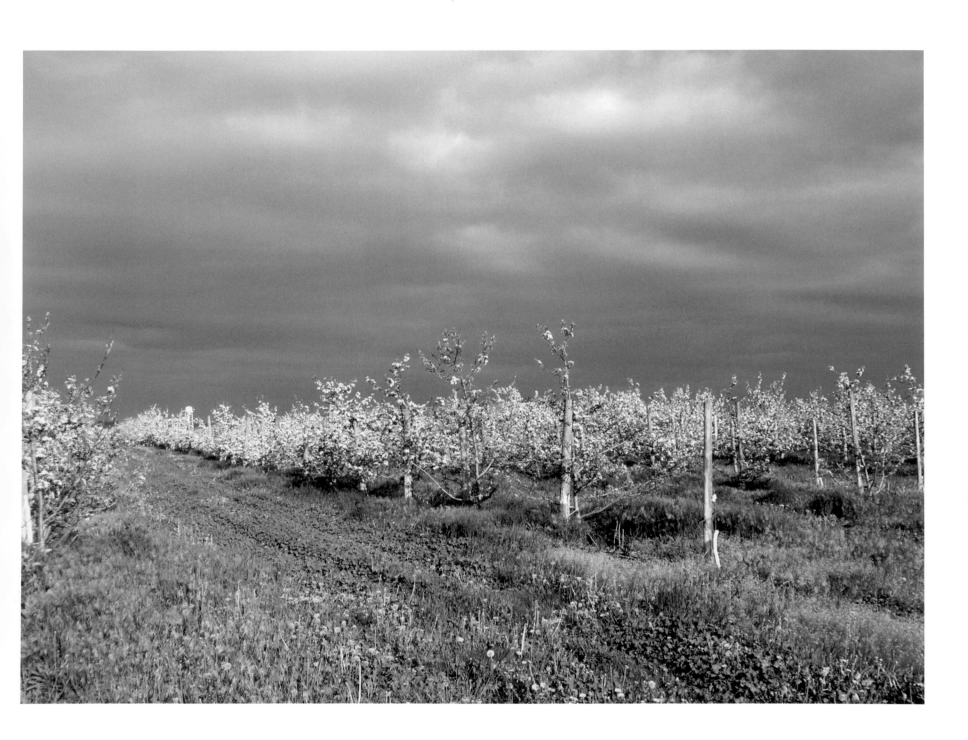

HARLEM
Children's Storefront School fourth-graders jump into action on the first warm day of spring. With minimal or no playgrounds, city schools close down the street at recess.
Photo by Martha Cooper

Marianna Fadhil and Marvin Lee wait for their dads outside Gentner Commission Market, a weekly auction dating back to 1939. While many come to this chaotic gathering in rural western New York to find hidden treasures among the mounds of molding books, lawn ornaments, and antique jewelry, Marianna and Melvin's dads come for the afternoon livestock auction.
Photo by Susan Stava

AURELIUS

At the entrance to the 53-year-old Finger Lakes Drive-In, owner Kevin Mullin sells tickets ($6 for a double feature) to Cayuga County's oldest outdoor picture show. In warm weather, viewers abandon their cars to barbecue before showtime and then set up their lawn chairs in front of the screen.
Photo by Kevin Rivoli

QUEENS

Between Times Square and Flushing, the 7 train may go through more neighborhoods than any subway anywhere. If you get out at the Roosevelt Avenue at 74th Street stop and walk toward 80th, you'll see people and businesses representing virtually every country in Central and South America.
Photo by Frank Fournier,
Contact Press Images

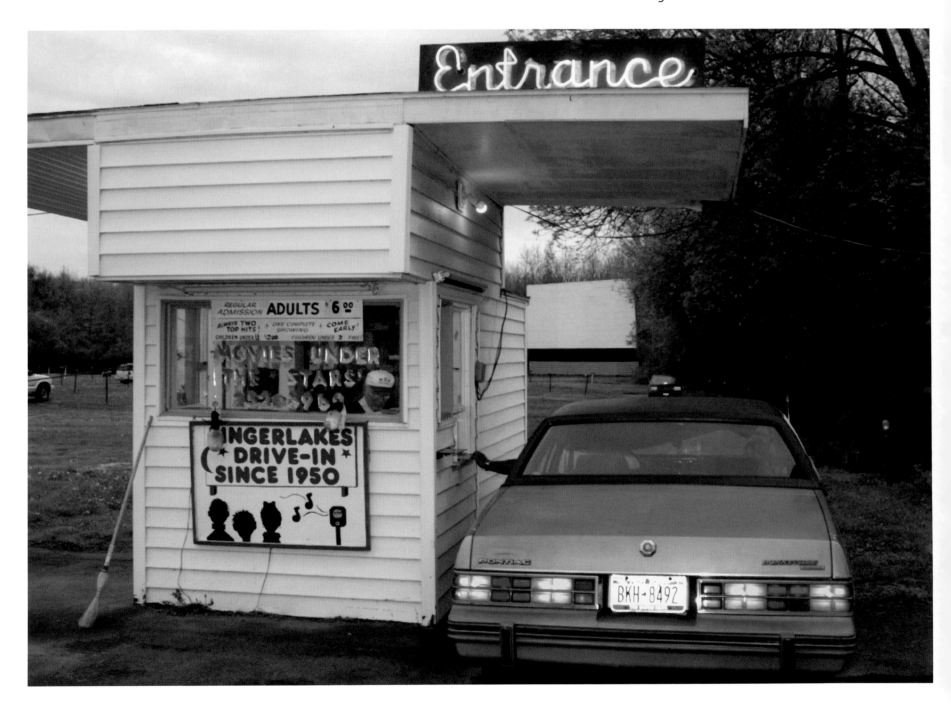

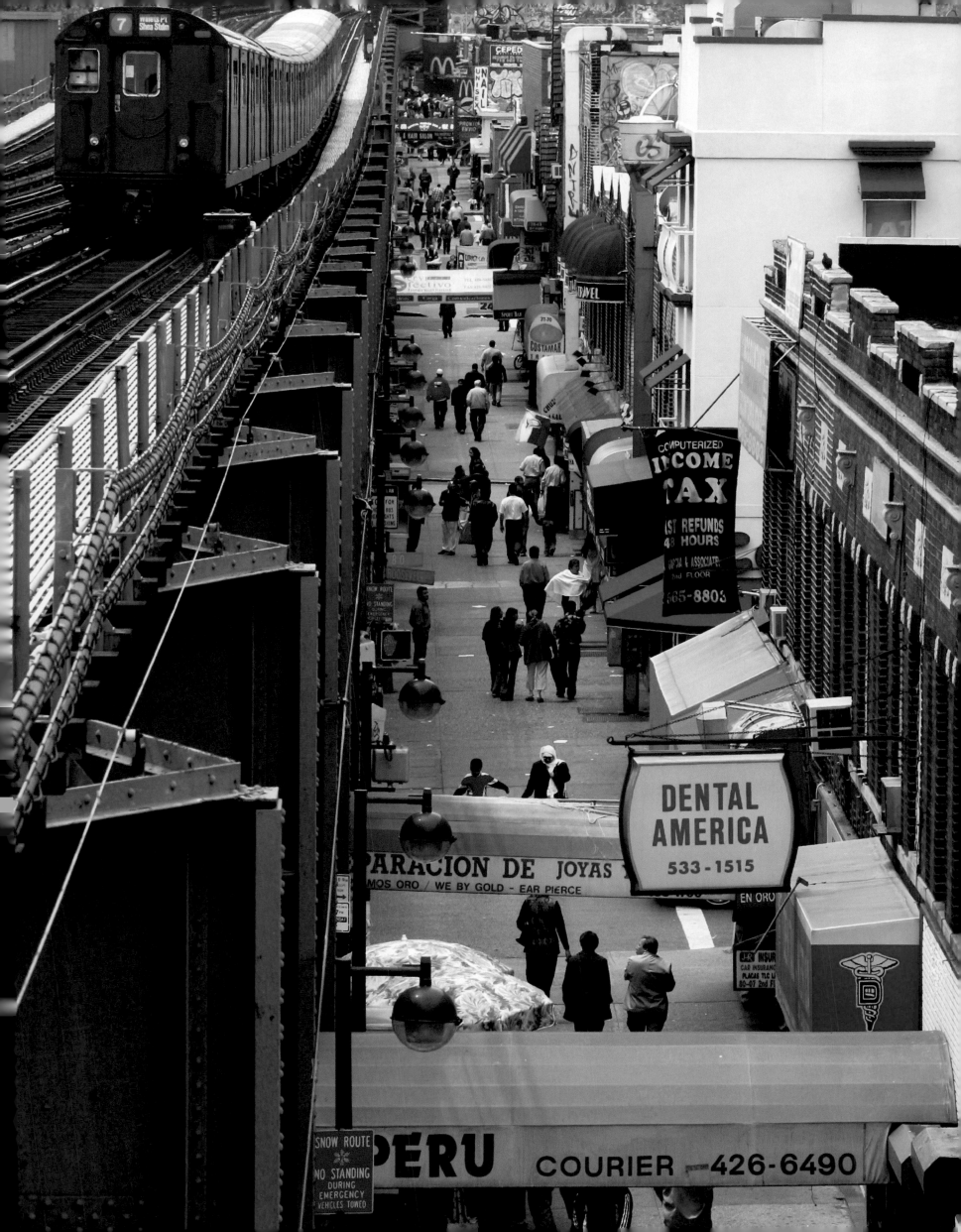

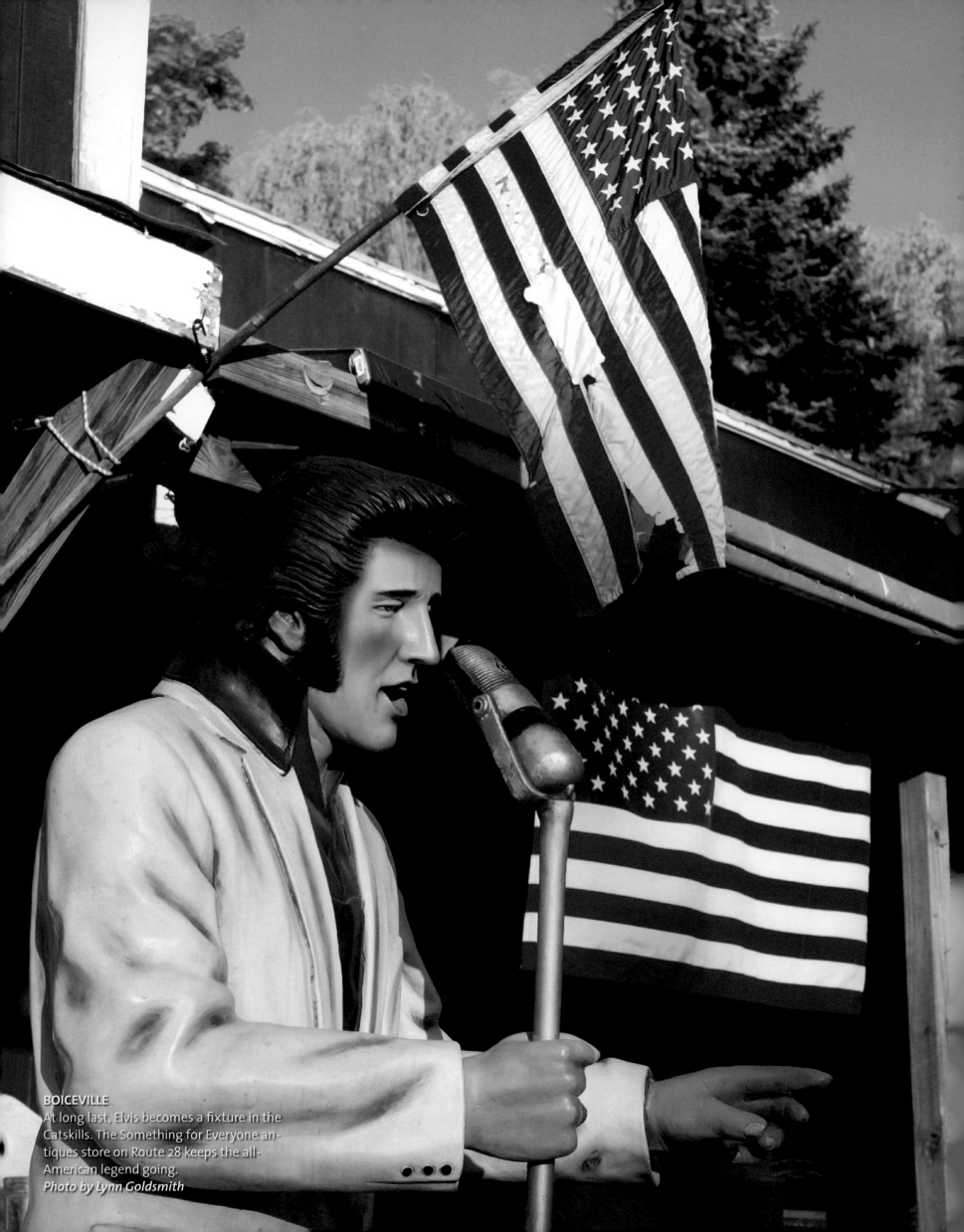

BOICEVILLE
At long last, Elvis becomes a fixture in the Catskills. The Something for Everyone antiques store on Route 28 keeps the all-American legend going.
Photo by Lynn Goldsmith

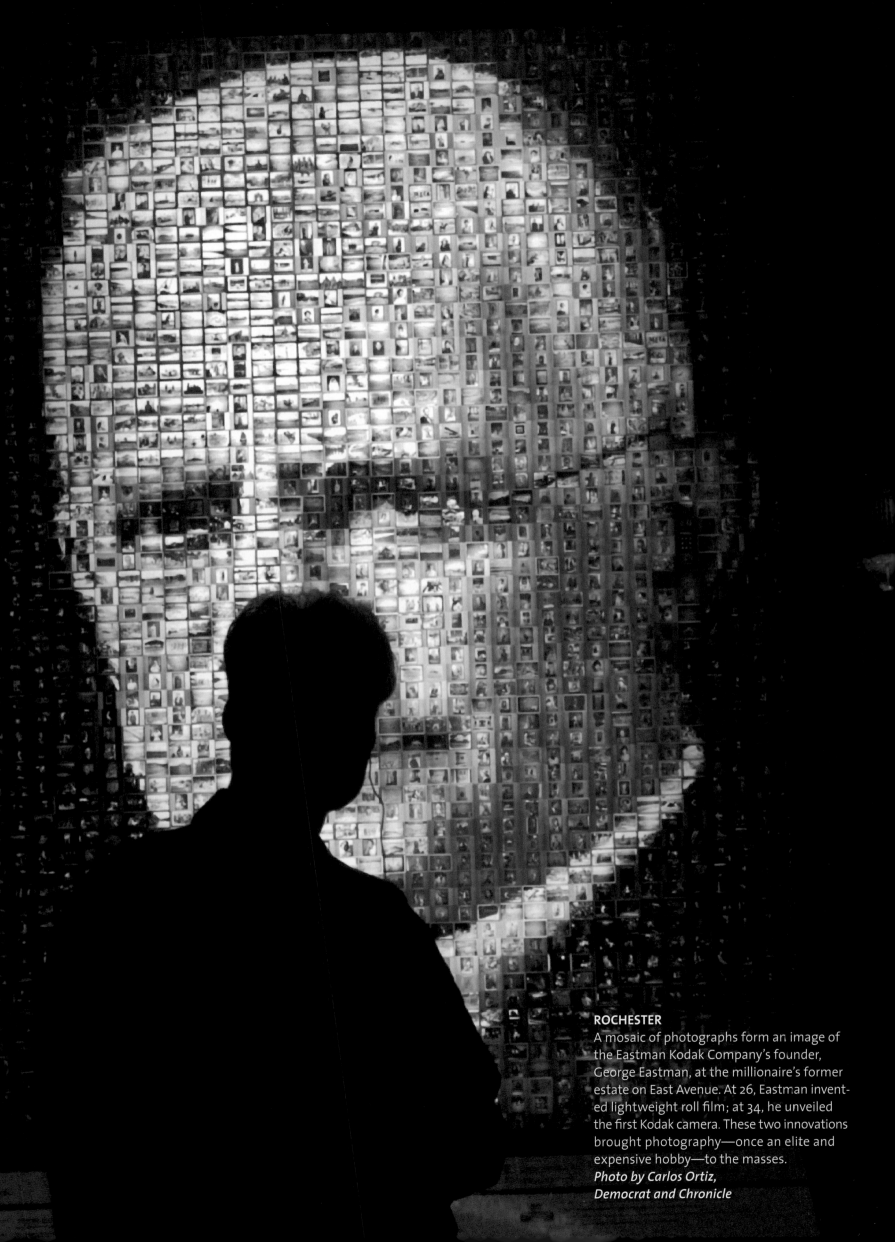

ROCHESTER
A mosaic of photographs form an image of the Eastman Kodak Company's founder, George Eastman, at the millionaire's former estate on East Avenue. At 26, Eastman invented lightweight roll film; at 34, he unveiled the first Kodak camera. These two innovations brought photography—once an elite and expensive hobby—to the masses.
Photo by Carlos Ortiz,
Democrat and Chronicle

INLET

The lapping of the lake, the dock's slow pitch, and the warm sun lull Brian Staiger and his daughter Maddie to sleep. The Staiger family drove from Binghamton to enjoy some off-season solitude at Seventh Lake in Adirondack Park, the largest protected area in the contiguous U.S.
Photo by Nancie Battaglia

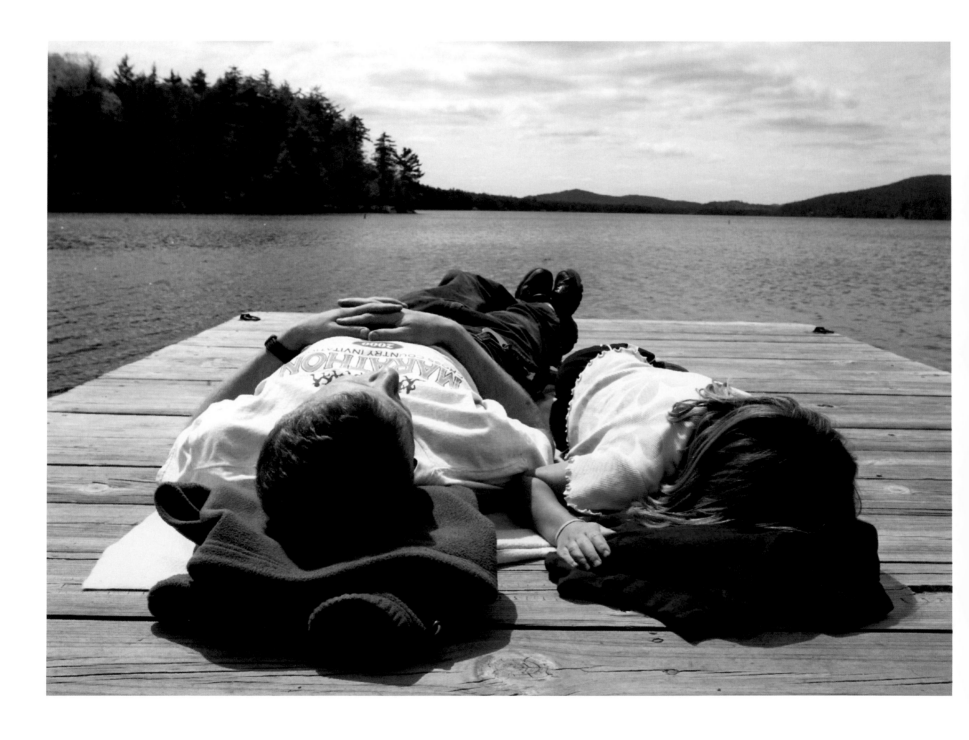

MANHATTAN
West Side stories: Taking daughter Sandy to
school and dogs Kimba and Mickey for a walk,
divorced father and muralist Mike Alpert runs
into a neighbor on West 107th Street.
Photo by Barbara Alper

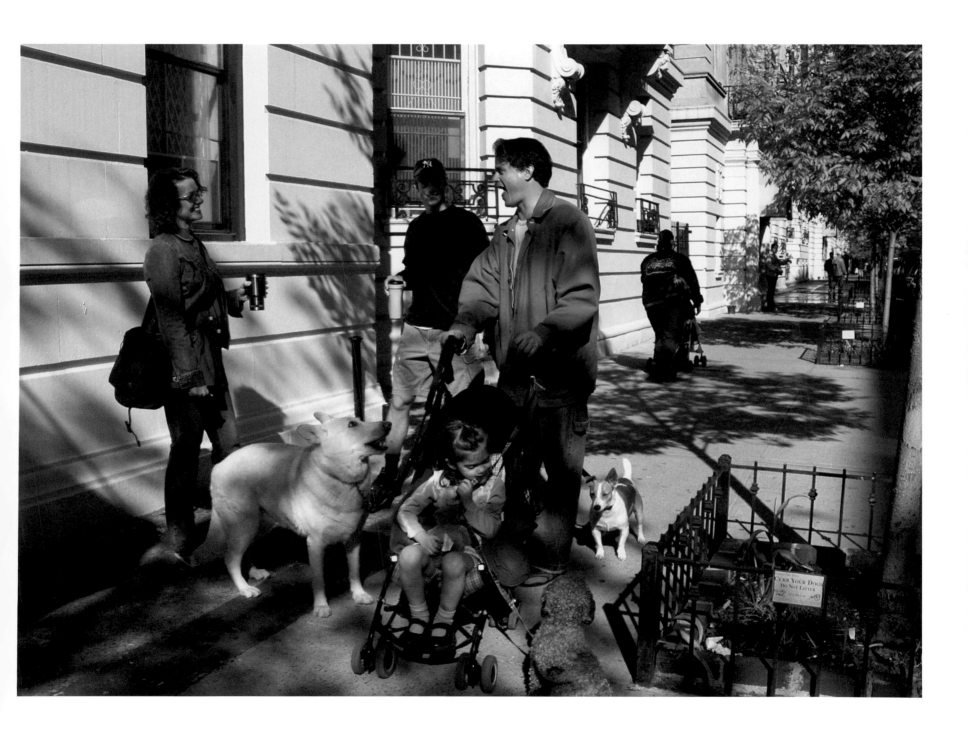

MANHATTAN

Rob Roth and Matt West—in the sunshine and spray of Lincoln Center—are fully vested in New York City entertainment. Roth is a director of musicals, West a choreographer of them. The best friends and working partners met while putting together a show at Disneyland.
Photo by Lynn Goldsmith

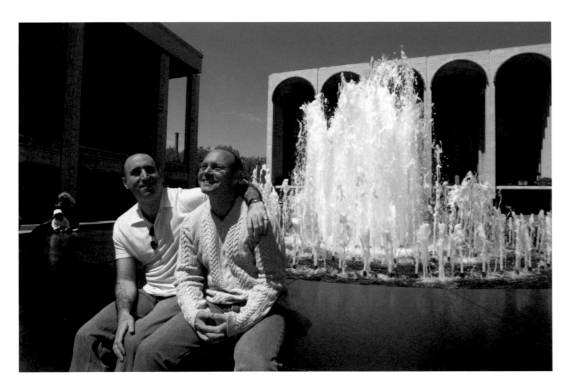

LAKE CHAMPLAIN

Overcast skies were exactly what Cheryl and Brian Ferry were hoping for on their honeymoon. "If we'd gone to the beach, we'd have had to put on SPF-90 and sit in the shade," says the groom. The two redheads avoid the sun at all costs, so this gray ferry ride across Lake Champlain was, in their opinion, "just gorgeous."
Photo by Nancie Battaglia

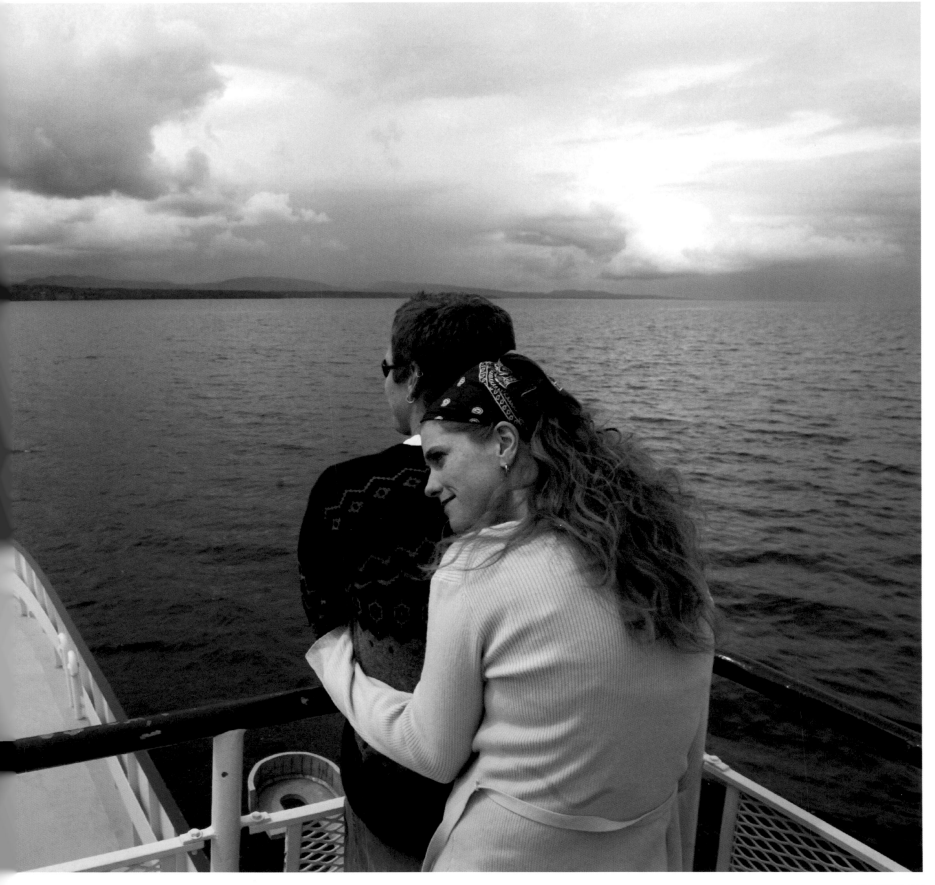

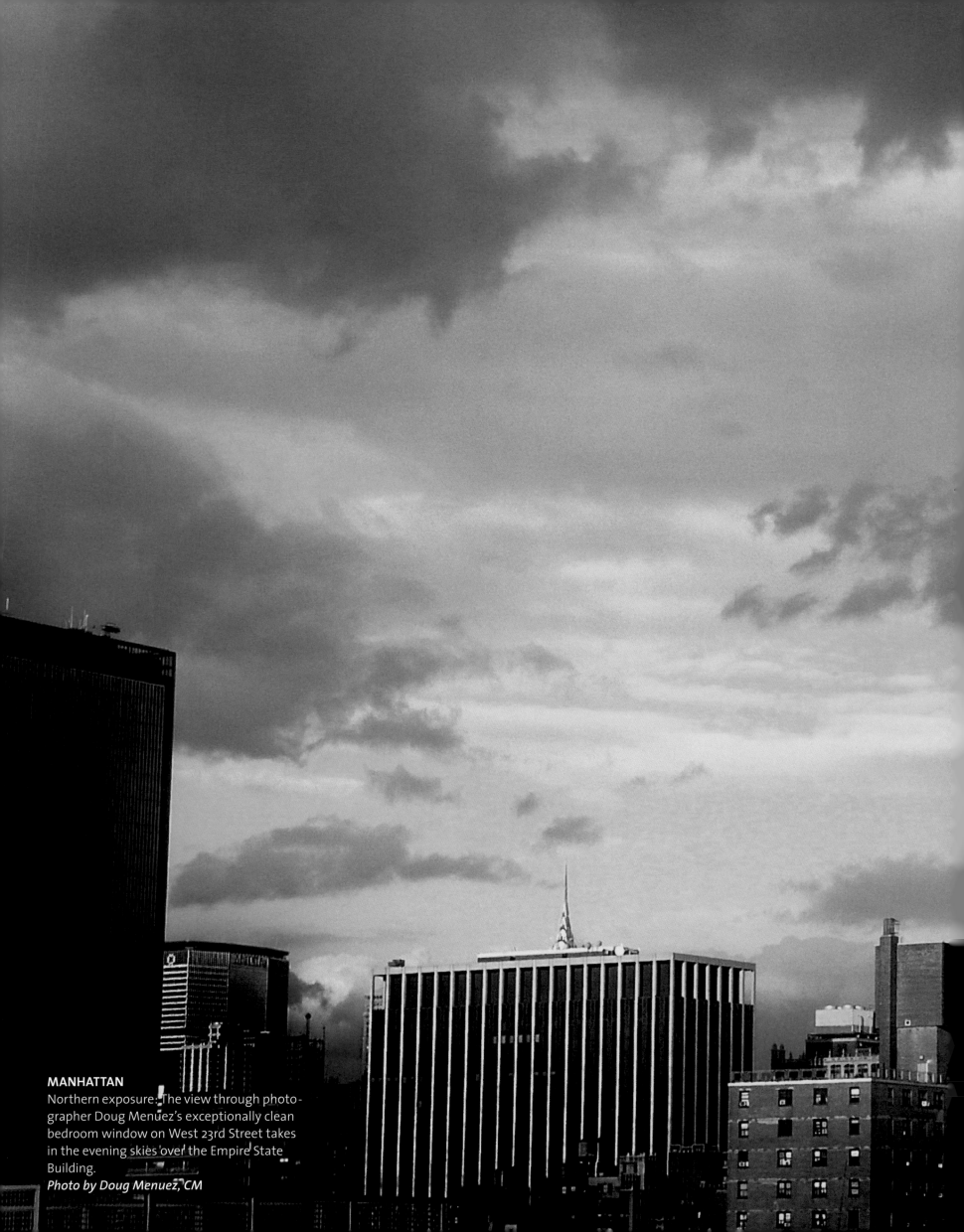

MANHATTAN
Northern exposure: The view through photographer Doug Menuez's exceptionally clean bedroom window on West 23rd Street takes in the evening skies over the Empire State Building.
Photo by Doug Menuez, CM

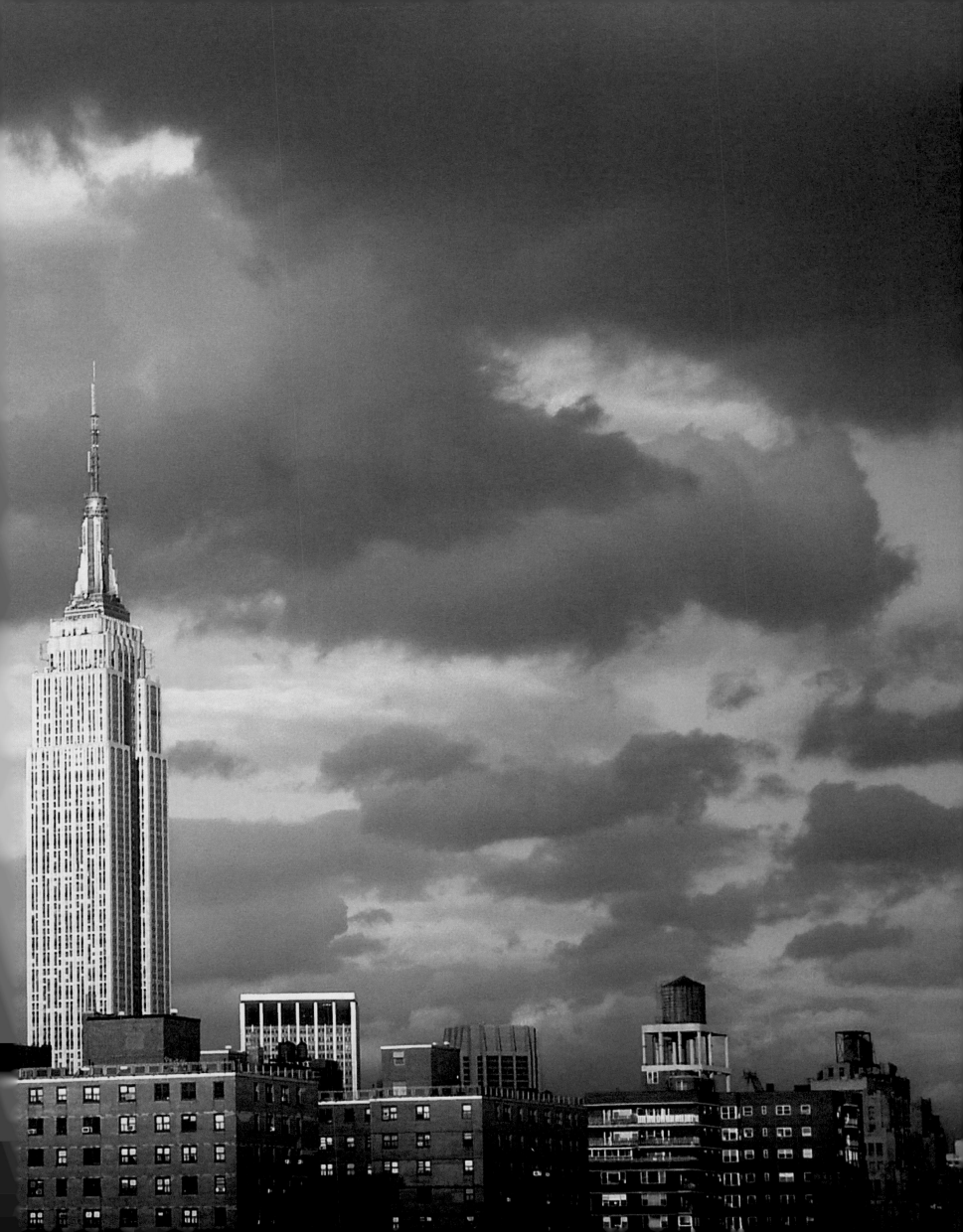

LAKE PLACID
Adirondack first light: Mirror Lake reflects cool
northern repose, before kayakers, canoers, paddle
boaters, and swimmers ruffle its waters.
Photo by Nancie Battaglia

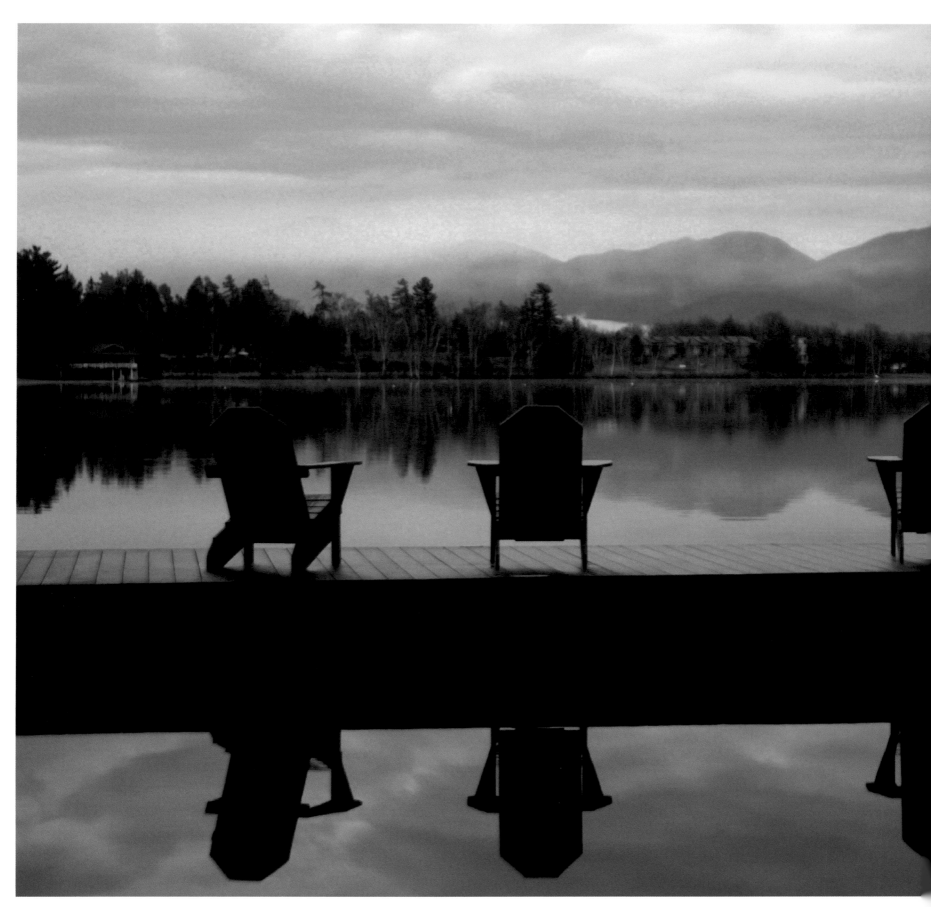

ROBERT MOSES STATE PARK
On a cold, foggy day, two hardy souls stroll the beach of Robert Moses State Park on Fire Island. The magnificent beach park anchors the western end of the narrow, 30-mile-long strip of sand, which protects the south shore of Long Island and harbors a series of car-less beach colonies.
Photo by Doug Menuez, CM

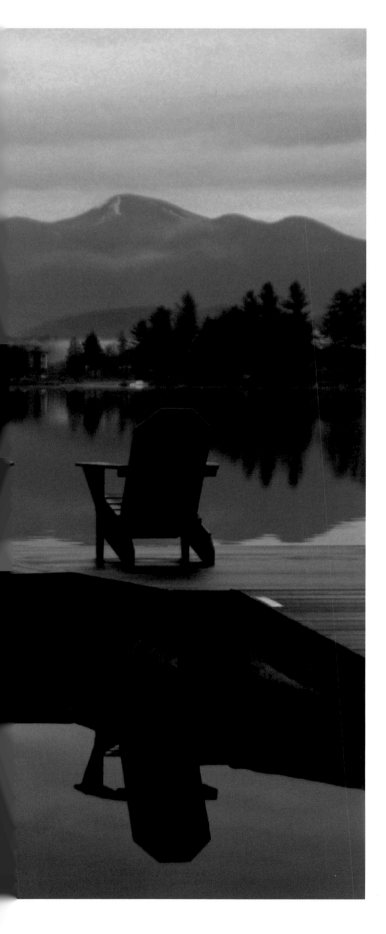

MANHATTAN

From the air, as from the street, lower Manhattan at any hour looks simultaneously packed with office towers and bereft of its two tallest ones.
Photos by Joe McNally

MANHATTAN

Work lights left on throughout the night illuminate the reconstruction of underground transit facilities at Ground Zero, site of the destroyed World Trade Center.

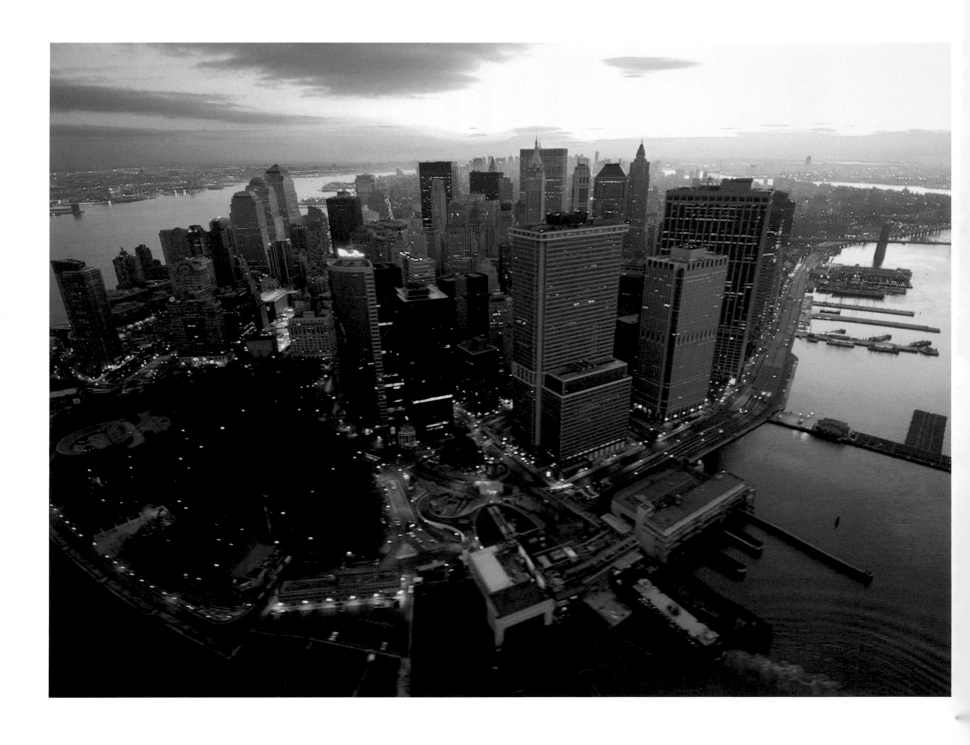

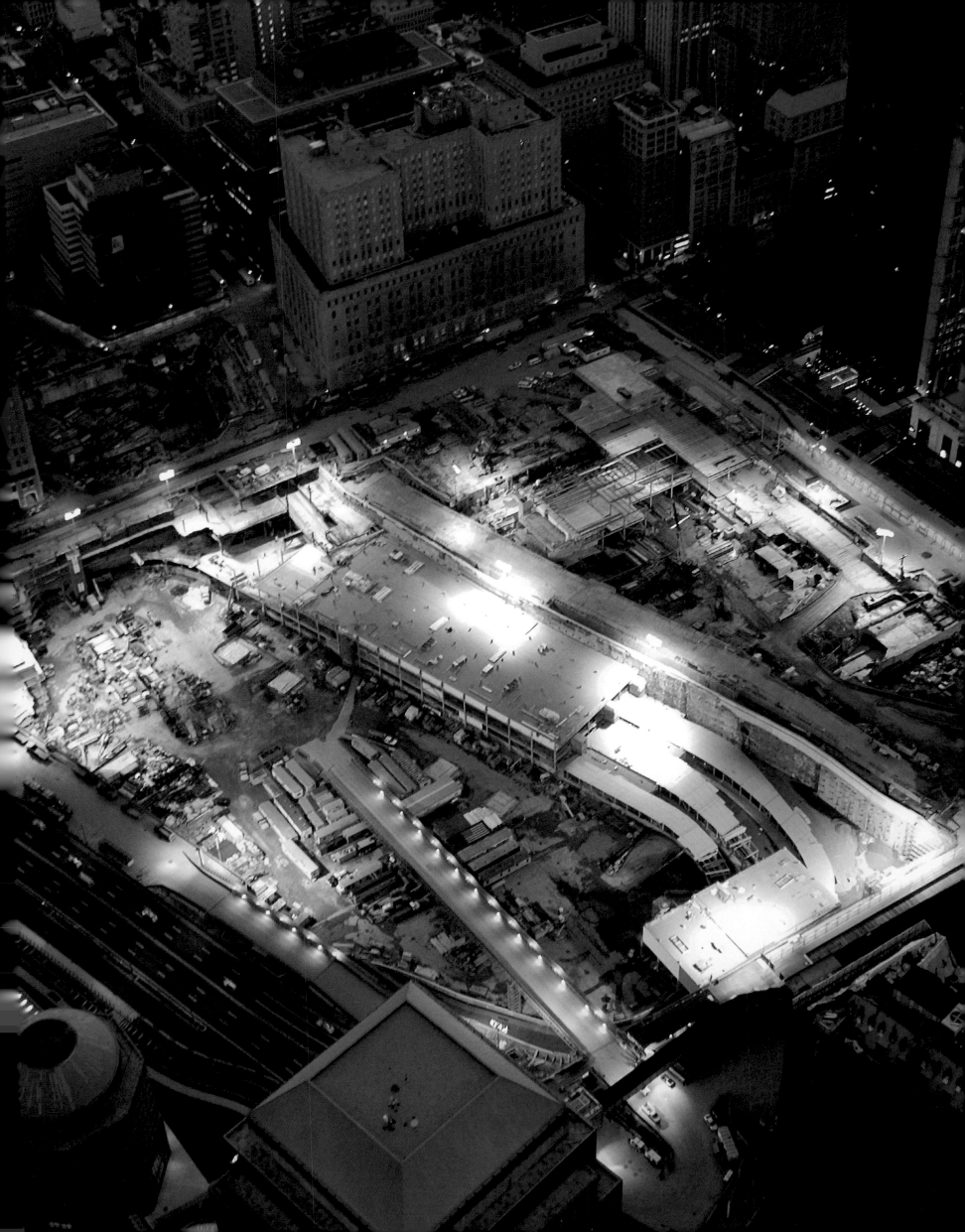

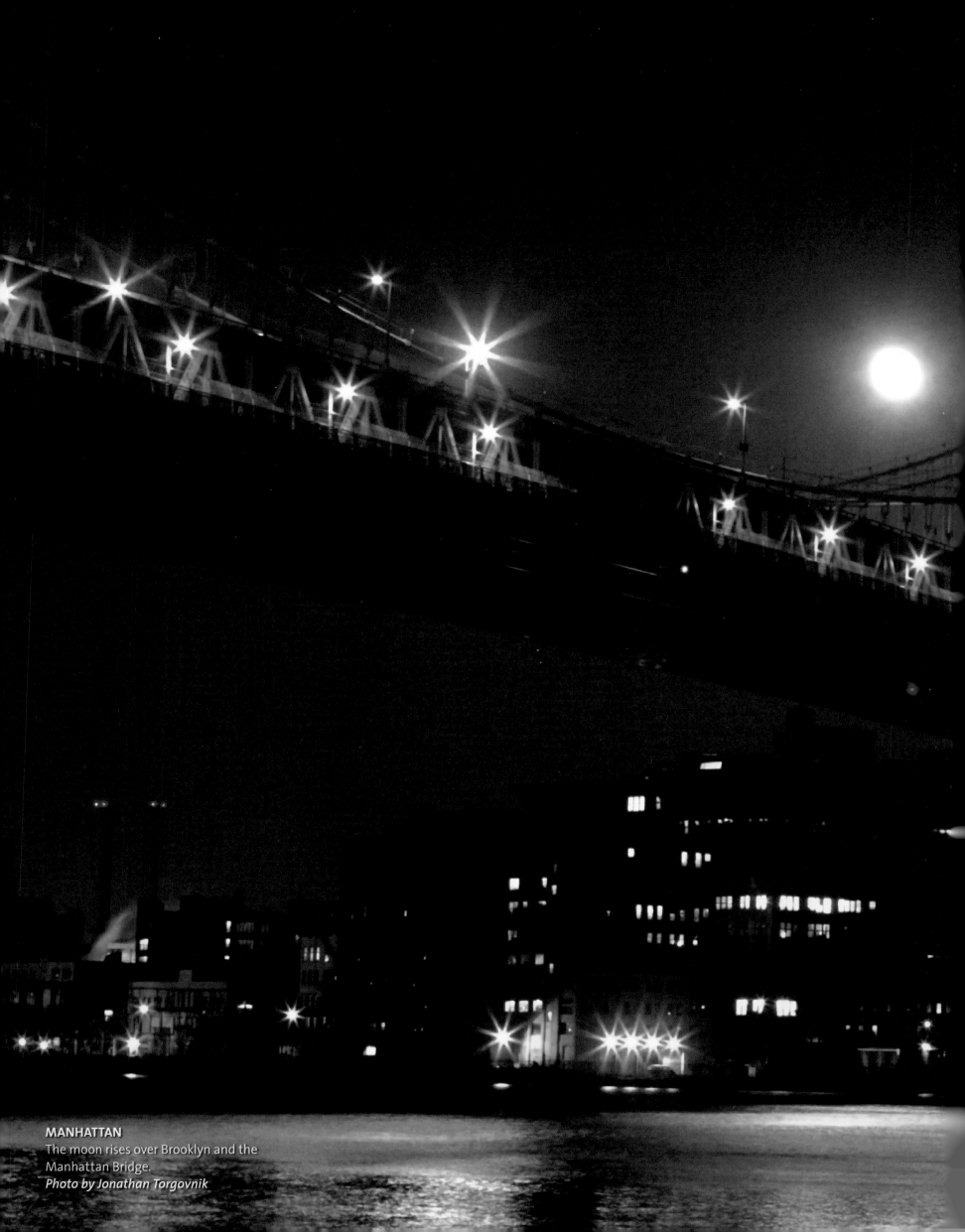

MANHATTAN
The moon rises over Brooklyn and the
Manhattan Bridge.
Photo by Jonathan Torgovnik

How It Worked

T he week of May 12-18, 2003, more than 25,000 professional and amateur photographers spread out across the nation to shoot over a million digital photographs with the goal of capturing the essence of daily life in America.

The professional photographers were equipped with Adobe Photoshop and Adobe Album software, Olympus C-5050 digital cameras, and Lexar Media's high-speed compact flash cards.

The 1,000 professional contract photographers plus another 5,000 stringers and students sent their images via FTP (file transfer protocol) directly to the *America 24/7* website. Meanwhile, thousands of amateur photographers uploaded their images to Snapfish's servers.

At *America 24/7*'s Mission Control headquarters, located at CNET in San Francisco, dozens of picture editors from the nation's most prestigious publications culled the images down to 25,000 of the very best, using Photo Mechanic by Camera Bits. These photos were transferred into Webware's ActiveMedia Digital Asset Management (DAM) system, which served as a central image library and enabled the designers to track, search, distribute, and reformat the images for the creation of the 51 books, foreign language editions, web and magazine syndication, posters, and exhibitions.

Once in the DAM, images were optimized (and in some cases resampled to increase image resolution) using Adobe Photoshop. Adobe InDesign and Adobe InCopy were used to design and produce the 51 books, which were edited and reviewed in multiple locations around the world in the form of Adobe Acrobat PDFs. Epson Stylus printers were used for photo proofing and to produce large-format images for exhibitions. The companies providing support for the *America 24/7* project offer many of the essential components for anyone building a digital darkroom. We encourage you to read more on the following pages about their respective roles in making *America 24/7* possible.

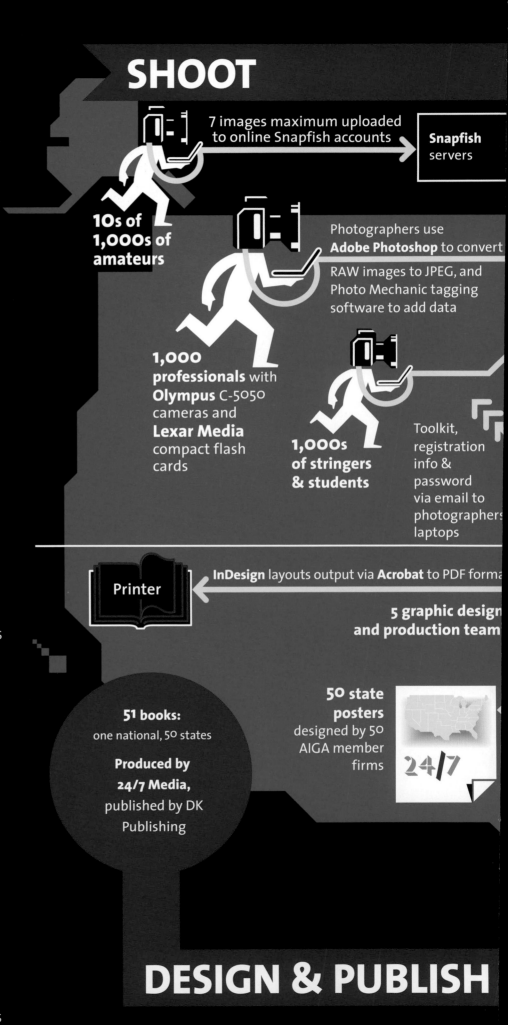

SHOOT

7 images maximum uploaded to online Snapfish accounts → **Snapfish** servers

10s of 1,000s of amateurs

Photographers use **Adobe Photoshop** to convert RAW images to JPEG, and Photo Mechanic tagging software to add data

1,000 professionals with **Olympus** C-5050 cameras and **Lexar Media** compact flash cards

1,000s of stringers & students

Toolkit, registration info & password via email to photographers laptops

Printer ← **InDesign** layouts output via **Acrobat** to PDF format

5 graphic design and production team

51 books: one national, 50 states

Produced by 24/7 Media, published by DK Publishing

50 state posters designed by 50 AIGA member firms

24/7

DESIGN & PUBLISH

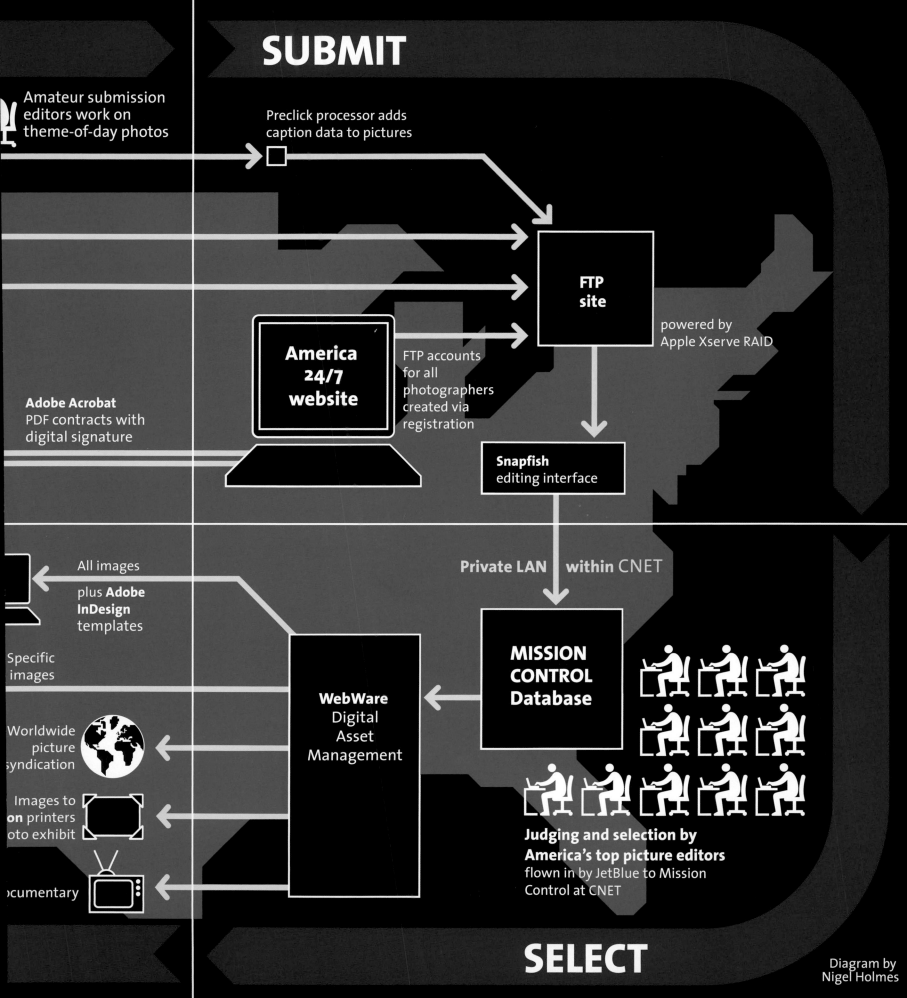

SUBMIT

Amateur submission
editors work on
theme-of-day photos

Preclick processor adds
caption data to pictures

**FTP
site**

powered by
Apple Xserve RAID

**America
24/7
website**

FTP accounts
for all
photographers
created via
registration

Adobe Acrobat
PDF contracts with
digital signature

Snapfish
editing interface

All images

plus **Adobe
InDesign**
templates

Private LAN **within** CNET

Specific
images

**MISSION
CONTROL
Database**

Worldwide
picture
syndication

WebWare
Digital
Asset
Management

Images to
on printers
oto exhibit

**Judging and selection by
America's top picture editors**
flown in by JetBlue to Mission
Control at CNET

ocumentary

SELECT

Diagram by
Nigel Holmes

About Our Sponsors

America 24/7 gave digital photographers of all levels the opportunity to share their visions of what it means to live in the United States. This project was made possible by a digital photography revolution that is dramatically changing and improving picture-taking for professionals and amateurs alike. And an Adobe product, Photoshop®, has been at the center of this sea change.

Adobe's products reflect our customers' passion for the creative process, be it the photographer, graphic designer, layout artist, or printer. Adobe is the Publishing and Imaging Software Partner for *America 24/7* and products such as Adobe InDesign®, Photoshop, Acrobat®, and Illustrator® were used to produce this stunning book in a matter of weeks. We hope that our software has helped do justice to the mythic images, contributed by well-known photographers and the inspired hobbyist.

Adobe is proud to be a lead sponsor of *America 24/7*, a project that celebrates the vibrancy of the American spirit: the same spirit that helped found Adobe and inspires our employees and customers to deliver the very best.

Bruce Chizen
President and CEO
Adobe Systems Incorporated

Olympus, a global technology leader in designing precision healthcare solutions and innovative consumer electronics, is proud to be the official digital camera sponsor of *America 24/7*. The opportunity to introduce Americans from coast to coast to the thrill, excitement, and possibility of digital photography makes the vision behind this book a perfect fit for Olympus, a leader in digital cameras since 1996.

For most people, the essence of digital photography is best grasped through firsthand experience with the technology, which is precisely what *America 24/7* is about. We understand that direct experience is the pathway to inspiration, and welcome opportunities like this sponsorship to bring the power of the digital experience into the lives of people everywhere. To Olympus, *America 24/7* offers a platform to help realize a core mission: to deliver and make accessible the power of the digital experience to millions of American photographers, amateurs, and professionals alike.

The 1,000 professional photographers contracted to shoot on the America 24/7 project were all equipped with Olympus C-5050 digital cameras. Like all Olympus products, the C-5050 is offered by a company well known for designing, manufacturing, and servicing products used by professionals to perform their work, every day. Olympus is a customer-centric company committed to working one-to-one with a diverse group of professionals. From biomedical researchers who use our clinical microscopes, to doctors who perform life-saving procedures with our endoscopes, to professional photographers who use cameras in their daily work, Olympus is a trusted brand.

The digital imaging technology involved with *America 24/7* has enabled the soul of America to be visually conveyed, not just by professional observers, but by the American public who participated in this project—the very people who collectively breath life into this country's existence each day.

We are proud to be enabling so many photographers to capture the pictures on these pages that tell the story of who we are as a nation. From sea to shining sea, digital imagery allows us to connect to one another in ways we never dreamed possible.

At Olympus, our ideas have proliferated as rapidly as technology has evolved. We have channeled these visions into breakthrough products and solutions to meet the demands of our changing world-products like microscopes, endoscopes, and digital voice recorders, supported by the highly regarded training, educational, and consulting services we offer our customers.

Today, 83 years after we introduced our first microscope, we remain as young, as curious, and as committed as ever.

Lexar Media has grown from the digital photography revolution, which is why we are proud to have supplied the digital memory cards used in the America 24/7 project. Lexar Media's high-performance memory cards utilize our unique and patented controller coupled with high-speed flash memory from Samsung, the world's largest flash memory supplier. This powerful combination brings out the ultimate performance of any digital camera.

Photographers who demand the most from their equipment choose our products for their advanced features like write speeds up to 40X, Write Acceleration technology for enabled cameras, and Image Rescue, which recovers previously deleted or lost images. Leading camera manufacturers bundle Lexar Media digital memory cards with their cameras because they value its performance and reliability.

Lexar Media is at the forefront of digital photography as it transforms picture-taking worldwide, and we will continue to be a leader with new and innovative solutions for professionals and amateurs alike.

Snapfish, which developed the technology behind the *America 24/7* amateur photo event, is a leading online photo service, with more than 5 million members and 100 million photos posted online. Snapfish enables both film and digital camera owners to share, print, and store their most important photo memories, at prices that cannot be equaled. Digital camera users upload photos into a password-protected online album for free. Users can also order film-quality prints on professional photographic paper for as low as 25¢. Film camera users get a full set of prints, plus online sharing and storage, for just $2.99 per roll.

JetBlue Airways is proud to be *America 24/7's* preferred carrier, flying photographers, photo editors, and organizers across the United States.

Winner of Condé Nast Traveler's Readers' Choice Awards for Best Domestic Airline 2002, JetBlue provides friendly service and low fares for travelers in 22 cities in nine states across America.

On behalf of JetBlue's 5,000 crew members, we're excited to be involved in this remarkable project, and for the opportunity to serve American travelers each and every day, coast to coast, 24/7.

WebWare Corporation is pleased to be a major sponsor of the America 24/7 project. We take pride in being part of a groundbreaking adventure that is stretching the boundaries—and the imagination—in digital photography, digital asset management, publishing, news, and global events.

Our ActiveMedia Enterprise™ digital asset management software is the "nerve center" of *America 24/7*, the central repository for managing, sharing, and collaborating on the project's photographs. From photo editors and book publishers to 24/7's media relations and marketing personnel, ActiveMedia provides the application support that links all facets of the project team to the content worldwide.

WebWare helps Global 2000 firms securely manage, reuse, and distribute media assets locally or globally. Its suite of ActiveMedia software products provide powerful media services platforms for integrating rich media into content management systems marketing and communication portals; web publishing systems; and e-commerce portals.

Google's mission is to organize the world's information and make it universally accessible and useful.

With our focus on plucking just the right answer from an ocean of data, we were naturally drawn to the America 24/7 project. The book you hold is a compendium of images of American life distilled from thousands of photographs and infinite possibilities. Are you looking for emotion? Narrative? Shadows? Light? It's all here, thanks to a multitude of photographers and writers creating links between you, the reader, and a sea of wonderful stories. We celebrate the connections that constitute the human experience and are pleased to help engender them. And we're pleased to have been a small part of this project, which captures the results of that interaction so vividly, so dynamically, and so dramatically.

Founded in 1995, eBay created a powerful platform for the sale of goods and services by a passionate community of individuals and businesses. On any given day, there are millions of items across thousands of categories for sale on eBay. eBay enables trade on a local, national and international basis with customized sites in markets around the world.

Through an array of services, such as its payment solution provider PayPal, eBay is enabling global e-commerce for an ever-growing online community.

Digital Pond has been a leading creator of large graphic displays for museums, corporations, trade shows, retail environments and fine art since 1992.

We were proud to bring together our creative, print and display capabilities to produce signage and displays for mission control, critical retouching for numerous key images for the book, and art galleries for the New York Public Library and Bryant Park.

The Pond's team and SplashPic® Online service enabled us to nimbly design, produce and install over 200 large graphic panels in two NYC locations within the truly "24/7" production schedule of less than ten days.

Special thanks to additional contributors: FileMaker, Apple, Camera Bits, LaCie, Now Software, Preclick, Outpost Digital, Xerox, Microsoft, WoodWing Software, net-linx Publishing Solutions, and Radical Media. The Savoy Hotel, San Francisco; The Pan Pacific, San Francisco; Four Seasons Hotel, San Francisco; and The Queen Anne Hotel. Photography editing facilities were generously hosted by CNET Networks, Inc.

Participating Photographers

Coordinators, New York State: David Frank, Deputy Picture Editor, *The New York Times*
New York City: Michelle McNally, Picture Editor, *Fortune Magazine*

Gwen Akin
Alyson Aliano
Barbara Alper
Kristen Ashburn, Contact Press Images
Wyett Baker
Nancie Battaglia
Nina Berman
Jay Brenner, Brenner Lennon Photo
David Burnett, Contact Press Images
John R. Collins
Martha Cooper
Sergio Rosa Cruz
Andrew DeMattos
Douglas Dubler 3
Jill Enfield
Paulo Filgueiras
Brian Fish
Lauren Fleishman
Frank Fournier, Contact Press Images
Peter Freed
Jason Fulford
Mark Garten
Dennis Gartner
Josh Gelman
Al Gilbert C.M.
Elizabeth Gilbert
Larry Glade
Lynn Goldsmith
Enrique Gonzalez
Gordon M. Grant
Mark Greenberg, WorldPictureNews
Philip Greenberg
Avital Greener
John Griffin
Lori Grinker, Contact Press Images
Michael Groll
Katherine R. Hais
Alicia Hansen
Patrick Harbron
Lyn Hughes
Angela Jimenez
Eric Johnson
Lisa Kahane
Ken Karlewicz
Dave Kaye
Greg Kinch
Douglas Kirkland
Frank Koester

Joe Kohen
J-P Laffont
Andre Lambertson
Kristine Larsen
Gillian Laub
Rebecca Letz
Darren Levant
Zack Leven
Andrew Lichtenstein
Roxanne Lowit
Lauri Lyons
Ian Macdonald-Smith
Andre Maier
Howard Mandel
Lou Manna, Olympus Camedia Master
Mike McLaughlin
Joe McNally
Doug Menuez, CM
Joel Meyerowitz
Mark Mulville, *The Buffalo News*
Michael J. Okoniewski
Carlos Ortiz, *Democrat and Chronicle*
Brian Palmer
Mark Peterson
Sylvia Plachy
Robert Polidori
Gus Powell
Chris Ramirez
Kevin Rivoli
Vincent Rodriguez
Marc Safran
James Salzano
Rick Sammon
Jenny Schulder
Frank Schwere, BRANSCH INC.
Shepard Sherbell, Corbis SABA
Jack Shutzman
Susan Stava
Joseph Sywenkyj
John Bigelow Taylor
Joyce Tenneson
Scott Thode
Jonathan Torgovnik
Stan Tracy
Nathaniel Welch
David H. Wells, www.davidHwells.com
Will Yurman

Thumbnail Picture Credits

Credits for thumbnail photographs are listed by the page number and are in order from left to right.

Staff

The *America 24/7* series was imagined years ago by our friend Oscar Dystel, a publishing legend whose vision and enthusiasm have been a source of great inspiration.

We also wish to express our gratitude to our truly visionary publisher, DK.

Rick Smolan, Project Director
David Elliot Cohen, Project Director

Administrative
Katya Able, Operations Director
Gina Privitere, Communications Director
Chuck Gathard, Technology Director
Kim Shannon, Photographer Relations Director
Erin O'Connor, Photographer Relations Intern
Leslie Hunter, Partnership Director
Annie Polk, Publicity Manager
John McAlester, Website Manager
Alex Notides, Office Manager
C. Thomas Hardin, State Photography Coordinator

Design
Brad Zucroff, Creative Director
Karen Mullarkey, Photography Director
Judy Zimola, Production Manager
David Simoni, Production Designer
Mary Dias, Production Designer
Heidi Madison, Associate Picture Editor
Don McCartney, Production Designer
Diane Dempsey Murray, Production Designer
Jan Rogers, Associate Picture Editor
Bill Shore, Production Designer and Image Artist
Larry Nighswander, Senior Picture Editor
Bill Marr, Sarah Leen, Senior Picture Editors
Peter Truskier, Workflow Consultant
Jim Birkenseer, Workflow Consultant

Editorial
Maggie Canon, Managing Editor
Curt Sanburn, Senior Editor
Teresa L. Trego, Production Editor
Lea Aschkenas, Writer
Olivia Boler, Writer
Korey Capozza, Writer
Beverly Hanly, Writer
Bridgett Novak, Writer
Alison Owings, Writer
Fred Raker, Writer
Joe Wolff, Writer
Elise O'Keefe, Copy Chief
Daisy Hernández, Copy Editor
Jennifer Wolfe, Copy Editor

Infographic Design
Nigel Holmes

Literary Agent
Carol Mann, The Carol Mann Agency

Legal Counsel
Barry Reder, Coblentz, Patch, Duffy & Bass, LLP
Phil Feldman, Coblentz, Patch, Duffy & Bass, LLP
Gabe Perle, Ohlandt, Greeley, Ruggiero & Perle, LLP
Jon Hart, Dow, Lohnes & Albertson, PLLC
Mike Hays, Dow, Lohnes & Albertson, PLLC
Stephen Pollen, Warshaw Burstein, Cohen, Schlesinger & Kuh, LLP
Rick Pappas

Accounting and Finance
Rita Dulebohn, Accountant
Robert Powers, Calegari, Morris & Co. Accountants
Eugene Blumberg, Blumberg & Associates
Arthur Langhaus, KLS Professional Advisors Group, Inc.

Picture Editors
J. David Ake, Associated Press
Caren Alpert, formerly *Health* magazine
Simon Barnett, *Newsweek*
Caroline Couig, *San Jose Mercury News*
Mike Davis, formerly *National Geographic*
Michel duCille, *Washington Post*
Deborah Dragon, *Rolling Stone*
Victor Fisher, formerly Associated Press
Frank Folwell, *USA Today*
MaryAnne Golon, *Time*
Liz Grady, formerly *National Geographic*
Randall Greenwell, *San Francisco Chronicle*
C. Thomas Hardin, formerly *Louisville Courier-Journal*
Kathleen Hennessy, *San Francisco Chronicle*
Scot Jahn, *U.S. News & World Report*
Steve Jessmore, *Flint Journal*
John Kaplan, University of Florida
Kim Komenich, *San Francisco Chronicle*
Eliane Laffont, *Hachette Filipacchi Media*
Jean-Pierre Laffont, *Hachette Filipacchi Media*
Andrew Locke, MSNBC
Jose Lopez, *The New York Times*
Maria Mann, formerly AFP
Bill Marr, formerly *National Geographic*
Michele McNally, *Fortune*
James Merithew, *San Francisco Chronicle*
Eric Meskauskas, *New York Daily News*
Maddy Miller, *People* magazine
Michelle Molloy, *Newsweek*
Dolores Morrison, *New York Daily News*
Karen Mullarkey, formerly *Newsweek, Rolling Stone, Sports Illustrated*
Larry Nighswander, Ohio University School of Visual Communication
Jim Preston, *Baltimore Sun*
Sarah Rozen, formerly *Entertainment Weekly*
Mike Smith, *The New York Times*
Neal Ulevich, formerly Associated Press

Website and Digital Systems
Jeff Burchell, Applications Engineer

Television Documentary
Sandy Smolan, Producer/Director
Rick King, Producer/Director
Bill Medsker, Producer

Video News Release
Mike Cerre, Producer/Director

Digital Pond
Peter Hogg
Kris Knight
Roger Graham
Philip Bond
Frank De Pace
Lisa Li

Senior Advisors
Jennifer Erwitt, Strategic Advisor
Tom Walker, Creative Advisor
Megan Smith, Technology Advisor
Jon Kamen, Media and Partnership Advisor
Mark Greenberg, Partnership Advisor
Patti Richards, Publicity Advisor
Cotton Coulson, Mission Control Advisor

Executive Advisors
Sonia Land
George Craig
Carole Bidnick

Advisors
Chris Anderson
Samir Arora
Russell Brown
Craig Cline
Gayle Cline
Harlan Felt
George Fisher
Phillip Moffitt
Clement Mok
Laureen Seeger
Richard Saul Wurman

DK Publishing
Bill Barry
Joanna Bull
Therese Burke
Sarah Coltman
Christopher Davis
Todd Fries
Dick Heffernan
Jay Henry
Stuart Jackman
Stephanie Jackson
Chuck Lang
Sharon Lucas
Cathy Melnicki
Nicola Munro
Eunice Paterson
Andrew Welham

Colourscan
Jimmy Tsao
Eddie Chia
Richard Law
Josephine Yam
Paul Koh
Chee Cheng Yeong
Dan Kang

Chief Morale Officer
Goose, the dog